TRUTH AND ART

TRUTH

AND ART

Albert Hofstadter

Columbia University Press New York and London

1965

Albert Hofstadter is Professor of
Philosophy at Columbia University.

For Manya and Marc

Preface

The essay that follows must speak for itself. Yet on the topic of truth one prefatory remark may not be without use. Truth, in one sense, is truth-about. If I say "Man is finite; his being is mixed with nonbeing," I have stated a truth about man. Such a truth can be known. It is essentially something knowable, and it is only knowable. Throughout the sphere of knowledge, truth in this sense of truth-about stands as standard and goal. When one speaks of truth, this is the sense that first comes to mind. Hence, when one speaks of truth in connection with art, what first comes to mind is the idea that the question is being raised of whether and how art may express such truth-about.

That is not the question raised in this essay. That some works of art attempt to state explicit truths is itself doubtless true—witness, for instance, Pope's *Essay on Criticism.* That others attempt to imply truths is equally true—every great work of literature, at least, falls into this class. And it may be argued that all art, in one way or another, offers us insight into truth about man and the conditions of his existence. But none of these considerations enters into the course of thought of the present study.

Truth-about is not the only sense of truth, nor is it the ultimate sense of truth. Truth-about is the first in a sequence of forms of truth on which man must build in order to attain

to the truth of his own being. Truth-about is considered here, in the specific form of truth of statement, as such a first stage in a sequence. The last stage is what is here called truth of spirit.

Truth of spirit is no longer a truth that belongs merely to cognition, when cognition is thought of as distinguished from will and from the concrete being of man. It is no longer something only knowable. Truth of spirit is first of all a truth of being, where "of" occurs in the possessive, not the objective, case. It is essentially something livable. When something *is* truly, as that thing, it has truth of being. It is as its own essence requires it to be; it *has* an essence that requires it to be itself. Man's essence is spirit. His truth is truth of spirit. For man, to be truly is to be truly as a spiritual being, in his finitude. Spirit includes cognition, and hence truth in the first sense, as truth-about, is included in truth of spiritual being. But truth of spiritual being goes beyond cognition to the actuality of being itself.

Art is part of man's being. The truth of art, therefore, is more than truth-about. It is truth of spirit. This means that beyond anything a work of art may say about this or that aspect of things, it has ultimately to be true to the being of spirit, i.e. to be truly as its own form of spiritual being. The essence of art is the articulation of human being, i.e. of the spiritual being of man, and eventually of the truth of human being, namely, the truth of that spiritual being. That is the point of this essay. Its aim is to point to that essential function, the articulation of the truth of human existence, by which art defines itself in its own existence.

Several acknowledgments are in order. To Ernest Nagel, friend of many years, I owe the constant stimulus of a mind of the greatest clarity and finest judgment, and to Meyer

Schapiro the boon—instruction and delight—of many hours of conversation on art. I am indebted especially to Herman Ausubel, friend and colleague, for his wise counsel and guidance and his never-failing encouragement. Ruth Nanda Anshen first suggested that this book be written and her faith has provided a most helpful support. Ludwig Edelstein, who has read the manuscript, has given me the benefit of his valued judgment. My debts to my wife and my son are endless; they have given of themselves in every way to assist the completion of the work.

I am grateful to the Trustees of the British Museum for the photograph of the Horse of Selene and for permission to reproduce it.

ALBERT HOFSTADTER

October, 1964
New York City

Contents

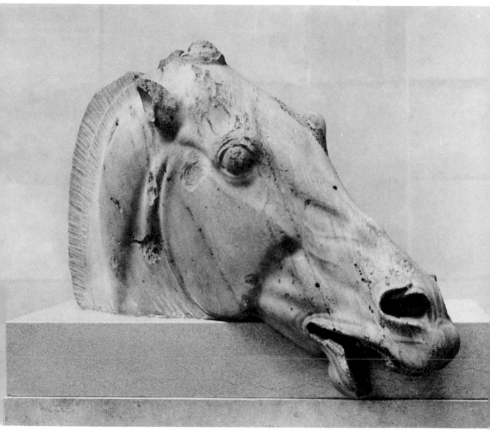

*Head of the Horse of Selene, Elgin Marbles, British Museum,
London. From the Eastern Pediment of the Parthenon.*

[1] *Art as the Expression of Subjectivity*

The aesthetic dimension of human existence enjoys a curious position in the subject matter of philosophy. For many thinkers something other than aesthetics stands at the center of concern in philosophy, whether it be metaphysics, epistemology, or logic; and ethics is considered by virtually all philosophers to be close to the center. Aesthetics, on the other hand, stands at the fringe, and is only of peripheral interest. This way of placing matters is understandable. At the center is the interest in being, truth, reality, that which *is* and the knowledge of it; and close to it is interest in the useful, the good, and the right. But aesthetics has to do only with art and the so-called beautiful, ultimately with the pleasure of contemplating things apart from their being, truth, or goodness. Such pleasurable contemplation, however enjoyable and refreshing, is, so to speak, a luxury, and the philosophy of it a tolerable but hardly very serious part of philosophy as a whole.

On the other hand, there is another and no less select band of philosophers for whom the aesthetic has a special and even key significance. One thinks first of all of Plato— the Plato not only of the *Symposium*, in which the rise to beauty is a rise from appearance to being and truth, and not only of the *Phaedrus*, in which the soul is envisaged in its

flight to the ideal realm that beauty inhabits, and certainly not only of the misleading *Republic*, in which imitative art is demoted to the rank of a third-rate copy, but above all of the *Philebus*, in which the order of goods is headed by measure, the mean, the suitable, that is, by the essential principle of beauty, and of the *Statesman*, which tells us that this notion of measure and the mean will one day be required for the demonstration of absolute truth. Then again there is Plotinus, for whom the ineffable One who is the source of all being may be named the Beautiful as well as the Good; and there are all the Platonists down the ages, from Augustine to Ficino to Schelling who revert in ever new fashion to the Platonic insight.

In modern philosophy aesthetics received its highest estimate at the hands of the German idealists. In Kant's *Critique of Judgment* art and beauty became the mediating and unifying link between scientific understanding and practical reason, feeling the link between knowledge and will, purposiveness the link between causal law and actual purpose. Kant thus gave to the aesthetic dimension a pivotal role in the structure of human experience: in it he found the intimation of the supersensible as the ultimate point of union for all our a priori faculties.[1]

This primacy of the aesthetic, which for Kant was only formal or regulative, became constitutive and metaphysical in his followers, and first of all in the early and middle stages of Schelling's thought, the stages of his transcendental idealism and his philosophy of identity. In aesthetic intuition Schelling located the highest insight which solves the problem that self-developing spirit sets to itself, namely, to know itself explicitly as the identity of freedom and neces-

[1] *Critique of Judgment,* Section 57, "Solution of the Antinomy of Taste."

sity. In art, both in the beauty that is the goal of art and in the creative process of the artistic genius, the free and the necessary come together to constitute an absolute unity. Everything in the work of art is freely produced and yet everything in it is absolutely necessary; the work of art is therefore absolute reality or absolute truth in intuitable form in a finite object. It is the infinite finitely represented. Aesthetics, as the philosophical science of aesthetic intuition and its object the work of art, thus became for Schelling the road to truth and the keystone of the arch of philosophy. In his later thought, religion and positive philosophy displaced aesthetics and art as the sanctuary of the philosophical temple, but art remained the approach to this region and thus retained its significance as the clue to reality and truth.

Finally in Hegel's *Phenomenology* and in his more mature reflection in the *Encyclopedia* and the lectures on *Aesthetics*, the brilliant insights of Schelling were developed into a rich system, and art became the first of the three forms of spirit that constitute the ultimate stage of existence, absolute spirit. Art was absolute spirit in its immediacy, religion absolute spirit in its otherness, and philosophy absolute spirit returned to itself; and accordingly, the philosophy of art, the philosophy of religion, and the philosophy of philosophy itself (the history of philosophy) became the three highest and most significant parts of philosophy.

Meanwhile, in an independent development out of Kantian idealism, Schopenhauer, too, gave art a central place in the philosophical domain, for it was through aesthetic intuition that, he thought, man could perceive the Platonic Ideas that were the eternal forms in which the restless Will objectified itself, and it was through musical intuition that man could perceive, even behind those Ideas, the Will itself in its

own intrinsic nature. As for Schelling so for Schopenhauer, art and aesthetic intuition became the organ by which the philosopher could achieve ultimate insight into the nature of reality.

Although the collapse of German absolute idealism meant the breakdown of the metaphysical interpretation of reality as a single mind, spirit, or will, and therefore had an inevitable effect on the interpretation of the significance of art, it remains the case that for those thinkers who place human experience at the center of their philosophical concern, art must retain something of the significance attributed to it by the idealists, and aesthetics must consequently retain something of the philosophical centrality they gave to it. And so indeed it does in the thought of philosophers otherwise so diverse as, for example, Nietzsche, Croce, Dilthey, Cassirer, Maritain, Whitehead, Dewey, and Heidegger.

What binds these philosophers together is the conviction that the clue to philosophical truth is to be found in human existence. Whatever be the ultimate goal of philosophy, the path of its attainment goes through the study of man. This does not mean that the only significant philosophy is humanism, nor does it mean that the proper study of mankind is man. It does mean that, in one way or another, we can and must find our way to being through man. Such a path to being is, indeed, the only one that appears traversible to philosophy since the advent of the Kantian criticism of human knowledge. No thinker who aims to do justice to the nature of knowledge can suppose that being exists as a thing-in-itself, independent of the human mind, which can nevertheless be grasped as and for what it is in itself by an act of pure vision, as it were, in which the mind passively receives its unadulterated essence. Knowing is an activity. The mind

actively sets goals to itself, asks its own kinds of questions, and induces the phenomena or appearances in experience to suggest answers that suit the questions.

Even the phenomenology of Husserl, which stresses more than any other philosophical viewpoint the vision of essences and the difference of the "noematic" object of consciousness from the "noetic" act of consciousness, nevertheless does not attempt to think of that object as a being that exists in itself, out of essential correlation with its constituting noetic act. The two are essentially, not contingently, correlated, even though we cannot identify the object as a part of or a material constituent in the act. And, indeed, underlying the entire split of the coimplication of *noesis* and *noema* in consciousness is the pure ego, the ultimate ground of being that shows itself in the constitution of the consciousness of a world. The being that shows itself to man in his knowing is thus impregnated, in its appearance, with man's ways of speaking and thinking; it betrays an a priori structure of understanding that is characteristic of man, exemplified by the grammatical categories of language or by the spatiotemporal and causal categories of physical science. Man knows through, by means of, and within such a structure of comprehension.

As Cassirer phrased it, language, science, myth, religion, and art are *symbolic forms,* or modes of symbolism whose characteristic forms of symbolizing give structure in an a priori way to man's access to and grasp of reality. Each represents a way in which man envisions and comes to grips with that which *is;* none constitutes an exclusive and absolute possession of being; only the living interplay of all—a unity which Cassirer adumbrated but never succeeded in formulating with full adequacy—suffices to exhaust the total scope of the human knowledge of being, i.e. to give the

ultimate insight sought by philosophy. As such a symbolic form, art works to reveal reality to man in its own unique way.

In his earlier thought Cassirer enunciated this function of art in language that was still close to that of post-Kantian idealism:

> In the whole of speculative aesthetics—from Plotinus to Hegel— the concept and the problem of symbolism arise precisely at the point at which the relation of the world of sense to the intelligible world, the relation of appearance and Idea, is to be defined. The beautiful is essentially and necessarily symbol because and in so far as it is split within itself, because it is always and everywhere both one and double. In this splitness, in this attachment to the sensuous, and in this rising above the sensuous, it not only expresses the tension that runs through the world of our consciousness,—but the original and basic polarity of being itself reveals itself therein: the dialectic that obtains between the finite and the Infinite, between the absolute Idea and its presentation and embodiment within the world of individuals, of empirically existent beings.[2]

The symbolic means by which the work of art exercised this function of representing the dialectical polarity of finite and Infinite, appearance and Idea, was constituted by a peculiar unity of two of the three basic functions of symbolism. The three functions were *expression* (*Ausdruck,* which gives inner life through objective sensuous content) *presentation* (*Darstellung,* which fixes and describes objective content as over against subjectivity), and *meaning* (*Bedeutung,* by which a sign or symbol, neither expressive nor presentational, signifies an independent content, as for instance a geometrical axiom system is a system of symbols

[2] "Das Symbolproblem und seine Stellung im System der Philosophie," *Zeitschrift für Ästhetik und allgemeine Kunstwissenschaft,* Band 21 (1927), pp. 295–312. See also Gilbert, "Cassirer's Placement of Art," *The Philosophy of Ernst Cassirer,* pp. 605–30.

susceptible of various interpretations). These functions are rooted in different capacities of the human mind: expression in feeling, presentation in intuition, and meaning in pure thought. Now the peculiarity of art and its aesthetic symbol is that, although it may make full use of meaning-symbolism as material, its form or substance as symbol is an indissoluble unity of expression and presentation. Of the presence of these two symbolic functions in the work of art Cassirer said that

it is first of all the merging of the one *in* the other, the ideal equilibrium that presents itself between them, that constitutes aesthetic activity as it does the aesthetic object.

Here, pure presentation is sought in and by virtue of expression, and pure expression in and by virtue of presentation:

Every perfected poem of Goethe sets both before us in indissoluble unity and wholeness. It is wholly immersed in a definite mood, it is saturated by this mood in every sound and in its entire rhythmical movement. But precisely in this melodic-rhythmical expressive content a new configuration of the world builds itself up for us, standing over against us in pure objectivity. The different arts, literature, music, the plastic arts, and among these painting and sculpture, may arrive at this unity in different ways and by different means, but it is absent in none of them because it belongs to the essence of the formative process of art as such.[3]

In this way the two experiential phases of subjectivity and objectivity are symbolized in their living unity by means of the symbol that expresses inner being in and by the presentation of outer being, that fills the sensuous with spirit and gives to spirit a sensuous body. Neither mere emotion nor mere object, the beautiful or artistic entity is

[3] "Das Symbolproblem," pp. 309–10.

both at once in thoroughgoing reciprocity. The polar tension and opposition of inwardness and externality is symbolized in the product of artistic formation. As in a poem by Goethe, *a world grows up within a feeling and a feeling crystallizes in the shape of a world.*

This indissoluble unity of presentation and expression was also the central idea of the idealistic aesthetic theory of Croce, which had so forceful an influence in the first part of this century. It is summed up in the equation intuition = expression. The aesthetic apprehension of a sensuous form is at once an intuition, i.e. an act in which something objective is immediately given, i.e. presented, and an expression, i.e. an act in which something subjective is given out in the form of an intuited object. The sensuous form thus becomes at one and the same time intuitive and expressive— which is exactly the combination that Cassirer found to be present in the art symbol.[4]

On Croce's view expression as activity is the transformation of an impression, i.e. a feeling, into an image, the transformation of an emotion that is simply undergone into an intuition that is possessed. And, indeed, every intuition is the product of such a transformation of feeling into image. To express is thus the same thing as to form an intuitive image, and this is the burden of the equation, expression = intuition. An impression, i.e. a feeling of one sort or another— feeling being the immediate, unarticulated form of spiritual being—when it enters the mind, acts as an irritant, just because it is not yet fully mentalized, spiritualized, or possessed *as* a spiritual entity. It is, as it were, an economic, not yet an aesthetic, fact. The mind seeks to form its matter, to transform its raw material into spiritual actuality; and this

[4] Croce, *Aesthetic as Science of Expression and General Linguistic,* pp. 8-11.

is, first of all, to make it into an intuition or vision, which is the same thing as to express it. Expression, therefore, is not the mere out-pressing of inner content; it is the intuitional-izing of a feeling, the embodying of it in the form of a vision—it is the creation of lyrical insight.

Hence Croce conceived of the work of art as an intuitional symbol of feeling:

> What gives coherence and unity to the intuition is feeling: the intuition is really such because it represents a feeling, and can only appear from and upon that. Not the idea, but the feeling, is what confers upon art the airy lightness of the symbol: an aspiration enclosed in the circle of representation—that is art: and in it the aspiration alone stands for the representation and the representation alone for the aspiration. Epic and lyric, or drama and lyric, are scholastic divisions of the indivisible: art is always lyrical—that is, epic and dramatic in feeling.[5]

If the content of the art symbol is feeling, then the image is the form given to that feeling. Thus in the art work content and form come together as unity: the feeling-content becomes a "figurative feeling" and the figure one that is felt.[6] Aesthetic apprehension, which is in principle the same in artist and spectator, is a significant unity of the two factors, feeling and image, that are one in the unity of the lyrical image. These are two aspects which can be distinguished but not separated in art. We can say that the image or intuition is "significant form," in the language of Clive Bell and the so-called formalist (really an expressivist) theory of art, but for a Crocean—and twentieth-century formalism was in essence close to, if not a development of, the Crocean view—this means only that in the aesthetic act there is a nexus of images generated and animated by a spiritual principle making the act all one with itself. Such an

[5] *Breviary of Aesthetic*, pp. 247–48. [6] *Ibid.*, p. 255.

animated image-whole consists not in a juxtaposition but an organic unity of its constituent images; and the principle of this unity is the feeling it embodies and symbolizes. The content of the form is the feeling; the form of the content is the image; the two are one, and this is what constitutes the artistic symbol:

For the truth is really this: content and form must be clearly distinguished in art, but must not be separately qualified as artistic, precisely because their relation only is artistic—that is, their unity, understood not as an abstract, dead unity, but as concrete and living, which is that of the synthesis *a priori;* and art is a true aesthetic synthesis *a priori* of feeling and image in the intuition, as to which it may be repeated that feeling without image is blind, and image without feeling is void. Feeling and image do not exist for the artistic spirit outside the synthesis.[7]

The indivisible unity of feeling and image, or in general the inner and the outer, belongs to the work of art in principle, however, precisely because of the kind of symbol that art is. This feature, the characteristic symbolic nature of the work of art, is what Cassirer added to the Crocean concept of intuitive expression: art is essentially symbol, but only one within a circle of symbolic forms; artistic symbolism is a unique kind of symbolism, namely, that in which two of the three basic dimensions of the symbol, presentation (of intuition) and expression (of inner life), occur in indissoluble union.

Later, Cassirer was to express the symbolic function of art in a less idealistic way, more empirical, more influenced by the theory of pure visibility and the existence of abstract art, but remaining faithful to his original conception of the interpenetration of expression and presentation and even extending it from a static to a dynamic process. The artistic

[7] *Ibid.,* 254–55.

form functions constructively in the framing of the human universe.

Beauty is "the Infinite finitely presented" according to Schelling. The real subject of art is not, however, the metaphysical Infinite of Schelling, nor is it the Absolute of Hegel. It is to be sought in certain fundamental structural elements of our sense experience itself—in lines, design, in architectural, musical forms. These elements are, so to speak, omnipresent. Free of all mystery, they are patent and unconcealed; they are visible, audible, tangible. In this sense Goethe did not hesitate to say that art does not pretend to show the metaphysical depth of things, it merely sticks to the surface of natural phenomena.[8]

But this surface is *formed* by the creative artist, and before he has formed it we do not know it; he discovers *the forms of things* for us. These forms embody inner life. Indeed, it is only in so far as inner life is adequately embodied in sensuous materials that things have forms. Art thus gives us the motions of the human soul. In the work of art we feel not a simple, single emotional quality but *the dynamic process of life itself,*

the continuous oscillation between opposite poles, between joy and grief, hope and fear, exultation and despair.[9]

The life of human passion becomes in art a creative power, endowing itself with the forms of pure visibility, pure audibility, pure imagination. In the creative process the passions are turned into actions. No longer does Cassirer think of a work of art as adequately described in terms of the intuitive objectivation of a mood or feeling; now, it is not such a special state but "the very dynamic process of our inner life" that art gives—motion, not merely emotion, "the motion and vibration of our whole being." [10]

[8] *An Essay on Man*, pp. 157–58. [9] *Ibid.*, pp. 148–49.
[10] *Ibid.*, pp. 149–50. Cassirer's ideas, especially as they were devel-

Cassirer's key phrase now is that by which Schiller defined beauty, namely "living form," the "dynamic life of forms." Whether in poetry, painting, music, or nature itself, to perceive beauty is to enter the realm of living forms, to live in the rhythm of spatial forms, the harmony and contrast of colors, the balance of light and shade. Here, as before, art exists in the tension—which is a living unity—between outward form and inner life, an objective and a subjective pole. By reaching this union, art both constructs and reveals reality in its own way—the aesthetic aspect of reality, reality seen by way of the aesthetic symbol. Art exercises its constructive power in the framing of the human universe, but it does this by revealing the forms of things, differing in this from science, which discovers the causes of things. Both science and art attempt to penetrate into the depth upon whose surface the sensuous appearances of things rest. But there are different depths, conceptual and visual. Science enters into the former and gives us the reasons of things, art the latter and gives us the living forms of things. Both the scientific conceptual interpretation and the artistic intuitive interpretation contribute to the complex depth that constitutes the world of human existence, and each is indispensable to the full realization of the enduring tension and fundamental polarity constitutive of the existence of man in his world: the incessant struggle between reproduction and creation, stabilization and evolution, con-

oped in his *Philosophy of Symbolic Forms*, were carried out in aesthetics by Susanne K. Langer, whose writings have been aimed at working out the theory of the expressive form, i.e. the aesthetic symbol as the unity of expression and presentation, the expressive content being conceived particularly as *the dynamic life of feeling*. See especially: *Philosophy in a New Key; Feeling and Form; Problems of Art.*

servation and production, objectivity and subjectivity, universality and individuality.[11]

The final element in Cassirer's view, which he never developed and which was also left without elaboration in Mrs. Langer's explication of the "living form" version of aesthetic symbolism, has to do with style, which is of decisive significance because in it thinking about art begins to touch the heart of its subject matter. As science has its ideal of truth so also does art. Indeed, every mode of symbolism essentially involves its own authentic mode of truth: "the symbol would not be a symbol if it did not lay claim to some kind of truth for itself." [12] There is an "objectivity," a "truth," that makes the difference between something merely subjective and arbitrary and something that is genuinely symbolic.

This truth cannot consist in the mere *copying* of an antecedently given being. On the contrary, the principle by which each symbolic form is form-giving is original, in the sense of originary: it is constructive of a meaningful ordering in its own spontaneous way. This is the fundamental burden of the Kantian discovery of the transcendental element in human experience—the discovery, namely, of the a priori element, i.e. the feature of spontaneity and originality of the human mind in all its enterprises.

Applied to art and the artist, this means that the artist's function cannot be interpreted as the mere reproduction of a beauty already given in nature and needing merely to be copied. Art is itself spontaneous, original, creative; and in this way it is prior to anything already given in nature. In fact, the relation between art and nature is the reverse of

[11] Cassirer, *An Essay on Man*, pp. 222–28.
[12] "Das Symbolproblem," p. 310.

that envisaged by the copy theory. The artist's individual intuition of nature—which we learn from him and in virtue of which we perceive nature now as never before his advent—itself *results* from the peculiar type and direction of his mode of artistic configuration. His vision of nature is given form through the *style* of his work. The law under which artistic creation stands is, thus, a law not of reproduction but of originary stylization, originary form-giving.

This law of style, which represents what is creatively original and not merely imitative in the artistic symbolizing of reality, is a law of *inner* truth, as distinct from truth of reproduction. Each art, even apart from any individual artist, already stands under its own law of inner truth: architecture is not music, not even frozen music, and music is not architecture. The *styles* of architecture and music—the architectural and the musical as such—are unique and original to each of these arts. They already embody stylistic laws which exhibit an independent specificity, autonomy, self-determination. Naturally, they are not "scientific" laws that could be formulated as universal statements in the symbolism of science and applied as precepts by artists who would then act as "engineers" or "technologists" of art. On the contrary, stylistic lawfulness constitutes the *inner* norm of the process and product of artistic formation. Any artistic product *is* a work of art and gets its ground as such by its agreement with this inner norm: it is a working out, a carrying out into actual being, of this inner principle of self-determinative being. The style of each art expresses its inner truth and objectivity.

As with each art, so with each artist—although in this place Cassirer did not discuss the question of individual style, a question which does not even stop at the individual artist but drives onward toward the single work itself.

The same applies to all the domains of mind. In each there is a law of formation in terms of which truth and objectivity are determined; and we can understand these latter only by way of insight into this law, a law not of substantial but of functional form. Being does not antecede the meanings articulated in the forms of symbolism. Symbol is not copy of preexistent being. Being unfolds in and out of meaning, and the different forms of being-meanings—science, religion, language, myth, art—do not contradict but rather realize and fulfill the demand for unity of being.

Croce and Cassirer were two of the original sources of the *expression theory of art*. They had many adherents and even today, despite occasional criticism, their theory has retained a large following. In our language the writings of E. F. Carritt and R. G. Collingwood [13] continued the approach of Croce, and those of Susanne K. Langer that of Cassirer. What is striking in all of these writers, as it is in their archetypes, is *the radical subjectivizing of the phenomenon of art*. Expression theory, in replacing the beauty theory of art and the concept of art as imitation, whether of a naturalistic reality or a beautiful reality, found the essence of art to lie in the very process of expression itself. Thus we see Croce proposing that beauty be defined as successful expression, or, he says, since unsuccessful expression is not expression, as simply expression and nothing more.[14] And although Cassirer and Croce both stressed the co-presence of intuitional presentation with expression, image with feeling-life, in the artistic symbol, it is undeniable that for

[13] R. G. Collingwood, *Speculum Mentis*, 1914; *Outlines of a Philosophy of Art*, 1925; *The Principles of Art*, 1938. E. F. Carritt, *The Theory of Beauty*, 1914; *What is Beauty?*, 1932; *An Introduction to Aesthetics*, 1948.
[14] *Aesthetic*, p. 79.

both of them as for expression theory generally the expressive aspect dominates over the intuitive, presentational aspect. That is, intuition is there for the sake of expression, not conversely. Expression does not occur merely as a means toward the having of a presentation that is valued simply as an intuitive presentation; rather, it is the other way around. The human spirit, in the mode of being of art, is conceived of as engaging in intuitive presentation in order to bring inner subjectivity to outer objectivity or to bring outer objectivity under the spell of inner subjectivity. Art's basic function is expression, and intuitive presentation becomes the means by which and the element in which this function is realized.

It is this domination of expression, understood in the manner of Croce and Cassirer, that leads to the subjectivistic concept of art. The idea of expression itself is not necessarily subjectivistic, and an expression theory need not be dominantly subjectivistic as it is in these thinkers. In the most general sense, to express is to present or represent something by means of a sign, symbol, likeness, or other external or sensuous form. Thus the sanctity of a holy person is expressed in Christian painting by the halo as conventional symbol. In a more restricted sense, to express is to present a content in a direct way, as by embodiment, in an external or sensuous form, so as to give it directly to the viewer or listener for immediate apprehension. For instance, the tragic condition of human existence is expressed in *Oedipus Rex* not by way of comment about it but by the direct presentation of it in the dramatic image. Such direct expression of content is especially striking in the expression of emotional conditions, as of gaiety or sadness in music or color design. We note that the content expressed may be anything that the human mind can apprehend by way of an

expressive form, for instance, a subjective feeling, as the feeling of sadness, or an objective state of affairs, as the implication of man beyond his control in the workings of destiny.

Croce and Cassirer, however, tend to restrict the concept of expression still more narrowly. In their sense, expression is an "outering," an utterance, of something inward, whether this inward something be viewed as feeling, emotion, passion, state of mind, on the one hand, or the dynamic movement of the life of feeling on the other. In giving exclusive dominance in expression to subjective content, and in making the objective image subservient to the expression of such subjective content, their expression theory limited itself by turning away from all forms of objectivism. It was a reaction against naturalism, which saw the task of art as the literal reproduction of actual reality; against essentialist realism, which located it in the reproduction of the essence of the object; against metaphysical idealism, which located it in the representation of infinite reality by finite appearance.

Precisely because it took such a determined stand on one side of a series of polar oppositions, expression theory showed itself to be a limited *aesthetic* rather than a comprehensive *aesthetics*. Indeed, it is noteworthy that the period of its bloom and greatest appeal is also a period of the development and appeal of expressionist art in Italy, Germany, France, England, and the United States. The culmination of that art in recent abstract expressionism was virtually simultaneous with the popularity of the expression theory. While Jackson Pollock was painting his expressive actions and American composers were learning to write in the style of Schönberg, Susanne Langer's books were being avidly read by an art-minded public, and Croce and Collingwood were

reprinted as paperbacks. This is not to be understood as a denigration of their value; on the contrary, it is a recognition of their authenticity as a genuine manifestation of the living art-reality of a period.

Mrs. Langer's theory was, as she explains, an attempt to build the structure whose keystone was hewed by Cassirer.[15] The heart of her concern was the problem of *how* the art symbol symbolizes. This was her focal question, and her recurrent answer (varying in slight detail but essentially the same throughout) was: it symbolizes by intuitively abstracting the form of feeling-life and realizing it in an image or semblance. Thus the content of art becomes the intuitively realized idea of feeling-life, art the articulation or vision of feeling, and the work of art the symbol of feeling.

What has not been sufficiently noticed is the closeness of this theory to *a particular way of experiencing art, a "peculiar impression" which is had in the presence of the work of art:*

An Art Symbol does not signify, but only articulate and present its emotive content; *hence the peculiar impression one always gets* that feeling is in a beautiful and integral form. The work seems to be imbued with the emotion or mood or other vital experience that it expresses.[16]

The word "hence" here shows the relation of theory to fact. It is assumed to be a fact that one always gets the peculiar impression that feeling seems to be present in the artistic form. This alleged fact, not itself investigated, is taken as the starting point of investigation, the aim being to offer a theory to explain the fact. The theory is that the work is a special kind of symbol, the art symbol, namely, one that presents and articulates, rather than merely signifies, emotive content. The explanation then takes the fol-

[15] *Feeling and Form*, p. 410. [16] *Problems of Art*, p. 134, my italics.

lowing form: although feeling is not actually present as such in the work, it appears to be present because of the unusual character of artistic symbolism, which presents rather than merely signifies its content.

This notion, that the primary and essential factual core of artistic experience is the impression of a form as apparently imbued with *feeling*, represents not a merely idiosyncratic experience of Mrs. Langer's, in which case it would have been of individual significance only and would not have interested a wide public; it is also the authentic experience of many persons living within a succession of recent generations. It is a genuinely historical phenomenon, the living experience of art as expression; it represents how the essence of art took shape for a while in the actual life of man. Mrs. Langer comes back to it again and again as the source of her theorizing, and indeed it is its wellspring; people of artistic discernment know, she says, that "feeling does inhere somehow in every imaginal form." [17] The feeling "seems to be in the picture"; vital processes of sense and emotion "seem to be directly contained in" the work of art; the artistic image "seems to be charged with feeling"; the work of art "appears not merely to connote [feeling] as a meaning, but to contain it as a quality"; our own sentient being, Reality, "seems inherent in the work itself"; "the dynamic image created in dancing strikes us as something charged with feeling [which] belongs to the dance itself." [18]

Such a description of the experience of art would surely have carried little weight for the generations who found their artistic impulses realized by Phidias, Raphael, or Hogarth; it is significant for those for whom Van Gogh, Klee, Kandinsky, and Pollock are representative. The peculiar ex-

[17] *Feeling and Form*, p. 54.
[18] *Problems of Art*, pp. 6, 9, 26, 34, 45, 58.

perience of expression theory is characteristic of a post-Romantic era, thrown back into subjectivity, and indeed to the most subjective part of subjectivity, namely, feeling, to obtain its hold in existence—it is of interest in this respect that Mrs. Langer makes "Reality" appositive to "our own sentient being"—because the sources of stability earlier found in a trusted world outside the self or in a transcendent Being of beings was not to be found in the vast waste of technologically automatic process and the world's violent collapse into competition, hatred, war, and bestiality. The consequence was that an alienated selfhood found a temporary lodging in itself and produced the vision of its dwelling place in expressionist art.

Mrs. Langer's theory, according to which feeling-life appears to be present in the artistic image because (1) feeling-life consists in a process of tensions and resolutions and (2) the form embodied in the virtual image (e.g. the musical time or plastic space) is also a complex of tensions and resolutions, so that (3) the latter is *congruent* with the form of feeling-life and hence (4) able to symbolize it by this congruence (likeness or identity), i.e. to present directly an intuitive "idea" of feeling—this theory need not be dwelt on here.[19] The essential point is that artistic perception is accounted for as subjectification of the objective or objectification of the subjective, a process in which reality is made into a symbol of feeling, so that *mere subjectivity is thereby established and confirmed as the meaning of being. Art has been subjected to the power of subjectivity, and through this art, man himself has been thus subjected.*

Expression theory is only the manifestation in conceptual thought of this ontological predicament of man. In his at-

[19] See *Philosophy in a New Key*, pp. 78–80, 184–85, 188–91; *Feeling and Form*, pp. 59, 64, 82, 372, 373–74; *Problems of Art*, pp. 8, 9, 72–74, 139, among many other equivalent passages.

tempt to find the sources of his being, man, driven into himself, brings his subjectivity, merely as such, to vision in his art and, endeavoring to become aware in conceptual terms of what he has done, makes for himself the corresponding aesthetic—the expression theory of art.

From these considerations we may draw a useful hint for aesthetics as a discipline. The history of aesthetics is littered with doctrines that, like expression theory, were the conceptualized voices of the art impulses of their day: art as imitation, art as wisdom, art as catharsis, art as the reflection of beauty, art as the presentation of harmony and concinnity, art as the expression of taste, art as embodiment of sentiment, art as symbol of morality, art as integration of finite and Infinite, art as mystic identification with the Infinite, art as Dionysian play . . . and so on. Such doctrines, each *an aesthetic* in the sense of being an option for one among the many possibilities opened up in the form of being constituted by art and each, therefore, constituting the conceptual counterpart of a possible form of art, are products of authentic spiritual forces. But they must not be confused with *aesthetics,* or with the *theory of fine art,* whose aim it is not to speak for a single kind of art but to understand art in all its forms and dimensions. Theory of art must begin not with one selected kind of art experience but with the whole aesthetic-artistic life of man so far as that is accessible to us from historical investigation, contemporary experience, and imaginative penetration into the lives of other men, other cultures, other times. It must try to bring to view the total context and the pulsing heart of artistic actuality, of which such a phenomenon as expressionist creation and experience and its counterpart in the conceptual form of a theory are but one manifestation.

Opposed to expressionism is realism, opposed to idealism

is naturalism, opposed to the poetry of symbolism is the poetry of statement; the classical, the mannerist, the baroque move in a succession; the geometric sculpture of earliest Greece and the sculpture of Chartres, that of Canova and that of Henry Moore all emerge in the process of artistic configuration. Objectivity and subjectivity, transcendence and immanence, measure and antimeasure, life yielding to a stern divinity or a divine grace, to a frigid earthly beauty or the primordiality of spatial existence—all belong to the one domain within which art exercises its being. Our view of art must be open to all of these in their differences.

[2] *Art as the Joint Revelation of Self and World*

What happens when these differences are taken into account in seeking to determine the nature of art?

There is one theoretical possibility that suggests itself immediately in the circumstances, and that is tempting because it seems to promise a way of incorporating the differences into an intelligible scheme that does justice to both the opposites in the subject-object, self-world polarity. It seems at once to pass beyond the limitation to subjectivity characteristic of expression theory and yet to retain that part of the whole truth that expression theory had made its own. This more comprehensive theory does not have a single commonly recognized name—but we may call it here the *joint revelation theory* of the work of art.

It may be found in recent form in Jacques Maritain's *Creative Intuition in Art and Poetry* [1] (as, indeed, in many other recent philosophical works), but it is already present in the maturest way in Schelling and especially in Hegel. Essential to the latter's concept of objective idealism was the view that the real, self-developing mind, precisely in order to be what it was, had to split into the in-itself and

[1] See p. 32: "the joint revelation of things and creative subjectivity in the work."

out-of-itself, so that it might become the in-and-for-itself. At the level of art, where the notion attains the status of objectivated subjectivity, the in-itself is subject, the out-of-itself object, and the for-itself the revelation of object to subject as the identity of the two. As a result, art becomes this revelation of the identity of subjective and objective being by means of a dialectical process. It first presents an objectivity that as yet secretes subjectivity (symbolic art). It then presents an objectivity in full harmony with and fully revelatory of a subjectivity that is adequate, but no more than adequate, to it (classical art). Finally, it presents a subjectivity that overshadows and strains beyond the objectivity that serves as the mode of presentation (romantic art). The details of the theory are not as important here as the general idea: we overcome the one-sidedness of an art and an aesthetic that are merely subjective, or merely objective, or merely balanced between the two, by developing the idea of the *constant joint presence* of subjectivity and objectivity in art, allowing these factors to *vary in their degree of revelation* in the work according to their character, intensity, and degree of development.

A similar idea, but weighted more toward the classical middle than the romantic-expressionist extreme, was put forth even earlier by Goethe in his short but significant essay on "Simple Imitation of Nature, Manner, Style." [2] One kind of artist will subject himself to the objects of nature (simple imitation); another makes his work into a language that expresses his own mind (manner); but a third finds the language for his mind only in arriving at a deep understanding of nature, and he has *style* in the highest degree:

[2] Originally published in *Der Teutsche Merkur,* July, 1789.

As simple imitation is based on quiet existence and a present full of love, and manner apprehends an appearance with an easy, facile mind, so style rests on the deepest fundamental ground of knowledge, on the essence of things, insofar as it is granted to us to know this in visible and tangible forms.

We recognize here the steady tendency in modern thought, especially noticeable since Goethe and Kant, to bring opposites together into a synthetic unity—the essential Goethean idea of polarity and heightening (*Steigerung*) and the essential Kantian idea of the triplicity of categories, which is brought to its limit in Schelling's notion of the indifference and identity of opposed potencies and in Hegel's concept of truth as the whole. Hence we are not surprised to find it operating in the present in Maritain's thinking:

As concerns . . . the work, it also will be, in indissoluble unity —as the poetic intuition from which it proceeds—both a revelation of the subjectivity of the poet and of the reality that poetic knowledge has caused him to perceive.[3]

The two opposed factors, the subjective self on the one hand and the objective things of the world on the other, are jointly operative and jointly revealed in the work. The work is a symbol, a made object that is at the same time a dual sign,

both a *direct* sign of the secrets perceived in things, of some irrecusable truth of nature or adventure caught in the great universe, and a *reversed* sign of the subjective universe of the poet, of his substantial Self obscurely revealed.[4]

Or, in a word, the work, swimming with significances and saying more than it is,

[3] Maritain, p. 128. [4] *Ibid.*, p. 128.

will deliver to the mind, at one stroke, the universe in a human countenance.[5]

With this inclusion of the polarity of subject and object in the symbolic unity of a work, it becomes possible to stress either side, both in theory and in practice. In theory, art—or rather, according to Maritain, poetic intuition, which as creative tends toward objectification in a work of art—is accorded a double cognitive function: (1) to know and reveal things, and, beyond them, the infinite reality which is engaged in them, and thus ultimately the mutual communication of things in existence that stems from the divine Cause; and (2) to know and reveal the self, the subjectivity of the poet, ultimately in its deepest truth, namely its creative nature.[6] Theory of art and poetic intuition can therefore stress things, ranging from the most superficial insistence upon a naïvely realistic representation to the profoundest statement of art as symbol of the divine influence manifested in the world; or it may stress the self, here, too, ranging from the superficialities of emotional thrill and sensuous pleasure to the profound realization of the self as creative agent. Maritain himself fluctuates. On the one hand, subjectivity is a means of catching the inner side of things; on the other, the grasping of things comes about in order to grasp the subjectivity of the poet.[7]

A similar diversification can occur in the practice of art itself, and it is this that explains the historical-stylistic differences between Oriental and Western art. Oriental art is an art of things, Western art an art of the artist's self. Oriental art never says "I"; it hides the self and stares only at things, seeking their secret meanings. The history of Western art, however, is a quest for the self, beginning with the sense of the self as object and as exemplified in Christ's

[5] *Ibid.*, p. 128. [6] *Ibid.*, pp. 27ff., 125ff. [7] *Ibid.*, pp. 32f., 127.

self and going on to the self as subject, the creative subjectivity of man as artist or poet.[8]

But poetic intuition and its objectification in the work always essentially includes both things and the self, and this is because poetic intuition is a knowledge through "affective connaturality." We know the inner meanings of things through emotion as intentional form, emotion raised to the level of intellect, because of the likeness to the soul of things that are connatural to it, a likeness between reality and subjectivity; moreover, due to this connaturality, the soul itself is revealed to such spiritualized emotion in the same poetic intuition that discloses these things:

For the content of poetic intuition is both the reality of the things of the world and the subjectivity of the poet, both obscurely conveyed through an intentional or spiritualized emotion. The soul is known in the experience of the world and the world is known in the experience of the soul. . . . In this single *and* double revelation, everything derives from a primal creative intuition, born in the soul of the poet, under the impact of a definite emotion.[9]

Because of this indissoluble dual unity of poetic intuition, the truth, according to Maritain, is that Oriental art cannot help revealing the creative subjectivity of the artist and Western art cannot help revealing the inner meaningful aspects of things. Such is the integral nature of poetic intuition that an art intent on one of these two aims, the revelation of things and their hidden meanings or the revelation of the creative subjective self of the artist, obscurely and despite itself reveals also the other. Emotion, raised to the level of intellect, is needed to grasp the inner meaning of things; and subjectivity cannot be grasped as subjectivity except as it fills itself with the universe. The two factors in

[8] *Ibid.*, pp. 19, 21f. [9] *Ibid.*, p. 124.

art are necessary to each other and inescapably connected in poetic intuition.[10]

Thus we arrive at a schema, so to speak, by which the interpretation and understanding of art may be guided. Look to see what of things is given immediately in a work, and what of their inner meaning and of transapparent reality is conveyed thereby; but look at the same time to see what of the creative self is given in and through the presentation of this objectively disclosed meaning and truth. Poetic intuition itself is needed to perform this two-in-one task, and there is no mechanical procedure to follow, only that of achieving actual insight; but this schema outlines in advance at least a frame in which understanding and interpretation must place the work. Within this frame, works of expressionism and realism, symbolism and statement, East and West, antiquity and modernity all find their place. We are no longer bound by the dogma of a one-sided aesthetic that is merely the conceptual representative of a single art movement, a single mode of poetic intuition; our vision is enlarged and made open to the unlimited panorama of all the styles.

It is not an accident that the joint revelation theory thus opens our eyes to the variety of styles, whereas the expression theory, being essentially limited, makes little or no theoretical use of styles. (Cassirer's reference to style, we must remember, was chiefly to the "style" of a medium, not to what is determinable as a genuine art style.) Despite the modernity of the writings of Croce, Cassirer, Collingwood, Langer, and Dewey, it is noteworthy that style does not assume a basic role for them; but this fact is also intelligible, since their thought is confined to one form of stylistic thinking. The joint revelation theory, on the contrary, be-

[10] *Ibid.*, pp. 27ff., 114ff.

gins not from the simple fact of the "expressiveness" of a work but from the more comprehensive fact of the variety and the historical transformations of styles of works. This fact, becoming evident to Winckelmann and the Schlegels, and through them to Schelling and Hegel, inspired the attempt to formulate a concept of art and artistic intuition which could allow and make intelligible this richly various history; and of necessity the style concept, whether called by that name or not, began to assume its rightful place in thought about art.

Nevertheless, the joint revelation theory does not escape another limitation which keeps it within the confines of the same general mode of thinking as expression theory, and which shows it to be indeed a metaphysically extended version of subjectivism.

This limitation is not merely incidental, so that it might be removed by some more or less slight modifications of the theory. It inheres in its very mode of vision. The mode of vision of a theory is given in the language it uses and especially in the figures it employs to open the subject matter to view. Now the joint revelation theory has its own characteristic cluster of figures in terms of which it goes to work: self, thing, beyond, mystery, hidden meaning, convey, disclose, reveal, sign, password, divine, penetrate, pass through, grasp, spiritual communication. One needs only to collect such key pieces to awake immediately to the sense of the game that is being played with them.

At the center there stands the work of art. In this work something is disclosed or revealed. But what is disclosure, revelation? The work discloses or reveals by being a sign or a password. A sign conveys something beyond itself to the self; a password permits the self to go through the gate to a

beyond. But the gate through which the work of art as password permits the self to go beyond itself also leads the self back to itself as self.

The artistic sign conveys by depicting things, which themselves are and are made to be signs. The things, which are signs *in* the work, which itself is a sign, are signs *of* the beyond, the hidden meaning, the mystery, the depths of being. In them the mind divines and discerns a mystery, a hidden meaning, the depth of being. Through them it penetrates and passes, so that it may catch and grasp, though obscurely, their inner side, their infinite inner aspects, their bound, buried, secret significance, the transapparent reality which they manifest.

But the work itself as a sign is dual; it reveals, manifests, and discloses not only the inner side of things, but also the inner depth of the self. In this dual signifying, the self arrives at spiritual communication with being; the mystery on this side joins with the mystery on that side to come forth, obscurely, still hiding much of itself, in the disclosure. Spiritual communication between the two is possible because they are connatural: reality and subjectivity are like in nature or essence. Hence, since only like can know like, the self, through the emotion which imbues it, comes into an intentional (not mystical, magical, ontical) union with its opposite, reality or being or the infinite depth of things.

The sense of this union, existing because of the essential connaturality of the depth of things and the depth of the self, is conveyed, manifested, and transmitted for the catching, apprehending, grasping act of mind. It constitutes the single complete and complex sense—embracing the secret senses of things and the still more secret sense of subjectivity—through which the work exists and which it exists to reveal.[11]

[11] *Ibid.*, p. 129.

If we reflect on this picture of the work of art and its functioning, we become aware that it operates with the conception of the work as a symbol whose function it is to mediate between two opposed depths, objective and subjective, the depth of the things of the world and the depth of the self, which already exist in separation, and to allow them to come together in an act of communication, and to do this by revealing each of them, however obscurely, for what it is. Since the two are connatural, their revelation can only be a joint revelation, manifesting them in their intentional union, and this intentional union thus manifested is the single meaning of the work. In other words, the depth of being already exists and is what it is before the work. But the two have not yet come together in the intentional (emotively cognitive) union. Poetic intuition brings them together in this way and reveals them thus jointly in the work.

This joint revelation occurs differently on both sides. On the side of things, it is a picturing of them; but it is also something more, namely, a revealing through them of their inner depth, which is connatural with the spiritual depth of the self. The revelation of the inner depth thus has the same general nature as expression, since it reveals reality that is connatural with spirit, in the outward form of the picturing of things. But it expresses this reality in a specifically different way, precisely as *objective* reality and not as *subjectivity per se*. To manifest subjectivity *as* subjectivity, the other aspect of the joint revelation is necessary, the self-expressiveness of the work. Yet this self-expressiveness comes about only as the expression of the objective reality behind things comes about:

The poet does not know himself in the light of his own essence. Since man perceives himself only through a repercussion of his knowledge of the world of things, and remains empty to himself if he does not fill himself with the universe, the poet knows

himself only on the condition that things resound in him, and that in him, at a single wakening, they and he come forth together out of sleep. In other words, the primary requirement of poetry, which is the obscure knowing, by the poet, of his own subjectivity, is inseparable from, is one with another requirement—the grasping, by the poet, of the objective reality of the outer and inner world . . . by means of an obscure knowledge . . . through affective union.[12]

The poem—the musical composition, the painting, the work of art of whatever sort—is a made object that comes about in the creative objectification of the poetic intuition in which this knowledge through affective union takes place. As the mind of the poet arrives at its affective union with objective reality, in which it discovers jointly a pre-existing depth of things and its own pre-existing (unconscious) depth of self, it utters forth this knowledge in the words of the poem. Or, since the words of the poem are a unity, and the poem is a dual sign having the above-described unitary sense, we may say without distortion of the intent of Maritain's theory that the poet's *word* emerges as the expression of this single knowing of the joint communication of the antecedently existing depths of the self and the world of things.

In the beginning there was the self and there was the world. And the self searched for the world and the world yielded itself to the self, for it was its connatural twin. And from their union was born the word. And in this word we perceive eternally fixed the spiritual communication of the two.

But is this how the word works? And is the word the child of brother and sister?

On this view, the word works essentially as an utterance, just as it does in expression theory. It outers an inner. The

[12] *Ibid.*, p. 114ff.

inner is, to be sure, more complex than expression theory conceived it to be, for it is a two-in-one inner—the inwardness of the world and the inwardness of the self in spiritual communion—and this complication of the theory represents an advance over expression theory. But just as in expression theory inward reality already exists, and the word is the means by which it is brought to outward manifestation, so in the joint revelation theory the twofold inner reality already exists and the word is merely the utterance of it. The so-called creativeness of the poet's intuition is, after all, only his capacity as a miner, to dig in both directions in order to uncover a lode already there and to dig out as much as he can; and his productiveness as artist in regard to the work is only his capacity to carry up as much as he can to the surface of pigment or sound. In short, there is no genuine creativeness at work here at all.

All the work that creation normally performs is supposed to have been done already, and the only task left to poetic intuition is that of reaching the products. Hence the images of penetration, passage, and grasping. It is supposed that there already is a depth of the world and a depth of the self; these having already been created, the poetic mind searches out the two in a single process.

But suppose that beforehand there is as yet no such depth of world or of self. Suppose, indeed, that beforehand there is no world or self at all. Where could the poetic mind then turn in its effort at intuition? What could the poetic word then say?

Is there any reason to suppose that a "meaning" of world and self, a "depth" of world and self, exist ready-made, waiting for the poet to reach them in poetizing, the painter in painting, or the musician in musicalizing? Especially if the world is a human world, a world inhabited by man, and

the self a human self, belonging to man? Is there not rather reason to suppose that the "depths of meaning" of world and self are products of an activity that goes on in man and that constitutes his primary vision of the being of the world and self? If we speak of a meaning existing beforehand and ready to be disclosed, is this anything more than a reading back into the preliminary stage of what eventuates from that stage, a reading of actuality *backward* into possibility? Genuinely creative art is art that brings forth a vision, producing it where it did not exist before; and, on the other hand, the coming into being of vision, i.e. intuition, is art that creates and does not merely copy a preexistent model. If there were a meaning beforehand, there would have to be a vision before the vision; and then the artist's intuition would be only a second intuition, copying a first.

In fact, however, our experience of expression-intuition, is different from any such reproduction. It is not like trying to remember a forgotten but once-known name; it is like seeking a new name that will be the fitting name for a new phenomenon. We have an intimation, perhaps, or an anticipation, which tells us, like a monitoring conscience, when we are on the right path and when on the wrong—and it itself may be wrong; the result is the test. Croce says:

The individual A is seeking the expression of an impression which he feels or anticipates, but has not yet expressed. See him trying various words and phrases which may give the sought-for expression, that expression which must exist, but which he does not possess. He tries the combination *m*, but rejects it as unsuitable, inexpressive, incomplete, ugly: he tries the combination *n* with a like result. *He does not see at all, or does not see clearly.* The expression still eludes him. After other vain attempts, during which he sometimes approaches, sometimes retreats from the mark at which he aims, all of a sudden (almost

as though formed spontaneously of itself) he forms the sought-for expression, and *lux facta est*.[13]

Even this description is misleading, for when Croce speaks of the creator as aiming at a mark, that implies falsely that the mark is already there for him to aim at, as the archer aims at the target which stands out there before him. But the point of the creative act of expression is *to arrive at a target that is not yet there:* once the target is there, the expression has been accomplished. If the poet already knew what he wanted to express, he would have expressed it. On the other hand, of course, it is not as though the artist is completely directionless. He is not without anticipation, intimation; he can tell, more or less, when a certain combination is unsuitable, unfitting, wrong; he can even often tell *why* it is wrong—too heavy, too light, too strong, too weak, too clear, too obscure; but here also, he may later find that what he rejected he should have retained. In other words, he even has to achieve his criteria in the process. What Croce calls "expression," or the formation of intuitive, imaginative vision, is always an activity in which *more is arrived at than is possessed to begin with and in which the point is to arrive at this more.* If there were a rule or a guarantee beforehand of what the more was, or even that there was a more, the activity would cease to that extent to be expression or imaginative formation and would be simply repetition of a content already possessed.

The image of the work of art as revealing hidden content, thus, is unsatisfactory because it is inadequate to the actual experience of artistic creation. It is not unsatisfactory because it attributes to art the function of opening up to human vision meaningful depths of the self and the world.

[13] *Aesthetic*, p. 118.

It is unsatisfactory because it takes for granted the result of the creative struggle without having any ground for doing so; it removes from the creative struggle its creativity. If it could tell us beforehand what the creative struggle would achieve, we could then have sufficient reason to give the revelation theory our allegiance. But it is no wiser than any prophet after the event. It, too, has to wait until the artist has arrived at his intuition before it can tell us what the depths of meaning are that the artist has conquered.

[3] *Aesthetics as Linguistics*

But we can go further and question not only the antecedent existence of a depth of meaning of world and self but that of the world and self themselves. Is there any reason to suppose that man's world and his self can exist ready-made, waiting for the artist, or for man himself, to discover them by a secondary act? Is there not, rather, reason to suppose that the world and the self are products of an activity that goes on in man's existence and that constitutes his being?

My world does not consist in all the things that in fact exist round about me, that have in fact occurred in the past, and that will in fact occur in the future. It consists in the things that exist *for* me, in the ways in which they exist for me. For instance, my world is full of signs. Some of them are conventional, like the signs on street corners or store fronts. Others are natural, like the sounds that signify to me the approach of a heavy truck or the happy play of children. These signs do not exist beforehand as signs. They become signs in the process of the growth of my experience. A sign and my understanding of it come into being jointly, in one and the same process. The sign is part of my objective world and the understanding of it is part of my self's existence.

What holds for signs and their understanding holds

equally for all other phases and contents of my world and my self. My self becomes and exists in the processes of sensing, feeling, perceiving, thinking, willing, and it does all this in relation to a world in which things are sensed, felt, perceived, thought, willed. The activity that is constitutive of man's being is the continuous activity of distinguishing out and relating together the self and its world. This activity is genuinely creative, for in it man's world and self are originated and maintained, not found already finished.

Realization of the fact that both self and world are phenomena emerging in the course of an activity that constitutes human being by giving rise to them appears first in modern philosophy in Kant. This activity is the transcendental activity of consciousness itself, ultimately the so-called synthetic unity of apperception. By it a manifold of sensuously given material is supposed to be combined according to universally necessary connections into the structure of knowledge that we call "experience." Kant tried to explain the process of the formation of experience—or the perceptually grounded knowledge of a world, a self, and their interconnections—as one in which raw materials of sensation are ordered into patterns of universal necessity, thus granting them objectively valid structure and meaningfulness at once. That is, he thought of the process as one that constructed a necessary texture of experience out of contingently given pieces of sensation. Hence the process was a synthesis, which united sensations into perceptions, eventually into a coherent ordering of perceptions that enables a world and a self to emerge in and for consciousness. That mental work goes on in this mechanical way, making a whole out of parts as a mechanical worker makes a whole thing out of material parts, is dubious. But behind this image is an essential idea that can be described in other ways.

The idea is that in man an activity goes on in which there comes into appearance a human world and a human self. And what is more, since other persons occur in my world and communication occurs among us, the constituting activity must be such that the world of experience is one that accommodates them and their experiences, so that what emerges is a comprehensive context that embraces the self, its fellows, and their joint world. This productive activity not only enters into the sphere of the personal but extends beyond that sphere into the interpersonal. It gives rise to the phenomenon of a world inhabited by human beings and constituted as such by meanings accessible to their minds.

This idea was transformed by the idealism of the early nineteenth century into the work of an absolute mind. Kant, though recognizing the activity, did not supply an agent for it. The idealists postulated such an absolute agent which came to self-knowledge and self-reconciliation by first producing the split of world and self out of itself and then healing this breach in itself by way of the self's discovery of its identity with the world. When that romantic metaphysics of self-loss, self-yearning, and self-recapture was abandoned, however, the essential Kantian insight remained and has continued in the center of philosophical thought to the very present.

In linguistic philosophy it appears in the realization that every real language has its own manner of structuring reality. Phenomenological philosophy reduces the split of consciousness into subject and object to the coming into appearance of the underlying ego's constituting power. Thus recent thought recognizes language, on the one hand, and the constituting of consciousness on the other, as an activity that gives its form to human reality. Linguistic and phenomenological thinking, although they appear to follow

separate paths and are practiced by different schools, nevertheless have this affinity: they are both finally concerned with the activity by which the meaningful structure of man's self and his world of things, other selves, and history is constituted.

Moreover, there are philosophers who recognize the affinity of language and consciousness and who consequently strive to see their unity in the activity that constitutes man's reality. We find this viewpoint foreshadowed in Croce's conception of the identity of aesthetics and linguistics. Philosophy of language and philosophy of art, he says, are the same thing.[1] This startling identification of two spheres that at first seem so different is, however, readily understandable from the viewpoint of Croce's equation of expression with intuition.

Art is, first, intuition. Intuition is the act of imagination, prior to any ascription of existence or of nonexistence to its object. In intuition, the mind first forms its materials into a knowledge of individual things. By intuition, impressions that I have somehow received subjectively are objectified, so that I am for the first time confronted with something concrete and individual over against myself. The room, the ink bottle, the paper and pen, and I using them, touching them, and making them instruments of my person, the color of the sky, the color of my regret, the cry of pain I hear, my effort of will—all these, even before they can be questioned as to their reality or unreality, must already be present as objectified images.[2]

Because intuition is prior to the distinction between real and unreal, Croce speaks of it as the undifferentiated unity of the perception of the real and of the simple image of the

[1] *Aesthetic*, p. 142. [2] *Ibid.*, pp. 1–8.

possible. It is the primal activity of our being, in which the world and the self first emerge in their individual concreteness: the pure intuition of the image. This is the realm of the *aesthetic*. It is the root of all art. Indeed, it *is* art as it functions in the primal constitution of human reality. Art is this originating act of intuition, which constitutes the human self and world in their pristine individual concreteness. Artistic intuition occurs before all historical or scientific knowing, and it is the source of all the data of history and science. It is independent of conceptual knowledge because it has its own autonomous mode of organizing its materials; namely, its goal is the production of the image, or intuitive knowledge of the individual. A play of Sophocles or Shakespeare may be full of concepts, ethical and metaphysical observations, but it remains a drama, i.e. an intuition, because those conceptual observations are ruled over as parts by the total imaginative effect.

The philosophy of art is thus the philosophy of intuition.

But, according to Croce, every intuition is an expression. It is a transformation of a subjective impression into an objective image. What does not objectify itself in such an image remains mere impression or sensation and never reaches the light of awareness. Only if the spirit succeeds in transforming the impression into an image, i.e. expressing it, does it succeed in having an intuition. As Croce says, intuitive activity possesses intuitions to the extent that it expresses them.[3] Hence the philosophy of art is equally the philosophy of expression.

To understand the connection between intuition and expression, it is necessary to note first that expression, as a process, is not limited to verbal language. If a poet expresses an intuition in the language of words, the painter expresses

[3] *Ibid.*, p. 8.

one in that of line and color, the musician in that of sound. But in any case, if the artist or anyone else is to be capable of intuiting something, a geometric figure for instance, he must be capable of expressing this intuition, of outlining it and drawing it, if necessary, on paper or blackboard. The degree to which something is capable of being intuited depends on how well we are able to formulate it. And when we actually formulate our impression, we possess it as an intuition.

In principle, I do not have to draw an ellipse actually on paper in order to intuit or imagine it; but I do have to draw it mentally. I have to construct it as an image, and this is to outline it just as genuinely as if I were drawing the figure on paper. The same holds for all other intuitions. The very process by which I possess them as images is a process by which they are inwardly formulated. The external formulation, as for instance the physical production of the word sounds, the physical marking of paper with pencil, or the physical production of piano tones, may be practically dispensable or indispensable. This depends upon the imaginative capacity of the producer. At most, their function would be, first, to aid in the internal formulation or expression by which the intuition is actually reached, and second, to stimulate others to reproduce a similar intuition.

Expression, therefore, not only occurs in media other than verbal language; it is, for Croce, fundamentally an activity that occurs inwardly and prior to the external activity more frequently called by the name "expression." Before I speak with my tongue in words, I speak originally in an inward act of imagination. Speech is first of all an inward spiritual act of transforming impressions into intuitions. It is a truly creative act, for no impressions can merely of themselves change into an intuition. Intuiting, or imagining, is

producing an image where there was no image before, transfiguring an impression in the act of forming it into an intuition.

Croce's separation of the inner aesthetic activity of expression from the practical activity of physical externalization has been much criticized. Indeed, it is too simple an account of the relationship between intuition and bodily behavior. He spoke as though the aesthetic activity were entirely involuntary and the physical externalization entirely voluntary.[4] But drawing with the hands is drawing with the spirit, and drawing with the spirit is drawing with the hands. For the hands are the organs of the spirit which, even when it draws with the hands folded, lives in them and innervates and moves them implicitly toward its own ends. So it is, too, with seeing and the eyes, hearing and the ears, singing and the voice, speaking and the tongue. When I speak, my tongue is no longer a merely biological thing. It is the organ by which audible or silent speaking takes place, by means of the actual physical motion or the implicit physical innervation. Thus, when Croce's separation of inner and outer facts is rejected, we must nevertheless retain the essential truth of his observation that the physical movement is not expressive merely as a physical movement. Only the movement—overt or implicit—which exists as a concrete spiritually determined act, and in which spirit is already present, can be expressive.

Just as the intuition of a circle is an expression, so the intuition of the complex of self and world, which is the primordial image at the foundation of all other spiritual activity, is an expression.

Understanding expression in this way, we see that it is the act that lies at the foundation of all forms of language,

[4] *Ibid.,* p. 111ff.

verbal and nonverbal. The spiritual act of formulating an impression, which transforms the latter into an intuition, is the act of expression, the first step that the human spirit takes in its characteristic round of activities. In the beginning there is the "word."

The philosophy of language, in the most comprehensive sense, is thus the philosophy of expression. And since art is intuition, and intuition is expression, and expression is language, it follows that philosophy of language and philosophy of art are the same thing. Hence the identification of aesthetics with linguistics.

That is Croce's argument.

How far can this identification be admitted? Is all language really the language of art? What about the language of mathematics or theoretical physics? Is the mathematician or the physicist an artist when he formulates his abstract ideas in his largely artificial language? Collingwood, who followed Croce in the matter of this identification, actually affirmed this consequence. But he was able to do so only by distinguishing the intellectual from the emotional aspect and arbitrarily identifying language with the expression of the latter. Symbolism, of the sort that occurs in mathematics or physics, or in theoretical science generally, is, for Collingwood, intellectualized language. It is language in so far as it expresses emotion. It is intellectualized language because it expresses intellectual emotions. In addition to these intellectual emotions—the feelings we have on the occasion of thinking, calculating, inferring, etc.—symbolism has meaning. We can distinguish what the speaker says and what he means. In expression, we cannot make such a distinction. The emotion inhabits the speaking as an emotional charge upon the thought expressed. But as symbolism, theoretical

language refers beyond the emotion to the thought itself. This reference to the thought is not essential to the language in so far as it is language; only the expression of the emotion—in this instance an intellectual emotion—is essential to it as language. Consequently, Collingwood restricts the linguistic aspect of intellectualized language, or symbolism, to its mere expressiveness of intellectual emotions.[5]

It is obvious that Collingwood is stretching his terms here to coincide with an expressionist viewpoint. Naturally, if you force the word "language" to refer only to language in its emotively expressive aspect, then all language is emotional expression and nothing but emotional expression. But then, language interpreted in that sense will not occupy the whole of man's activity of speaking, writing, drawing, etc. Hence you have to add something else, as for instance the thought expressed, in order to complete the account. It would be simpler and more in accord with the realities of language to admit more than one function of language to begin with, and to recognize the unique function of emotional expression as one among them.

The goals of art and science differ, and their languages share in the difference. Croce himself pointed to this difference at the very outset of his aesthetics; he drew a sharp contrast between intuitive and logical knowledge, imagination and intellect, individual and universal, thing and relation, image and concept, assigning one side of the distinction to art and the other to science. This contrast entails that the language of science does not aim at expression, i.e. the formulation of intuition. It surely does not aim at the expression of intellectual emotions, for which a special language entirely different from scientific symbolism would be required. Its goal is the formulation of concepts. Hence the

[5] Collingwood, p. 269.

philosophy of language cannot be restricted to the philosophy of expression alone.

Nevertheless, the philosophy of expression must be admitted to be an indispensable part of a philosophy of language. And here Croce's identification of expression with intuition remains significant. For he does not unduly restrict expression to the formulation of emotions, as does Collingwood. Expression formulates intuitions, and in this activity, now jointly named "expression" and "intuition," the complex of man's self and world which belongs to him in concrete immediacy, the starting point and the terminus of all other activities, is first produced.

Whatever I possess of a world and a self, I possess in the primal experience in which I first am myself and encounter things, persons, the land, the sea, the sky, life, history, fate, death. This complex of self and world is the place in which I exist as a human being. It is the locus in which I first become and am a human entity. It is the concrete universe of my intuition.

But intuition is expression. It is language at the primal level of imagination. Hence the primary locus of my existence as a man is the locus of expression. And it is at this point that the significance of art in the constitution of human reality becomes apparent. For since expression = art, art is the creative activity in which the human reality first comes into being and endures as such. It is the creative activity that produces the groundwork for all human existence—the immediate concrete interplay of self and world.

The world of the ordinary man is, as a rule, a small thing. Croce describes it as consisting of little expressions, which may grow larger as spiritual concentration increases. These little expressions are, as it were, silent judgments, words that

we speak silently to ourselves: here is a man, here is a horse, this is heavy, this is sharp, this pleases me. There is little coherence, depth, and definiteness in the world we thus actualize for ourselves in intuition. What we possess, of things, of others, of land and sky, of past and future, and of ourselves, is a fragmentary sketch, with a hint here and there of something more substantial. Our impression of the smile on our friend's face is so vague that we have only the intimation of an intuition of it.

The artist goes beyond this stammering speech of ours. He speaks in a language in which genuine, solid, well-developed intuitions are expressed. The painter sees what we do not see but only feel or catch a glimpse of. Each of us partakes of art, because each of us brings to intuition in some degree the self-world structure in which we dwell. But how small is our artistry in comparison with poet, musician, sculptor! Each artist, too, is limited in his own way. Yet all we possess of a world and a self is what we can bring to intuitive expression, whether by ourselves as little artists, or with the help of art in its developed form in the works of the great artists.

Are there, then, depths to be plumbed, of the world and of the self? Yes, but not such as already exist. Before language says "tree" there is no tree; before it says "tree of the knowledge of good and evil" there is no tree of the knowledge of good and evil. There are, according to Croce, only impressions, feelings, impulses, namely, only what falls short of spirit and is unassimilated by spirit. And even here, the expression "there are" is illegitimate, for to be, to exist, is also a fact of the spirit. This was the remnant of idealism in Croce. He could not admit the existence of the nonspiritual, despite the fact that he conceived of every intuitive expression as a forming of matter.

The question of the existence of a material foundation of expression is one that belongs to metaphysics. Its solution is not a matter of mere conceptual demonstration. Precisely because nothing can enter our world except through the process of expression, it is already the product of an act of language. Its being is its peculiar mode of presence in the sphere opened up by language. The concept of being is thus impregnated with the concept of language. To speak of a being outside the sphere in which language defines being is to make an effort to speak the unspeakable. Hence Croce has to use as the name of what would be outside expression the "nonexistent." And even this is ambiguous. For if the existent is what is expressed, then the nonexistent is the nonexpressed, and this might just as well be called the indeterminate, or absent, or the wholly and merely potential, pure matter, pure possibility of being. But all these already *are* just exactly what we have called them and have been expressed and intuited as such. We reach here a limit of the possibility of thinking itself, and no other terms will do than limiting terms to express the end of thought.[6]

We have found in Croce guidance toward an understanding of the creative function of art, according to which language and consciousness are seen in their fruitful unity. Language, in its expression of intuition, is the activity by which the human self-world complex comes into being and endures in being. On the other hand, imagination, in its primary immediacy as expression-intuition or lyrical vision, is precisely this self-world complex both as activity and as product. Hence expressive language is the act in which primary imagination takes shape. And since art is language specialized toward the end of being intuitively expressive,

[6] Croce, *Aesthetic*, pp. 9–11.

art is the activity par excellence by which primary human imagination, and therefore man himself, first comes into being and remains in being. It is all one to say that art is man speaking intuitively-expressively, that it is intuitive-expressive language which is at work making man, or that it is the primary imagination arising, establishing, and maintaining itself.

We should bear in mind that, understood in this way, art is only the first stage, and not the whole of the speech that makes man. Imagination does not yet raise the question of real or unreal. Its truth is imaginative, not realistic.

Still, art *is* the primary process of imagination, and the truth of which it is capable is a truth that is unique, irreplaceable, and immeasurably precious. In the course of identifying art with imaginative intuition, Croce was led to emphasize the continuity of the work of art with the slightest, most insignificant act of intuition—the vision of the sky's color, the hearing of a cry of pain, the feeling of the pen writing. One finds the same emphasis on the continuity of art with ordinary life in Dewey's conception of art as experience devoted to its self-formation as experience. Here the genuine work of art is seen to be the same in essence as the smallest, self-fulfilling, consummatory experience—the having of a meal, the meeting with a friend, a walk down the avenue. It is important to emphasize this continuity because, by doing so, we come to realize that art is the process of human existence in operation along certain lines, and that it is not a mere bypath into which we turn for amusement and recreation.

But it is important also to emphasize the difference between the rudimentary work of art that consists in this or that primitive intuition of being in a human world and the developed work of art that is the product of artistic genius.

For in art, as in every other field of human existence, there is a truth that we seek; and the truth of the primitive intuition and that of the creative imagination of the great art work are as far apart as the truth of a simple sense perception and the truth of a profound theory in science. Science and simple observation are also continuous. Science carries the cognitive impulse that already manifests itself in simple observation ahead and upward to levels that simple observation could not dream of. If we wish to know what the truth of scientific cognition is, we do not look to find what is merely common to developed science and simple observation. We note, rather, that the latter has been absorbed and transfigured in science, and that science manifests the essence of cognition far more extensively and clearly than simple observation. So also it is with art and simple intuition. Simple intuition is absorbed and transfigured in great art in such a way that its simple form of truth is replaced by a far more significant form of truth.

Art, therefore, is not only continuous in essence with the simple beginning of human experience in imaginative intuition; art not only stands at this beginning; but also, it moves ahead toward the development of human experience in imaginative intuition, and is a consummation as well as a first step. It aims to reach, not only a cry or a smile, but the truth of spirit itself. In his eagerness to proclaim the identity of art in all its forms, in simple intuition and in Shakespeare, Bach, and Michelangelo, in epic, lyric, and drama, in the sublime and the beautiful, the tragic and the comic, the romantic and the classical, Croce attempted throughout to eliminate distinctions. The result is that, although he was well acquainted with these distinctions—with aesthetic genres, types, and styles—he lost the opportunity to find the locus of truth in their unity. One finds an even more striking

absence of reference to the truth of art in the differentiated unity of genre, type, and style in Dewey's aesthetics, for here, too, the concern to establish the continuity of art with experience led to an undervaluation of differences, a failure to bring into view the truth that belongs to art as such.

The ultimate aim of aesthetics as a philosophical discipline is to think the truth of art.

The question that faces us, then, is that of the nature of the truth that belongs to artistic imagination. In the Crocean approach, no fundamental distinction is made between the aesthetic and the artistic. Hence it recognizes no fundamental difference between imagination in the aesthetic experience of nature and the artistic imagination in creating and beholding a work of art. Nature, for it, is a work of art. As opposed to Croce, we must take note of a genuine difference between the two modes of imagination and their objects. For the work of art is constructed in a special medium, as well as the generic medium of the human imagination. Hence the work of art is meaningful in the manner of a specially constructed symbol, not merely in the manner of a thing of nature. The vision of the sky in a painting and the vision of it in primary experience differ by the interposition of the medium of paint. As soon as this special medium enters, we are confronted with language in the specific sense. Hence to understand the truth of art, it is necessary to understand the truth that can belong to artistic language in this specific sense, in which meaning is associated in an essential way with a special medium. And to understand the truth that can belong to artistic language, it is first necessary to understand the meaning formulated by that language. The mode of truth is related to the character of the meaning.

In what follows, it will be proposed that all language, whether in science, practical life, or spiritual life, has the same generic character of meaning. Namely, all language articulates human being. Differences that separate language into the languages of science, practice, and spirit, are due to the different ends toward which they are directed. Each such end is related to an ideal of truth. Hence it becomes essential to distinguish the different truth-ideals connected with these differences of language, so as eventually to reach a concept of the ideal of truth that prevails in the domain of spirit, and of art in particular.

[4] *Language as Articulation of Human Being*

The concept of art as expressive language dominated aesthetic thought during the first half of this century. Expression took the commanding position that beauty had occupied in earlier aesthetics. But the concept of expression itself suffers from a weakness because of which it must be replaced by a new concept. That new concept is here named "articulation."

The trouble with the expression concept is not that it describes language and the work of art incorrectly. It is that, correct as it may be in its application to both, it describes them only from the outside and not in terms of their actuality as forms of symbolism. The very name itself impresses this externalistic standpoint on its user. To express something is to ex-press it, hence to press it out, to force into outwardness what is inward by nature. Approaching a linguistic sentence from the outside, the expression theory sees it as a thing, involving (1) an external form, a structure of sounds, (2) a content, which does not consist of sounds but is a meaning or some sort of thinkable, understandable, or otherwise representable content, and (3) a process or relationship by which the meaning-content is expressed by or in or into the outer sounds. Similarly, when applied to art, the model of expression sees a piece of music

or a painting as a thing, involving (1) an external form, consisting of sounds or colors, (2) an artistic or aesthetic meaning, the content which is apprehended in aesthetic contemplation of the work, and (3) a process or relationship by which the content is ex-pressed by, in, into the external form.

The vision of the sentence and the art work formulated in this expression model is clearly a view from the outside. Standing outside the speaking of the sentence, the saying of the poem, the showing of the painting, the sounding of the music, one sees each of these first of all as a thinglike external form. For, being outside, one is not present in and with the sentence or the art work itself. Accordingly, the living actuality of the sentence or the work is hidden by the external form, and it thereupon appears, *as* hidden, in the form of something, a content, not itself external but only ex-pressed by, in, into the external as form. Thus the concept of the content or meaning which, different from the external form, is supposed to be expressed in or by the form, is a concept that can only give us the actuality of the sentence or the work by closing it off from our understanding of it. A word like "content" or "meaning" becomes a tag that we can use in talking about language and art without stopping to grasp the theme of our thought.

This form-content model is parallel to the sign-significance and symbol-meaning models of language. In all three, a distinction is made between an external side, the form, sign, or symbolic vehicle, and another side, not itself external or sensuous, which is related in some mysterious way to the external side by ex-pression. And there *is* a kind of truth in this model. One can always discover an external side to language, namely, by ceasing to speak it, stepping outside it, and observing it from the outside, just as one can find an

external side to man when one ceases to live as man inside the being of man and instead looks at him from the outside.

Actual experience of language as language and art as art, however, refuses to accept these models of form-content, sign-significance, symbol-meaning as fully adequate. This is evident in the effort to overcome the distinctions. In this way there originate those views that attempt to bring as close together as possible, even to the point of identity, the two sides of the distinctions. We hear then of the direct presence of the content in the form, the embodiment of the content in the form, and eventually the identity of the content with the form.

But this way of trying to overcome the form-content distinction is fruitless, for it does so by retaining it. It begins by looking at the work from the outside. Consequently it sees the outside of the work directly, but not its genuine being. In order to grasp this genuine being, it forces it to the surface, under the mask of content, significance, or meaning, supposedly presented or embodied in the surface or even identified with it. But a being that is not superficial can never be forced to the surface without being radically distorted in the process. As long as we continue to look at language from the outside, we cannot help retaining the separation of surface and being that is forced on us by our standpoint. The being is hidden from us and can only be thought of as a latent content to be made manifest through the external form. And then, realizing that the genuine being of language remains hidden, we resort to violence in our attempt to bring it into our possession, i.e. we try to force it to the surface.

The only proper way to understand language in its actual being is the reverse. We must leave the external viewpoint to the scientists who concern themselves with the great

body of information than can be gathered thereby, and enter on our own account into the act of language—speaking and hearing, simultaneously. From that position, we must try to become aware of what goes on inside the act. Once we do this, we discover that we no longer are confronted with an external form behind or in which there occurs a nonexternal content. We are, instead, in a different world altogether. And we must realize that this is true of the sentence as well as the music, poem, or painting. It is true of all language that is really language and not merely a set of counters for the purposes of logistical manipulation.

When we attempt to understand language from within, what do we discover? If we abandon the expression model, we are not therefore compelled to abandon the notions of symbolism and meaning altogether. On the contrary, we first begin to approach adequate notions of these phenomena. We do not have to deny that there is a certain bodily or sensuous aspect to language; it is only a question of what it is, how it occurs, in the actual being of language. Language remains symbol and it retains its meaningfulness. In its symbolizing, it means. What we surrender in giving up the expression model is only its artificial splitting of the being of language into parts that are essentially incapable either of existing apart or of being united as such, and with regard to which it is compelled to proceed to such unfruitful images as "presence in" and "embodiment in" or to an unintelligible "identity" of a form and a content that began by being un-identical.

Our question, consequently, is now: How does language mean? What is language in its actuality as symbolism? In briefest form the answer will be that language is the articulation of human being.

In order to grasp the nature of language it is necessary to turn to language itself, in accordance with the phenomenological maxim of Husserl, "To the things themselves!" Language is a unique phenomenon, not reducible to a mechanical mixture of other, already familiar, phenomena. Hence to grasp its nature we must perceive it as it is, and we must not substitute a conceptual analysis or an explanatory or genetic theory for the primary phenomenon itself.

Understanding speech is somewhat like perceiving a thing. Speech is not a mere thing; it is a very special kind of thing. Yet understanding it is a kind of taking it in, just as perceiving a thing is a kind of taking it in—or, equally, a going out toward it. The comparison with thing-perception is in fact instructive, to a certain point, for our understanding of speech-perception.

Not so long ago, perceiving was analyzed into two components. On the one hand, it included a passive receptivity of matter given to the perceiver, as sensation of sensible matter or sense data. This sensory material was ordered, on the other hand, by means of an active spontaneity that made use of concepts or meanings. To perceive an object was thus to order sensory materials by means of conceptual meaning into a coherent and intelligible pattern. Perception was conceived of as a process by which raw materials of sensation are worked up by conception into the more concrete and coherent representation of the world with which we are familiar in ordinary experience.

For example, a physical penny provides us, through sight, with a multiplicity of sense data of various shapes and sizes, from circular patches through ellipses of growing eccentricity, to line segments. In more sophisticated versions of the theory, these are replaced by penny-appearances seen from

different viewpoints. Our perception of the penny as such is then supposed to be the result of the interposition of a process or rule for ordering these raw materials into a coherent grouping of series of actual and possible sense data. Such a process or rule, as a concept, is a meaning which, applied to the sensory materials, results in the perceiving of the perceptual object, the penny.

A more complex instance of the same general process is the explanation of the perception of spatial depth and distance—and thus the occurrence of a spatial world for perception—by means of the theory of sensory cues or clues. Sensations of eye convergence, accommodation, and retinal disparity, together with other sense data such as the overlapping of sensory images, apparent convergence of parallel edges, atmospheric perspective, and the like, are supposed to function as cues or clues that set off a mental process, a kind of unconscious inference or reasoning based on rules derived from past experience or even innate at birth. This is supposed to result in spatial meaning being added to the sensory data, thereby providing the perception of a world in three dimensions.[1]

This type of theory was called by Gestalt psychology, which opposed it, the meaning theory of perception, its basic principle being that "meaning transforms sensations into 'things.' "[2] A simple example of this process, and one of special interest in the context of language, is the case of a symbol like +. This symbol is perceived by us as the sign for addition. Before we learned arithmetic it did not look like that and it was not such a sign for us. It was a mere cross. Learning arithmetic included learning how to read

[1] Gibson, Chapter 2, "Theories of Perception."
[2] Köhler, p. 84. Köhler's reference is to the *Allgemeine Sinnesphysiologie* of von Kries.

this cross *as* the symbol for addition. Thus, it appears, a meaning, derived in this case from learning the convention (rule) of using the cross for the corresponding operation of addition, is added to, or even fused with or embodied in, the sensory datum to produce the perception of a symbol. A "thing," here a symbol, has been constituted, to all appearances, by the fusion of a meaning with a sensation.

It will be noticed that the meaning theory of perception is much like the expression theory of language. The two are variants of the same mode of thought. Both distinguish a meaning from an external sensuous form which becomes the vehicle of the meaning. According to expression theory, the meaning is in some way connected with the sensuous form to give rise to a linguistic entity, just as according to the meaning theory of perception, a meaning is in some way connected with a sensuous form to give rise to a percept. We must in consequence expect the meaning theory of perception to suffer from the same difficulty as the expression model of language.

Neither of these theories describes the actual phenomenon, whether of language or of perception. This may be seen by the following example. According to the meaning theory, a sense datum such as an image of lines on a plane converging toward a center, by the fusion with it of a meaning or interpretation, constitutes a three-dimensional percept. The sense datum, itself devoid of meaning, is granted a meaning, and the combination of the two is the meaningful percept.

The only trouble with this theory is that we do not detect the presupposed sense datum in the percept. When I perceive a three-dimensional receding corridor, I do not see lines converging toward a center, and when I see lines converging toward a center, I do not see a three-dimensional

receding corridor. The two configurations exclude each other. The corridor, as I actually have it in perception, is not a hybrid fusion of a datum and a meaning: it is an entity in its own right.

There is naturally a question of the validity, or the veridical quality, of the perception. This arises because I may perceive fictitious entities in perceptual illusions. But in an illusion, as in a veridical perception, it is an entity in its own right that is experienced, not a compound of a datum and a meaning.

Even the existence of the sensuous datum, as something purely given and entirely without meaning, is dubious. Thus, by dint of considerable effort or by some artificial device, I can see lines on a plane converging toward a center instead of the three-dimensional corridor. For instance, holding up a cross-ruled glass, I look at the corridor as an artist might who wished to draw the scene on paper. I thereupon see the edges laid out on the glass. But then, what I see is lines on a plane converging toward a center, which is hardly what the meaning theory could correctly call a meaningless given. And no matter how far I pursue the goal of experiencing a pure sensation devoid of all meaning, there will always be something left—a black line, a round patch, an acrid smell—which, as being this rather than that, is already something, an entity, and therefore would have to be granted some amount of meaning by the meaning theory.

Perception, even when it approaches toward the fictive limit of pure sensation, is normally the apprehension of entities, actual or fictitious, and an entity is always something, not nothing, even if as something it is highly indeterminate, like the figure approaching at a distance, which we cannot

make out to be a man, a beast, or a machine; it is, nevertheless, a figure at a distance, etc.

In any event, we never perceive pure, meaningless, sensuous data. Hence if any such data exist, they must exist unperceived by us. They would then be, indeed, a theoretical kind of entity, like the unconscious or the proton. But even if by sense data we mean not pure, meaningless, characterless nonentities, but such definitely particular entities as convergent lines on a plane, red circular patches, piercing sounds, acrid smells, these are not present as such in ordinary perceptual experience. As Gestalt psychology has always emphasized, what we experience in normal perception is the persons, things, events of our ordinary (phenomenal) world, not the artificial objects induced in a special laboratory situation by means of a peculiar method of introspection.

Again it should be noted that no epistemological position is necessarily assumed in saying this. Nothing is presupposed about the veridical quality or ontological locus of the percept. We may "hear a truck approaching" when there is in fact no truck in the neighborhood. The innate standpoint of perception itself tends to favor a naïve realism, but the *description* of perception here given is not itself forced to take up any such position. The genuine fact that is at hand is, rather, that in normal perception we do not experience any sort of fusion of data with meaning, but do have the experience of entities.

Further, it is not necessary to deny perceptual learning. Before the child has learned its meaning, the + is experienced by him only as a cross. After he has learned its meaning, and has had sufficient arithmetical exercise for this to sink into his mind as habit, he comes to experience it as the

symbol for addition. But now, in this latter experience, it is no more a cross than the three-dimensional corridor is a pattern of converging lines. He can, by an effort, see it as a cross, just as I can by an effort see the corridor as converging lines; but this happens only by changing the perception, i.e. developing a different perception, not the one in which the symbol occurs.

It is a little like the smooth scale that the expert pianist plays. He has practiced the finger and hand movements, working at different notes and groups of notes at different tempi over a long period, and now he plays a scale legatissimo, prestissimo, pianissimo. What you hear is not the notes and groups of sounds, the painful practice materials, or the working of the finger muscles, but the outcome—the smooth, homogeneous, liquescent flow that is a unique entity that has to be grasped for itself and is nothing other than itself. What you hear is this purling whispering sweep, not the practiced sounds and movements. The pianist's whole effort has been to attain to the purl.

Suppose, then, that we do perceive entities rather than compounds of data and meanings. Are not the perceived entities themselves meaningful and not meaningless? Do they not have character and do not concepts apply to them; and does not the percept consequently contain something of the nature of meaning? To this the answer must be no in one sense but yes in another.

If we think of meaning as a sort of thing, like a gas or a fluid but more diaphanous, then there is no meaning in the entities perceived. If I hear a humming bee or see it in flight, I do not hear or see some meaning-material impregnating the percept. I hear or see the bee. It is an entity I

hear or see. What then can the meaningfulness of the percept consist in? If I hear a humming bee, it is I who hear the bee. I hear it by way of my own act of hearing. In this hearing I project mentally toward a heard thing. This act of mental projection, or intending, is an act of aiming. I do not merely receive the bee passively. I can be in error. I aim at being, at an entity. I point toward the entity aimed at in the very projection of the percept. It is true that I could not do this unless my sense organs and brain received certain impulses rather than others from the physical environment. Nevertheless, what I perceive is a humming bee, not physically originated impulses. This aiming of mine, in the way of intending a humming bee, is an act of mean-ing.

The word "meaning" is first of all the gerund of the verb "to mean." The verb derives from the Old English *maenan*, to recite, tell, state an intention, intend, and is akin to the German *meinen*, to think or mean. Among the primary senses of "to mean" are: to have in mind, to intend, to purpose, to design. As gerund of this verb, the word "meaning" therefore means *that which is had in mind, intended, purposed, designed*.[3]

Now what is had in mind in hearing the humming bee is, of course, the humming bee. Otherwise one wouldn't be "hearing a humming bee." But a humming bee is something with a certain character. When I hear a droning plane, I also hear something with a certain character, but the character is

[3] Compare with what follows, Heidegger's discussion of language in *Being and Time*. See pp. 55–58, 203–10, 370–72, as well as the index. See also his *Unterwegs zur Sprache*, 1959, and *Vorträge und Aufsätze*, 1954. It is of interest to note that in a dialogue in *Unterwegs zur Sprache* Heidegger makes clear that his thought has centered from the beginning around the problem of language and being; see pp. 91ff.

different. Moreover, it is possible that I should first hear something as a humming bee and then correct myself, and discover that I am hearing a droning plane. My auditory perception then changes from hearing the thing as a humming bee to hearing it as a droning plane. Thus, what I have in mind, or what I intend or project in such an experience, is something *as* something. My projective understanding becomes in each case an interpretation. It apprehends the entity perceived *as* this or that, a humming bee, a droning plane.

Such intelligible character is present in all human experience, inexplicit when not explicitly expressed, and explicit when brought out in spoken and written language. It is in virtue of meaning that entities enter into man's world. What is something outside that world, something consequently outside the structure of meaning? This is the question that, in the language of Kant, was phrased, "What is the thing-in-itself?" Schelling pointed out that, put in this way, the question is self-contradictory, for if something is a thing it cannot be in itself, and if it is in itself it cannot be a thing. That is, to think of an *entity* without meaning or intelligibility is a self-contradiction, since to be an entity is already to have a meaning, i.e. to be *as* an entity.

As was remarked earlier, we reach here a limit of the possibility of thinking. As Croce found it impossible to obtain an intuition of an impression merely *qua* impression, since then it would not have been expressed and would consequently not be an intuition, so we now find it impossible to obtain an interpretation of that which is without all interpretation, since then it would not have been interpreted. Even to speak of it as nonbeing, the indeterminate, matter, is to interpret it, for all these are also modes of being; the Nothing is that which *is* in the way of being not anything.

This does not mean, however, that we cannot try to discover what things are like in so far as they exist independently of human beings. The effort to do this is called "science" in the modern acceptation of that word, whose outstanding instance at this early stage of its development is physics. In physics man studies independent being by way of physical models of interpretation. Such models are meaning-structures introduced by the human mind. But they are the particular meaning-structures that seek to omit the contents of human being, and particularly selfhood, from the character of the entities they interpret. They do this by way of a language whose predications are as far as possible invariant with regard to human feelings, wishes, purposes, perceptions, and thoughts.

Returning to the notice of the intelligible structure of interpretation in ordinary perception, we now see how the entities meant in perception are meant and thus have meaning. They are meant always as being this or that. What we understand in perception is a given entity. How we understand it, our interpretation of it, is *as* this or that, a humming bee, a ticking clock. Thus, given that we understand (mean, intend, project) the entity, it has a meaning by way of that very process of understanding, since the process is an interpretation and thus provides an intelligible character for the entity meant. In the very mean-ing of the entity, the entity has a meaning: being a humming bee, being a ticking clock.

In perception the percept has a meaning or is meaningful. Its meaning, however, is not a mysterious something compounded with sense data to produce the thing. In the percept there is neither the sense datum nor a hypostatic meaning. The percept is itself an entity that is meant (intended, projected, understood). It is that toward which the act of

meaning aims. But the act of meaning is always an interpretative act. It always intends the meant entity *as* something. By virtue of this mode of intention, the percept is interpreted as this or that, and the this or that *as* which it is interpreted constitutes its meaning. Your coat has a meaning because it is interpreted *as* being a coat that belongs to you.

We may now apply the same mode of consideration to language. I do not hear neutral sounds which, by an accession of meaning, are transformed into speech. I hear—a cry of pain, a polite greeting, a statement. I never hear neutral word-sounds plus word-meanings, just as I never hear neutral bee-sounds plus bee-meaning. The sounds I hear are already concretely meaningful. Thus I hear a *cry* of pain. A cry of pain is not a neutral sound plus something of the nature of meaning. If we are to call it—quite properly—a sound, then our concept of sound must be sufficiently rich to encompass cries of pain, in their full concreteness as cries of pain, as being genuine sounds. But then, to hear a cry of pain will be to hear a certain kind of sound which is neither a mere sound by itself nor a mere sound compounded or fused with something else; it will be to hear—a cry of pain.

A cry of pain is a sound of a special sort. It is a primitive linguistic phenomenon—hence, already, a kind of saying or speaking. This is the kind of sound that belongs to language, namely, the sound that is a saying or a speaking. In the first place, then, to hear it understandingly is to hear it *as* the saying or speaking that it is. Thus, to hear a cry of pain understandingly is to hear it *as* a cry of pain. A parrot may hear what we hear as a human cry of pain so accurately as to be able to reproduce it vividly, but he does not hear it *as*

such a cry and his reproduction of it is without its human meaningfulness. His world is not our world. The perception of language is so far like any other sort of perceiving. Perceiving is perceiving, i.e. it understands or is intelligent perceiving, because it projects the intended entity *as* something, the figure *as* a man running toward us. The perception of language is intelligent or understanding when it projects its own special sort of entity, experiencing it *as* a saying or a speaking—a cry, greeting, question, statement. Even when we experience something in a language that we cannot understand, we are already exhibiting a minimal linguistic understanding, for we are hearing it *as* language, albeit unintelligible to us. This is different from hearing it as mere sound. It is also different from hearing it as gibberish, which is also an intelligent or understanding hearing, but now of a sounding that has broken down in its attempt to be speech.

But in the second place, what we hear when we hear language understandingly has a further level of meaningfulness. For whereas in ordinary perception the perceived entity—the person, tree, fire, plane, bee—is an ordinary sort of entity, however unusual it be in other respects, in the perception of language the perceived entity is quite extraordinary as an entity, for it is itself something that *means*, i.e. it is symbolical. Not only is the cry of pain perceived *as* a cry of pain, so that it has the meaning of being a cry of pain. In addition—and this is something characteristic of language—as a cry of pain it itself means or symbolizes, i.e. it is a cry *of pain*. It itself "means" in a sense that corresponds rather to an act of meaning than to the object of such an act. And it is this mode of meaning, specific to language, that led in particular to the expression model of

language. Thus we must ask: Of what nature is this specifically linguistic meaning? What does the cry of pain, or any other linguistic entity, do when it means in the manner of a linguistic symbol?

Let us stay with the cry of pain temporarily, although it represents only one extreme of language, the so-called language of emotional expression. The commonest way of saying what it does is to say that it expresses in sound an inner state of pain. But we are now to try to get beyond this expression-model account by consulting the cry itself.

A cry is an exclamation. An exclamation is a calling out that may range from the howl of a wolf to the lamentation of a prophet. As a calling out it is an utterance. We hear it as an act performed by a being that has the power to utter. Even if it were produced by artificial means, as by electronic apparatus, it would be heard as an utterance.

The cry of pain is more than just an exclamation. It is a cry of *pain,* and differs in this way from a cry of grief, distress, surprise, wonder, triumph, or pleasure. How does the pain of which it is a cry relate to it as a cry? How do the grief, surprise, and triumph relate to the cries of them? What is the sense of the "of'" in the expression "a cry of . . . "?

If we hear the cry of pain as the cry of a being that has the power to utter, we hear it also as the cry of a being that has the capacity to suffer pain, that is suffering pain, and that utters in relation to its pain. This utterance "of" pain is far from being a sound that merely *has* pain in it, as if the pain of the cry were a quality like its pitch, loudness, voluminousness, or timbre and simply belonged to it as a sonal quality does to a sound. It is equally far from being a sound that *signifies* pain in the sense in which a sign points to a signified entity beyond it by some natural or conventional

association or rule. The pain is neither in the cry as a qual-
ity is in a thing nor outside the cry as a signified object is
outside the sign that points to it.

Each cry of pain has, as such, the concrete character that
belongs to an utterance by one who can both experience
pain and utter a cry "of" it. Take as example the moan of
grief. The one who moans is moaning *over* the loss or de-
struction of something cherished. Unless the moan makes
use of names and other forms to specify the loss, what is lost
remains indefinite. But we do not mistake it. There is a
grievous loss over which the moaner moans. And, in re-
sponse to this loss, the moaner grieves. We hear his moan *as*
the moan of one who is grieving over a loss. All this we
hear. Our hearing is intelligent, an understanding hearing.
We do not have to make a special inference, just as in
looking down the corridor we see the corridor and do not
have to infer it. (What our brain does is another question.
But we do not listen *to* our brain; we listen *with* it.)

In hearing the moan as the moan of one who is grieving
over a loss, we hear one who is grieving over a loss; and in
hearing him, we hear his grieving over his loss. That is, the
one who grieves, the loss, and the grieving are all grasped in
the act of grasping the moan *as* such a moan. We could not
hear the moan as the moan of one who grieves over a loss
unless the loss, the grief, and the one who grieves were
elements in our interpretive hearing of the moan as such.

Another example is the cry of pain wrung from the
sufferer of a physical injury. It sounds different from the
moan. The sort of cry it is depends on the temperament and
character of the sufferer. This particular sufferer, let us say,
is being conquered by the pain which he has tried to resist.
He is more than hurt by it, more even than distressed and
oppressed. He is giving way to it because he cannot any

longer hold out. It is too much for him. Relentless in its grip upon him, it advances, overcomes his defenses, unmans him, reduces him to the condition of a weeping child. As with the moan so with this cry, we hear it *as* the cry of one who is conquered by irresistible pain. And in hearing it as such a cry, we hear the pain, the sufferer, and his suffering. If we did not hear the pain, the sufferer, and the suffering, we could not possibly hear the cry *as* a cry of this particular form of pain.

Here, at this primitive level, we experience the mysterious and wonderful phenomenon of speech: *the hearing of a piece of human existence in the very process of hearing a human utterance.* In hearing the utterance as what it is, we hear the human existence of which it is the utterance. The cry may be sincere or lying; the piece of human existence heard in hearing it may be real or fictional. But the question of its fictionality or reality has not yet arisen, for the hearing, merely as such, constitutes the act that is first required before this question can be raised, namely, the auditory act of linguistic imagination. Just as we hear the bee humming or the plane droning, so we hear the person who grieves over his loss moaning or the person who is being conquered by pain crying. There occurs here the remarkable phenomenon that the sense of hearing functions as an avenue by which human existence itself becomes accessible to us as meaning when it is heard in the process of hearing language.

I see a glove. I hear a moan—of grief. The grief is not a mere quality or character of the moan. How indeed could anything like grief, which is a piece of human existence, involving a self, a world, and their interconnection, become so simple an entity as a quality or character of a sound? Or, again, the grief heard is not the mere pattern of tensions and resolutions of sounds that, according to Mrs. Langer's the-

ory, is supposed to be congruent with the pattern of tensions and resolutions of feeling. No hearing of a pattern of tensions and resolutions of sounds is the same as a hearing of grief. There is one and only one way to hear grief, and that is to hear it as such and not as something else. It is to hear the grief that is moaned.

This discovery gives us a first indication of how we may answer the question: How do linguistic entities mean? We have seen that in ordinary nonlinguistic hearing, as in vision, what is heard is entities *as* such-and-such. We hear something *as* a droning plane as in vision we see something *as* a corridor. These entities are intended or meant in ordinary auditory and visual perception. What distinguishes the perception of linguistic entities—and in the first place the hearing of them in speech—is that we hear them *as* utterances of human beings, and consequently we hear, as their specifically linguistic meaning, the special kind of entity that belongs to man. In hearing the cry of pain, we hear a piece of self-world being. When man speaks, we hear man spoken.

In general, as we hear the cry of pain *as* the crying of a piece of human suffering, and the moan of grief *as* the moaning of a piece of human grieving, so we hear human speech *as* the speaking or saying of a piece of human existence. Speech is the articulation of human being. In hearing speech, we apprehend human existence by way of the saying of it. This is our experience. It is the phenomenon of speech.

How it comes about that we should be able to hear a self in relation to its world in hearing a piece of language is a problem. It is equally a problem how it comes about that we should be able to hear or see anything at all in ordinary perception—a visual world or an auditory world with all their inhabitants. What we shall find hard to question, how-

ever, is that we do hear and see such things and that, in language in particular, we obtain access to the complex of world and self as such by way of the saying of it. For this is the phenomenon with which we are confronted when we turn even to the most primitive form of language, like the moan of grief or the defeated cry of pain.

To the question, "What does the cry of pain do when, as linguistic entity, it means?" we may now answer: it lets us hear grief or suffering or some other such piece of human existence.

It is tempting to say that in this respect a cry of pain is like a picture. As a picture lets us see what is pictured, we might try to say, so the cry of pain lets us hear grief or suffering. But the analogy would be misleading, not because the cry is not like a picture, but because the interpretation of the picture is itself at issue. We think—inadequately—of a picture as, say, a picture "of" a cathedral, an actress, or a forest. But a picture is more than this. It too, lets us perceive a piece of human existence, and hence is properly understood as a picture only when this constitution of it is understood. At present, we understand the cry of pain better than the picture, rather than the converse, so that for us at this point it would be more illuminating to see the picture as being like a cry than to see the cry as being like the picture.

We must therefore stay with our experience of language itself, and in this instance with the cry. The cry lets us hear the grief or suffering. These latter entities occur for us as the things that are meant, in the sense of being intended or projected in the auditory perception characteristic of language. Thus language, even at this primitive level, may be said to have meaning. Its meaning is constituted by the enti-

ties it discloses to our projective, intentional understanding, in the mode of audition.

What holds for the cry holds for all language. Language is that entity whose being consists in the saying of a piece of human existence as such. Wherever language occurs and in whatever mode of itself it occurs, whether as the language of science, art, religion, law, or everyday life, its function consists in opening for linguistic imagination a segment of human being as a meaning. This happens in different ways that vary with the particular task assigned to language, i.e. with the particular phase of human existence it is designed to make accessible to understanding. But all of these ways are only specific forms of the generic function of granting access, whether truthful or not, to the realm of human existence by the saying of it. Language is the medium, the pathway, and the mode of operation of the imagination by which we become aware of human existence—the existential imagination.

We may see this in what would seem the form of language least likely to have such an existence-disclosing character, namely, *statement*, the form that determines the prosaic character of prose and the opposite pole to the cry of emotion. Let us therefore consider an example of statement, so as to discern even here the essential constituents in the structure of the opening of access by speech to human existence.[4]

Consider the statement "The sky is cloudy." Usually, in textbooks of logic or grammar, two semantical functions are noticed as being fulfilled in such a sentence (the simple

[4] Compare Heidegger's treatment of "Aussage," which is rendered as "assertion," in Section 33 of *Being and Time*.

categorical proposition). This is indicated by the grammatical distinction, followed also in logic, between the subject and the predicate, with which the function of the copula, "is," is connected.

(1) The first of these semantical functions is noticed when the subject is emphasized: The *sky* is cloudy. The statement *speaks about* something, its subject, in the particular manner of statement. This statemental manner of speaking about a subject is different from the way in which other linguistic forms speak about their subjects. "Look at the sky!" speaks about the sky in the manner of an imperative. "Is the sky cloudy?" speaks about the sky in the manner of a question. In all of these forms, however, there is a common function performed: the subject is picked out and *exhibited* as an entity regarding which something further is said. This entity, the subject, which is in this instance the sky, appears as something intended in the way of being meant or thought, in a position ready for further consideration. This is seen if we begin "The sky . . ." and add only later one of the forms, ". . . is cloudy," ". . . look at it!" ". . . is it cloudy?"

Of decisive importance is the fact that what is exhibited as subject is an *entity*, not just a sign, image, concept, or other representation of it. What we think about by means of the statement is the entity itself about which the statement states. This, again, is a phenomenological fact about statement, as well as other forms of language. Language might be said, in some suitable sense, to represent or present such an entity; but the sense must be such that, in terms of it, language is understood as speaking of the entity itself and not something in between the speech and the entity.

(2) The second semantical function is noticed in emphasizing the predicate or the total verb: The sky *is cloudy*. In

speaking about a subject, the statement *predicates* something of it. The statement thus says something in relation to its subject; that is the generic function fulfilled here. In the question "Is the sky cloudy?" something is also said in relation to the subject, but it is said in the interrogative manner, not in the manner of predication. In the statement it is said in the manner of stating, i.e. predicating; and in the affirmative statement, as we have it here, the predicating occurs in the form of an affirming predication.

By means of the copula "is," the predicate "cloudy" is joined to the subject "the sky" in the way of an attribute. The sky, intended as an entity, is intended as a thing (in the broadest sense) which is susceptible of one or other of a group of attributes: clear, overcast, cloudy, etc. If the set is exhaustive, the sky is understood as having one of them, and the function of predication is to select and set forth, in its connection with the sky, one of them *as* affirmed of the sky.

Again, the point of decisive significance is that in predication an entity, which in this case is an attribute, is brought out in its connection with the subject. Or, it may be said, the original entity, the subject, the sky, is determined as an entity in a particular way by virtue of the attribution: as cloudy. Here, of the many possibilities open, one is chosen and the others thus foreclosed. In either case, the language of statement again has brought out an entity in its determination as such: the sky in its determination as cloudy.

These two semantical functions, exhibition and predication, are obvious, being manifest in terms of the logical, grammatical structure of the statement. There are other such functions that are not so obvious because they are noticed only in observing the statement as a whole.

(3) If we consider exhibition and predication together,

we see that they constitute a single function which might be called *the presentation of objectivity*. Their function is "to say a piece of world." By virtue of them, out of the background of the world, the sky is made to step forth as a figure, and it is further determined in that setting as being cloudy. It is not a picture that is thereby painted. The presentation occurs here through a straightforward noun and adjective, without any attempt at providing images. Rather, the effect is one of bringing out and forward for thought a specific intelligible structure: the sky as being cloudy. This structure is thought in the form of a segment of world. The sky, with its cloudiness, belongs to the world-half of the self-world complex; it is assigned to it as objective being.

This corresponds to the function fulfilled in the moan of grief, of suggesting a destruction or loss of something cherished. That destruction, the downfall of the important, is something belonging to the world *qua* other than the self of the moaner. Although in the moan this world-element is highly indeterminate, it is nevertheless present, so that the moan, too, like every form of language, presents objectivity.

(4) But as contrasted (though united) with the presentation of objectivity, there is also *a manifesting of subjectivity*, in which the self-constituent of the self-world complex enters into the total meaning of the linguistic form. Such subjective manifestation was already evident in the emotional outcry. For instance, in hearing a moan as the moan of one who grieves over a loss, we hear the one who grieves together with his grieving. Thus, the one who grieves and his grieving, i.e. the self and its functioning as a self, is heard in hearing the moan. What is thus heard on the side of the self and its functioning as self I speak of as "manifested" rather than "presented," because the self with its function-

ing is not given to us in the form of an object, pre-sented, but as a self, in the form of subjectivity.

By "subjectivity" is meant here the exercise of selfhood on the part of a self. Now one fundamental activity of the self is understanding, with its essential concomitant of interpretation. Statement, as such, is the most direct and uncomplicated form of linguistic articulation of intelligent interpretation. This is to be understood literally: statement is a form of articulated understanding.

As we have seen in the first two functions, and restricting ourselves again to the relatively simple form of the categorical proposition, statement distinguishes and relates a (logical) subject and predicate, or, in ontological terms, a thing or substance and an attribute. Thus in statement, two categories of entities are distinguished in such a way that one of them, the attribute, is related to the other, the substance, in the unique relation of "belonging to" or "inhering in," which is expressed by the copula-form in the affirmative statement. The difference between the two types of entity is indicated by the fact that we cannot meaningfully interchange subject and predicate. "The cloudy is sky" does not make sense in the usual interpretation of "the" and "is" and the positions of subject and predicate adjective in relation to the copula.

At work here in the constitution of statement, and hence in the constitution of the presentation of objectivity provided by the statement, is the formative power that belongs to human subjectivity. The self that speaks this language shows objectivity to itself and others in a certain form, which is the form of its understanding. The self sees world as background against which sky stands forth; it sees sky as being cloudy; and it presents this complex of world-showing-forth-as-sky-being-cloudy by way of the subject-

predicate form of statement. The total form of understanding that gets stated in the statement—substance with its attribute existing in the world—is a form that belongs essentially to, and is granted essentially by, the self that is a self precisely by exercising such a function as thinking in such a form.

Let us note further how the self manifests itself even in the particular details of the form of understanding. In the first place, the statement has a logical and ontological structure. Thus, as we have just noticed, it distinguishes and relates substantial and attributive being. This latter structure is a categorial structure.[5] It is a structure by which things in general are brought into the sphere of intelligibility or interpretation. By means of it we come to grasp what exists in a form susceptible of meaningful articulation. What is, is *as* a substantial thing or an attribute of a substantial thing. This is a fundamental categorial pair. Another such pair is given in the complex of cause-effect, which is expressed by a rigorously universal conditional proposition.

The insight that, in its use of basic logico-grammatical structures in language, the human mind gives utterance to its fundamental logico-ontological structures for the interpretation of existence is one of the lasting insights of Kant's *Critique of Pure Reason*, which I have simply been following here. Kant argues that the a priori character of these basic structures of understanding indicates that they are con-

[5] For purposes of uncomplicated exposition I speak of this structure as single when in fact it is manifold. E.g. an electromagnetic wave, an electron, a molecule, a stone, a worm, a pen, a poem, a heaven, a temple, a god, a category—these are all "substantive," but obviously in somewhat different senses. To display the types and interrelations of such a manifold would be to follow the categorial work of the understanding in the details of its actual constructions, as exhibited in this or that actual language—English, Latin, ancient science, modern science, philosophy, theology.

tributions of the self toward the constitution of the world of experience. By its introduction of them, the self makes a coherent order out of what would otherwise, on his view, be an incoherent rhapsody of sensations. We must, however, note on our own account that the world, as we know it, is determined *as* world precisely by means of these and analogous categorial structures, so that their function is to project a world—which is a projection of the background of all intelligibility—as well as to manifest subjectivity.

In the present context, our aim is to notice that the categorial structure of world-understanding manifests selfhood. And indeed, the selfhood it manifests lies at a deep level, since the categorial structure is determinative of the total world of the self whose world it is. The structure manifests the self by determining the world as the world of the self that thereby interprets it: the self's world. In order to be a self at all, man must project a world. Man's world exists, as world, for the sake of man, or as we may also say, for the sake of man's being; and, on the other hand, man's being is essentially the being of selfhood. As will be made out later, it is more than mere selfhood; but it is selfhood at the ground level, and the principle that obtains here is: no world, no self. The world-structure, no matter how valid or invalid it may be as regards the cognitive function it fulfills, is nevertheless a constituent of human being and manifests the intelligent nature of human existence at its basic level.

In addition to the logical, grammatical, ontological structure of linguistic understanding, there is also the temporal and material structure of language, which functions toward the manifestation of subjectivity.

The statement reads, "The sky is cloudy." It mentions the sky first. In understanding the sentence, therefore, priority is given to the grammatical subject. This subject, the

sky, is first given as emerging against the background of world; and it is given secondly, without further determination. The determination is thereupon given; its cloudiness is announced, once the sky has been given. These matters of emphasis are ways of shaping the structure and movement of attention to the objectivity presented. The same objective state of affairs might be seen in a different way: "Cloudy is the sky."

Thus within the intelligible structure of the statement, the way of the self in its step-by-step grasping of the objectivity is articulated. This way is a rhetorical character of the statement's meaning. More of subjectivity is also manifested by the statement in analogous ways. "Cloudy is the sky" would be said to be a more "poetic" version of the objective fact than "The sky is cloudy." Admitting that the degree of poetry in it is indeed quite small, the inversion nevertheless differs in its global meaning from the direct version. How does it differ? It presents the attribute first, leaving us to wait for the weightier constituent, the substance to which it belongs. Thus a different and more effective suspense is created than in the direct version. Once we have the substance we are more assured, for it is the substantial element in the construction, the ground on which it is erected. Again, the initial emphasis on "cloudy" tends to make us produce images of clouds, whereas its later position in the direct version has a weaker tendency along this line. Again, the rhythm of "The sky is cloudy" is a singsong of a prosaic sort (iambic-amphibrach, a variant of the more prosaic double iamb of "The sky is blue"), whereas in "Cloudy is the sky" the pattern is not only more unusual (trochee-anapest), but contains an exciting swing from the height of "cloud" to the bottom and back again to the even greater height of "sky."

In general, intonation, modulation, tempo, rhythm, sound-quality all operate in the two forms in different ways. By these rhetorical and aesthetic means the self manifests itself differently in the two. The self of the inversion is livelier, brighter, more personal than that of the direct version. The self of the direct version tends to retire into that anonymous impersonality that makes all selves who speak the language of information and science so like each other that one can be exchanged for the other. The self of the inversion comes forth, because of the difference and the new intensities of inversion, as a fresher self, more of an individual.

In other words, not only is the self's act of intelligence articulated by the logical structure of the statement; its condition of willing and feeling as a self is also articulated by the rhythmic and cognate materials and structure. The result is that we hear even such an apparently merely prosaic linguistic form as the direct categorical statement *as* an utterance of self, and indeed a self that is cognitive, conative, and affective in its being, since all these attributes are at work and made manifest there.[6]

(5) Not only does the statement give us the presentation of objectivity on the one hand and the manifestation of subjectivity on the other; it gives us the two in their unity. If the sky, as being cloudy, is presented in the form of segment of world, it is thus presented only as thought or envisioned according to that structure. If the sky is attended to first and the cloudiness second, the former is attended to only as the substance to which the latter belongs as attribute. That is, the relation between subjectivity and

[6] The separation in the text of understanding on the one side and willing and feeling on the other, assigning them to different aspects of language, is too arbitrary to have final validity. The situation is more complex, and the above procedure has only the merit of allowing us to get on temporarily in the discussion.

objectivity, which is essential and constitutive of the unity of experience, is itself given in the single statement that both presents objectivity and manifests subjectivity. Here, too, as in Cassirer's account of the artistic symbol or Croce's account of the intuitional expression, the two basic functions of presentation (taken now in the most inclusive ontological sense) and expression (now better seen as manifestation) exist only in an inextricable though distinguishable unity. The language of statement has the same generic character as the language of poetry, despite their difference.

(6) Finally, the statement, as a form of oral language, articulates in sound. Not only does it articulate being, both objective and subjective in their unity, but it makes it audible. Written language is a score for oral performance, except in extreme cases of artificial symbolic language-construction. Human being becomes audible in the articulate form of the declarative sentence. The serial ordering of different phonemes, making use of their sound qualities, rhythms, and other characteristics, constitutes an utterance which is heard as the uttering of the self-world, subject-object complex just described, and which therefore is the means by which that complex is itself heard as just that complex.

But since the self-world unity is the form that human being takes, the statement is an articulation in sound of human being. This was what was to be shown, namely, that like the cry of pain in its general linguistic function, even the statement form, apparently so distant from the selfhood of the self, also makes a totality of human being accessible to the linguistic imagination by way of the saying of it.

What we have seen to hold of the cry, at one pole of language, and of the statement at another, holds of all lin-

guistic forms: precept, maxim, advice, request, command, warning, judgment, condemnation, praise, prayer, ritual, ceremony, oration, lecture, boast, prediction, description, narrative, poem. In every one of these, and all the many others, a specific form of human existence is articulated as the meaning of speech. This is, indeed, their reason for being. To describe their constitution additional features to those already mentioned would have to be introduced, as, for example, the feature of *communication*, which, while present in statement, as in all language, is more obvious in advice, command, prayer. For in these, the aspect of *address* comes out more explicitly in the linguistic form itself (whereas in the lyrical poem, the question of address is less easy to decide upon—to whom is the lyrical poem addressed, if anyone?). Again, the meaning that is communicated in command is a *conative attitude*, which creates the *imperative mood* for its express articulate utterance, just as the different conative attitude of wish coins the *optative mood*.

In the end, every feature of language, from vocabulary, case, tense, and mood to synonymy-antonymy, logic, rhyme, rhythm, and rhetorical order, is intelligible as a functioning constituent of a medium that articulates human existence. Language is the act by which man brings himself out as man.

Our criticism of the theories of expression and revelation turned in part upon the error of supposing that what language means is already there beforehand, waiting only to be ex-pressed or repeated. But experience teaches us differently. For we do not know what we are trying to say unless and until we have said it; and the reason we do not know it is because it is not yet there to know; it is not yet actual. What we are trying to say is our own being, which has yet to be.

Take as example an apology. You have unwittingly offended a friend by an offhand remark about a member of his family. Only the next day, in puzzling about why he so suddenly grew cool, do you realize what happened, and you sit down to write an apology. What is it that you wish to communicate to him? What *are* you now, before you have written the apology? You do not even know how to start. What shall you say about the family member in explanation or excuse of your remark? Indeed, what *was* the meaning of that remark? And so on. Once you have gone through the process of writing the letter, after destroying three or four versions and filling the final one with a number of corrections, you think, "This will do."

In writing the apology you have shaped a piece of your own existence—if it is sincere. In any event, you have shaped a piece of communicable human being as the meaning of your words: an act of regret, excuse, reconciliation, restitution. In this meaning, a piece of the world and of the self is offered to another person to share in understandingly and to respond to. This has been brought about by the writing; it did not exist beforehand.

In the same way, even in the most objective, descriptive, neutral, informational language, like "The mass of the earth is 5.976×10^{21} metric tons," something has been produced that did not exist antecedently to the formulation. It is the meaningfulness of the existent. This is man's typical product, in all his doings, and his language lies at the root of it. Although it is factually and objectively true to say that the earth has that mass, nevertheless, outside the saying there is no earth, no mass, no having. Earth is something determined out of the indeterminate possibility of the existent (perhaps better called the nonexistent) for man to name, mean, understand. To be earth is, already, to be the theme of a

certain mode of meaning. To *be* at all is to be something so determined as theme for meaningful interpretation.

The relation of substance and attribute expressed by the "is" of the above sentence is a being-structure that the human mind brings to its task of determining the existent as existent. In performing this task, the human mind gives meaning to the existent. It provides the meaning by which the existent enters into the status of phenomenon, becomes something within a world, or the theme of intelligent interpretation. Meaningfulness accrues to the existent through the operation of mind.

But the operation of mind is essentially linguistic. The intelligible structure by which the existent is accorded meaning is the structure that requires language for its articulation. Intelligent interpretation turns in two directions at once—toward the existent and toward the power of speech. It brings itself about by bringing the two together in fruitful union. As speech comes to utterance, the existent comes to meaningfulness, and the intelligible structure comes into being by which man understands the existent. In the very same process, the subjectivity that acts in finding the speech manifests its own selfhood as it articulates the intelligible structure. The result is that, as the speech comes to its first utterance, the complex of self-world comes to its first articulation. In speech, man articulates his being.

"Articulation" means not merely copying or reproducing an antecedent reality. It means bringing about forms and joints and building up an organized product, with interconnected members, where beforehand there was only the potentiality for it. Articulation is the process by which a living formative impulse works itself out. It is creation, not out of nothing in the absolute sense, but out of that relative nothing which the existent (or better, the nonexistent) is before

it has attained to the status of being. In speech, man articulates his being out of the relative nothingness which he is as mere existent (or nonexistent).

"Articulation" also means utterance.

Art is in the first place the articulation of human being, like all language.

[5] *Truth of Statement*

If in language man articulates his being, this happens in all the forms of language and certainly not alone in art. What happens to language when it is fashioned as art, therefore, must be something unique and different from what happens in linguistic articulation in other spheres. Our aim is to bring to light this distinctive feature of language by virtue of which it is specialized as artistic.

Language is an intentional, purposeful phenomenon. When man speaks, he is trying to do something. An intention is at work in his speaking, guiding it toward an end. The intention may be more or less conscious, more or less unconscious; linguistic behavior remains purposive. In every form of language some facet of man's being is articulated, but there are many facets and consequently many types of linguistic intention. For instance, the intentions differ in a judicial decision, an executive order, a legislative decree, a magic incantation, a scientific hypothesis, a declaration of war, a philosophical question. Each of these is a different way of speaking, moving in a different direction.

Intentional, purposive entities are subject to criticism; they can be judged as right or wrong, good or bad, valid or invalid, successful or unsuccessful. There is always more than one way of criticizing a given thing. A given judicial

decision, for instance, may be critized for its awkward language, its excessive length, its too liberal or too conservative social viewpoint, its inconsistency with state law, its federal unconstitutionality, its historical lateness, and so on. Some such criticisms are, as it were, external to the decisional character of the decision itself. To criticize it for its awkward language or its historical lateness is not to criticize it strictly as a decision. It can remain a legally valid and binding decision even if it is convicted on those grounds. "Legally valid" refers to the decision *as* a decision. Criticism of a judicial decision as being legally valid or invalid is not external to its decisional character, but strictly relevant to it in that character.

It is this kind of strictly relevant criticism that is of greatest philosophical interest in regard to language and other purposive entities. For here, the criticism deals with them in strict relevance to their own intentional, purposive nature, i.e. to what they *are*. It is very difficult, and probably in the end impossible, to give an accurate definition of what could be meant by "strictly relevant criticism", but this is not important for our purpose provided we can recognize reasonably close approximations to it.

Criticism of this strictly relevant or internal sort is possible because and in so far as there is an *ought* to which the entity is subject *as* the kind of entity it is. Thus the judicial decision is subject to such criticism because and to the extent to which it ought to meet certain legal conditions. If all competent persons agree on the conditions it ought to meet, criticism has a common standard with which to operate; if not, criticism splits into camps. Even with a common standard, differences are possible over questions concerning the degree to which the decision has in fact satisfied the stand-

ard's requirements. The tension between community and divergence of standard and of factual ascertainment is always present in human society.

Common, however, to all types and camps of criticism are certain indispensable concepts: "ought," "should," "is," and "is not." These distinguish between the ideal and the actual, what ought to be and what is the case. Such a distinction is necessary for all criticism. Even the most extreme relativist in the theory of criticism adopts for himself his own "ought"—his own standards whether of law, morality, or taste—and determines for himself his own "is." Criticism is impossible without some such distinction.

The basic terms of criticism, such as right and wrong, good and bad, valid and invalid, successful and unsuccessful, refer to things in relation to *both* the ought and the is. The right, good, valid, successful is that which is as it ought to be, that in which the ought is realized in the is; the wrong, bad, invalid, unsuccessful is that which is not as it ought to be and ought not to be as it is. The differences in meaning of these basic critical terms derive from differences in the things they are applied to and the particular content of the standard involved. Thus rightness is predicated of moral intention, character, and conduct, of statements and opinions, and of things subject to codes or aesthetic tastes, whereas success is predicated of efforts, enterprises, and the like. Formally, however, all these basic critical terms belong to the same fundamental type; they signify some form of a thing's being as it ought to be or not being as it ought to be. They might also be said to signify some form of perfection or imperfection, understanding by "perfect" that which fulfills the requirements of an ought, a standard, or ideal concept, and by "imperfect" that which in some manner

fails to fulfill such requirements. Of what nature is the perfection that is characteristic for language?

Taken generally, the perfection of language lies in the adequacy with which it performs the work of articulating human being. But a question must be raised about the particular nature of this adequacy, for, since there are different modes of language with their correspondingly different intentions, there are also different modes of perfection or adequacy possible.

On the whole three comprehensive forms of linguistic adequacy can be distinguished in principle. The principle of distinction lies in man's being itself which language tries to articulate, hence in the intended meaning-structure and goal of the language itself as language. These are (1) cognitive or theoretical, (2) practical, and (3) spiritual adequacy. In the course of describing these forms of perfection or adequacy of language I shall use the term "truth" for the most part. The reason, as we shall see, is that the three forms of linguistic adequacy are suggested by the three possible interpretations of the traditional formula for truth as the adequation of intellect and thing. But if "truth" seems to the reader too limited or too presumptuous, the term "validity" might also be used. This is suitable particularly because it combines the connotations of rightness and cogency that belong to the idea of the adequacy of language as such, and consequently its use helps to keep our ideas about linguistic adequacy pointed in the proper direction.

The three forms of truth will also be called (1) truth of statement, (2) truth of things, and (3) truth of spirit, for reasons that will appear. Once we get beyond truth of statement, truth belongs not only to language but to things, and eventually to man. In the cases of truth of things and truth

of spirit, then, we have to ask as well what the truth is of the language that is especially associated with them.

The first form of validity is that belonging to language in its cognitive employment. One intention intrinsic to language is that of articulating knowledge, or the human understanding of existence. The concept that is traditionally applied here is that of truth. Language is perfected from the cognitive-theoretical viewpoint in so far as it articulates truth or in so far as it is itself true.

The concept of truth, as it occurs in this context, is a concept of a certain perfection or adequacy of thought and language. The pair true-false, as it is especially used in this context, is one of the basic critical pairs, belonging together with right-wrong, good-bad, valid-invalid, successful-unsuccessful, which refer to the realization or lack of realization of an ought in an is. This means further that in the concept of truth there is reference to an ought or standard which is supposed to be realized in actual linguistic entities. What is this ought?

It is already expressed in the traditional formula for truth: *adaequatio intellectus et rei,* the adequation of the intellect and the thing. This formula is interpretable in three ways, according to the direction in which the relation of adequation is understood: adequation of intellect to thing, adequation of thing to intellect, and the mutual adequation of the two. The first sense refers to the truth of the intellectual act, the proposition, or the statement; the second refers to the so-called truth of the thing, or its conformity with the concept held of it; the third, unnoticed in earlier accounts, refers to a truth that unites concept and thing in their mutual conformity, or truth of spirit. At present only

the first sense of adequation, *adaequatio intellectus ad rem,*
the conformity of our ideas to the things themselves, is of
concern to us, because it represents the cognitive ideal of the
human understanding of existence.

As applied to language, the cognitive ideal is the adequa-
tion of the language to the thing it speaks about, in such a
way that it says of what is that it is and of what is not that it
is not. This ideal is the ideal of propositional truth or truth
of statement.

The problem that lurks beneath these harmless-looking
phrases, the inclusive problem of the nature, possibility, and
criteria of truth or of the cognitive ideal, is a deep and far-
reaching problem of philosophy. Our aim here can only be
the limited one of obtaining a first approximation to this
ideal of truth of statement, so that it may be seen in relation
to the other two ideals.

What is the concept of truth—the adequation of our idea
to the thing—that is suggested by common-sense experience
of it? Consider an illustration used by Heidegger in his
account of the nature of truth.[1] Someone with his back to
the wall utters the true statement, "The picture on the wall
is hanging askew." How shall we understand the truth of
this statement? What is the adequation of this statement to
the thing that is required of it by the ideal standard of truth
of statement?

To answer this question we must ask: How does the phe-
nomenon of adequation become explicit as phenomenon
here? How do we experience the statement's truth? What
does adequation prove to be in the actual experience of
it?

Adequation shows itself in the confirmation of the state-
ment. In this process or act of confirmation, the adequacy

[1] *Being and Time*, p. 260.

of the statement becomes phenomenally explicit. Hence we look to see what happens when the statement is confirmed. In order to test the statement, the man who makes it turns around and looks at the wall. If he perceives the picture hanging askew on the wall, he confirms the statement; if he perceives no such picture or if he perceives the picture hanging properly upright, he refutes the statement. Here, in the testing of an ordinary observation statement, we should find an elementary instance of the adequation that belongs to truth of statement. What does it show itself to be?

Husserl suggested that this adequation is at root an *identity*, namely, the identity between what is meant or intended in the statement and what *is* and is given as such in perception.[2] His suggestion is derived from the nature of the experience of confirmation such as that just mentioned.

Central to the experience of confirmation is the idea of *evidence*. In a broad sense, evidence occurs when a positing intention, especially an assertion, is confirmed by perception. There can be degrees and stages of evidence, up to the ideal limit of objective completeness of the objective presentation in perception. For instance, I say "That is a watch." Looking at it, the outside looks like that of a watch, since it has a face, hands, etc. But this is not complete evidence, since it might be empty on the inside. Opening it, I see works. This makes the evidence objectively fuller. The object shows itself more fully *as* a watch. The ideal of objective completeness would be attained if and when nothing further remained to be brought to appearance in perception in confirming the statement, so that the object showed itself fully as a watch.

[2] *Logische Untersuchungen*, pp. 115ff. (part of the Sixth Investigation). Paraphrase-translation in Farber, pp. 441ff. See also the discussion by Heidegger in *Being and Time*, pp. 256ff.

Naturally, what we have for the most part is incomplete, fragmentary evidence.[3] The thing shows itself only partially in relation to the statement's full intention. But we are interested in the ideal of perfect evidence. What is the content of this ideal, where the objective presentation would be complete?

Even in partial evidence the object shows itself, though fragmentarily. What makes the experience one of evidence, or confirmation, is that the object shows itself, even if only fragmentarily, just as the statement means it. The man who turns around and perceives the picture hanging askew on the wall does not only perceive the picture. He has a more comprehensive experience which relates the intention of his statement to what he perceives. He experiences the selfsameness of the perceived picture with the picture he had in mind in making the statement. The actually perceived picture on the wall, hanging askew, is experienced as being just the selfsame entity as the intended or meant picture on the wall, hanging askew. (Instead of "experienced" one could also say "perceived" or "apprehended.") Part of the meaning of "hanging askew on the wall" is that, looked at from such-and-such a position, the picture's edge is not parallel to the edge of the floor. Now this nonparallelism shows itself, just as it was intended by the statement, in the perception.

In other words, confirmation or evidence occurs where there is an act of *identification*, partial or complete, between what the statement means and what the thing shows itself as being in the perception. Corresponding to this act of identification there is its objective correlate, or what is experi-

[3] For an instance of the realization of the ideal, see the author's article "Does Intuitive Knowledge Exist?" *Philosophical Studies,* VI, No. 6, December, 1955, 81–87.

enced in the confirming identification as such. This objective correlate is the (partial or complete) *identity* between what is intended by the statement and what is given in perception. In confirmation or evidence we experience a certain objective content, namely, *an identity of meant and given entities.* Here the entity that *is* (is given in perception as *being*) is the selfsame entity as that which *is meant* in the statement. Were evidence complete, this objective selfsameness of entity-meant with entity-given would be complete.

We have here a sense that can be given to the adequation that belongs to truth of statement: *the identity of the meant with the existent.* (Husserl speaks, rather, of the identity of the meant with the given. But we would not think we had attained truth unless we thought that what was given in perception was the thing itself which was meant by the statement, hence, the existent thing.) This is the objective correlate of the act of evidence, and it may be called truth in the objective sense.

Truth, therefore, in its root sense is the (ideally complete) identity between the entity intended and the entity that *is.* The *adaequatio* of the intellect to the thing turns out to be an identity between what the intellect intends or means and the thing as it is. Confirmation takes place so far, and only so far, as the thing shows itself to us in the act of perception, so that it is given there as it *is.*

Heidegger in particular, in his own analysis of the situation, stresses the identity of the intended entity with the entity as it is. For, he maintains, the statement would not be confirmed by discovering it to agree merely with some representation or image of a picture on a wall. The statement is about a picture on a wall, not about a representation or image of it. The representation or image would be a different entity. What we mean or intend in the statement is the

picture itself on the wall and nothing else. Our statement is, he says, a "being-toward" the thing itself that *is*.

On the basis of this concept of the selfsameness of the entity intended in the statement and the entity that *is* (which is discovered in perception), Heidegger goes on to define the truth of the statement itself as an *uncovering*. Just because in the case of the true statement the identity of meant and existent entity occurs, the statement itself can be said to uncover the entity, so that a new sense of truth, uncovering, can be attributed to the statement, corresponding to the identity that is the objective correlate of the experience of evidence.[4]

This uncovering by the statement is not the same as the evidence in which the identity becomes explicit, for the statement is true before the man turns around to confirm it. It is not the appearance of the entity in perception that is its propositional uncovering; before the confirming perception occurs, the statement itself uncovers the entity as it is—the uncovering already happens in the disclosive intention of the statement itself. What constitutes the truth, or uncovering, of the statement is that, in its own unique way *as* statement it reaches out in its intention to open a sphere of overtness for an entity, the picture, to enter just as it is, that selfsame entity. Thus Heidegger's definition of truth of statement, founded on Husserl's identity-concept of objective truth (or what Husserl calls being in the sense of truth), reads:

The statement *is true* signifies: it uncovers the entity in itself. It states, it exhibits the entity, "lets it be seen" (apophansis), in its

[4] Heidegger uses "uncovering" for things that are present-at-hand, "disclosing" for man, and "unveiling" for being; but these distinctions are irrelevant to the present discussion and may therefore be neglected. See his *Vom Wesen des Grundes*, pp. 11–15, esp. p. 13. His general term for truth is "unconcealment," the Greek *aletheia*.

uncoveredness. The *Being-true* (truth) of the statement must be understood as a *Being-uncovering*. Truth therefore does not at all have the structure of an agreement between knowing and object in the sense of an assimilation of one entity (subject) to another (object).[5]

We might therefore say that statement, as such, articulates a human aiming at what-is. This aiming is an attempt at or an effort after the uncovering of what-is. If the effort succeeds, so that the intended entity is selfsame with the real entity, the statement is true. It uncovers the entity; the intention, transcending itself, reaches its destination; or, *vice versa*, in reaching its destination, it uncovers the entity, bringing it into the openness of human being.[6]

It is of more than incidental interest to notice that in a context and spirit far removed from the phenomenological sphere of Husserl and Heidegger, the same fundamental notion of an identity at the root of the truth of statement recurs. This happens in Rudolf Carnap's logistical formulation of the semantic concept of truth, on the basis of the earlier work of Alfred Tarski.[7] The definition reads:

The sentence S is true (in a given language L) if and only if there is a proposition, *p*, such that S designates *p*, and *p*.

For instance, let S be "Immanuel Kant was born in Königsberg." Then there is a *p* such that S designates *p*; namely, *p*

[5] *Being and Time*, p. 261.

[6] From truth of statement Heidegger moves toward the ground of its possibility. This ground turns out to be twofold: (1) *ontical truth*, or the prestatemental, prepredicative disclosedness of entities, which is the immediate ground of possibility of statemental truth; and (2) *ontological truth*, or the preconceptual understanding of Being that illuminates and guides all comportment toward what-is, which is the ground of possibility of ontical truth, and hence the ultimate ground of possibility of truth of statement. See *Vom Wesen des Grundes*, pp. 11–15.

[7] Carnap, Sec. 12, pp. 49ff.

is: *Immanuel Kant was born in Königsberg.* Also, *p;* i.e.
Immanuel Kant was born in Königsberg. Hence, S is true.
One sees here the recognition, in a formal way, of the
identity-element in the ideal of truth. As in the phenomeno-
logical version the statement intends or means an entity, so
here the sentence designates the proposition as entity. If
phenomenologically the objective truth of the statement lies
in the identity of entity-meant and entity as it *is,* so here
there is identity between the designatum, *p,* of the sentence
and the propositional fact itself, namely, *p.* And even Hei-
degger's notion of uncovering has its counterpart in Car-
nap's formula. For according to that formula a sentence S is
true if it *designates* a *p such that p.* It does not merely
designate a *p.* The *p* it designates is *such that p.* Thus in
designating-such-that the sentence S brings this *p,* which is
already a such-that, into the sphere of designation, the
counterpart to Heidegger's open place of truth.

There is this thoroughgoing parallelism between the lo-
gistical and the phenomenological concepts of truth only
because both branches of philosophy are concerned with
the same ideal. In both cases there comes to expression the
same requirement upon language and thought that consti-
tutes the single ideal of truth. It is expressed in different
ways only because of the difference of concern of the two
kinds of philosophizing.

What is this ideal of truth in its concrete nature? In
Carnap's logistical formulation of the concept of truth as a
semantical concept, explicit reference is made only to the
sentence and what it means. But in the expression "desig-
nates" there is already an intimation of what Carnap has
called the "pragmatical" element of the mind that does the
interpreting, meaning, and using of the sentence as a state-

ment, and in this case as an assertion. The statement actually functions here as an assertion. When used in this way, its intentionality is realized as an intending of an entity. The statement in itself articulates a possible posture toward an entity. When it functions as an assertion, it becomes an actual intending of an entity. What, then, is this actual intending of an entity which we call "assertion"?

Assertion is a form of man's being. It is a special form that human being takes on, namely, the intending of an entity in the way of aiming to uncover it as it is. Here there comes into play man's capacity to point to entities, to aim at an entity with the goal of striking it as a target of an act of understanding. This is not a mere capacity; man *must* exercise it, so that it is a necessity as well, or part of his "nature." In bringing this capacity into play, man brings about one form of his being as man.

In introducing the act of aiming at the target, man also introduces a positing of its counterpart, the target itself, the entity that *is*. The whole point of assertion lies in the presupposition that there is a target to be hit, i.e. an entity to be uncovered by the statemental intention, i.e. an entity identical with that meant by the statemental thought. Thus assertion includes in its structure: (1) the distinction between thought or its articulation in statement and what the thought is *of*, namely, something that *is;* (2) the supposition that the intended entity can also *be* as such, as distinct from the thought that intends it, with the collateral requirement; (3) that the entity intended and the entity that *is* should be one and the same.

Because of the split thus introduced between the intended entity and the entity that *is*, even though the aim is that the two should be identical, a further split is introduced into assertion itself, namely, between assertion as it ought to be

and assertion as it is. As the intending of an entity, assertion takes upon itself the requirement that it *ought to be* an uncovering of something that is, while at the same time it *is* itself in the form of an intending of that entity. It is true, as a human act of assertion, if and only if it itself, the *is* of intending an entity, *is as it ought to be*, namely, an intending that is an uncovering, that is, an intending in which it means its entity in such a way that its meant entity is the selfsame entity as the one that is.

In assertion, man, within his own being, energizes in a process that is subject to an ought. The demand expressed in this ought is not imposed from the outside, even if the demand is that the act conform itself to an entity beyond. It is generated from within. In it man subjects himself to his own ought. The will to truth is intrinsic to man as a radius of his being. He does not set it up artificially or by convention. It lives in every act of assertion and therefore in every act of thought that is articulable in statement. It exists immanently in thought before it is reflected on in philosophy.

Man's thinking, as far as it takes the form of the thought that is articulable in assertive statement, is an intending of entities that incorporates in its own structure a positing of the existence of entities in distinction from the mere intending itself, a positing of the possibility of the identity of intended and existent entities, and a requirement or demand that this intending *should* realize that identity. Thinking contains within itself the fundamental aim that gives rise to its ought and that makes it possible and necessary to seek for the means by which that ought is to be realized.

This structure of thinking shows that man, as far as he is a thinking being, is a being in whose constitution there originates a truth-tension between ought and is that consti-

tutes a demand for its resolution. Man *is* the aim at truth. So far, however, only one side of the nature of assertion has come into view. Its complement is brought out when we look to its particular character as an intending of entities. The peculiarity of the aim here is that it is an attempt to *yield* the self to the entity whose being it posits and which it aims to uncover. The adequation here is of the thought *to the thing*. Not only does thought here posit independent being; it seeks that independent being in order to conform its own intention to it just as it is. Thought's self-given norm is that it ought to be ruled by what-is. Thought is to pattern itself so that what it intends is to be identical with what-is. The ideal of thought is articulated in an ideal of the truth that belongs to it as thought. Thought is to try to be, *as* thought, what the existent is *as* being: the identity of thought and being in truth.

It is important toward the understanding of human being that this immanent ideal and standard of truth of thought be seen for what it is. There is at present a prevailing tendency to identify true thinking with scientific thinking and scientific thinking with thinking in the sciences of natural causality. Since in phenomena of natural causality energy is the central concept, and every discovery brings with it the possibility of using energy, or exercising power to accomplish work, it is easy to fall victim to the Baconian pragmatic notion that knowledge is essentially power, the power to institute the use of means toward ends, of causes toward effects, and hence the power to transform situations from an undesired to a desired condition. But true thought is also possible about entities with regard to whose nature power and energy are irrelevant. For instance, the phenomena of pure appearance, such as orange hue, sour taste, smooth feeling, are also objects of knowledge. I know that orange is

between red and yellow in hue. This truth is not a truth of natural causality, but of intrinsic relations of phenomenal qualities. I cannot make an explosion by the use of such an insight. It does not even tell me how to make a painting. It only tells me something true. In doing so, however, it lets me be what, in one dimension of my being, I aim to be: true (or uncovering) intending of entity.

How far is the ideal of truth realizable? In intuitive phenomenalistic truth it is fully realizable. In perceptual knowledge difficulties begin. The "picture hanging askew on the wall" might, after all, be only a clever illusionistic painting of a picture hanging askew on the wall. Incompleteness and misinterpretation of evidence raise their heads here and become more serious the deeper and more systematic the knowledge that we seek to attain, as in the sciences of the natural world.

The problem as to criteria of truth, or ascertainable conditions under which it could be said that a statement of this or that class is true, need only be mentioned in order to indicate the range of difficult questions posed by the ideal.

Again, must not the ideal of truth be abandoned in favor of some substitute closer to what is attainable, like the warranted assertibility of Dewey or the probability of the logical empiricists?

Man cannot abandon the ideal of truth. He can introduce other goals as well, e.g. that of probability, where they are wanted and needed. But even here, in making assertions about probability, he retains the ideal of truth. Assertion involves the ideal of truth in its constitution. Man is essentially assertion, in one dimension of his being. He would have to abandon himself if he were to try to abandon the ideal of truth.

Truth in the sense of adequation of thought to reality is

one form of validity open to man by virtue of his constitution as man. In his constitution there is the element of understanding or thought, articulable in discourse and language. At the root of this function is the drive toward identity of the intended with the existent. This drive is the thought-drive, the will to truth, or the form that will takes in so far as it develops, for its own self-guidance and self-articulation, the ideal of truth. In giving himself to the service of the ideal of truth (truth of statement) man articulates himself as man along a certain radius, namely, understanding. He performs this articulation by opening up the difference of ought and is with regard to his thoughts or statements, where the particular ought involved is the ought of accommodation of thought or statement to the existent as such. In so far as such an accommodation—or identification of thought with the existent through the identity of what is meant and what-is—is reached, man arrives at a terminus that belongs to him in accordance with his nature. Hence the great satisfaction that knowledge provides, especially purely theoretical knowledge that is not sought after for the purpose of its mere practical employment.

A sacrifice, however, must be made for this blessing of the knowledge of truth, namely, the laying down of the self's will as self. In order to know truth, the self, as a being in the world, must take the form of an intending of entities in which its aim is to identify itself in intention, as far as possible, with the existent. The self, therefore, must become an intention identical with what is not itself. It must abandon any effort to be on its own account in order to be an intending of what-is in the form of what-is as such.

We recognize, however, that in his self-abandonment there occurs a certain self-attainment. For one dimension of the self is precisely to be a knowing self. In so far, therefore,

as the self knows, and by the very act of abandonment through which it knows, it nevertheless attains to an actualized selfhood. Man becomes a self, in knowledge, in the act of abandoning his self. This is not a contradiction. It is a coherent fact about the process by which the human being attains a self. Man's existence is that of a will to be, namely, a will to be a being in the world, and hence to be a self that has a world. When this will to be turns in the direction of knowing, it is a will to be identical, in intention, with the existent. This is the form that human intention takes in knowledge, and therefore it is the form that the self attains to in knowledge.

To will to be identical in intention with the existent inevitably entails the will to refuse anything that interferes with the establishment of the cognitive identity of truth. What could interfere here is the self-will, in which the aim of the self is not intentional identity with the existent, but just the reverse, the identity of the existent with the intention of the self. This brings us to the second form of validity, namely, practical validity, which takes shape as truth of things.

Truth of Things

The idea of practical validity is expressed in the second interpretation of the traditional formula for truth, which may now be read: *adaequatio rei ad intellectum*, the adequation of the thing to the intellect. Here we encounter a new ideal, the practical ideal. Unlike the cognitive ideal of the *understanding* of existence, it is the ideal of the *governance* of existence. If in cognition the self yields itself to existence, in practice the self demands that existence should yield itself to it.

Because the positions of thing and self (*intellectus*) are now reversed, this concept of validity applies to *every thing*, not only to language, idea, or the being of the self. It is the concept which traditionally is understood as that of the *truth of things*, the truth of beings or entities (not to be confused with Heidegger's ontical truth). The core of every case of truth of things lies in the notion of the agreement of the thing's existence, or the thing as it *is*, with the concept of it as it ought to be. Given this concept of the thing as it ought to be as a standard, the thing in its actual existence is to be measured against that standard. It is true if it conforms, false if it fails to conform.[1]

[1] There is another interpretation of the adequation of the thing to the idea that treats the idea not as a concept of what the thing ought to be but as a concept merely of such a thing. Thus, we speak of something being a true coin if it really is a coin, i.e. if it conforms to

This sense of truth finds its classical expression in Anselm's *Dialogus de Veritate*.[2] Anselm defined it here as *rightness perceptible to the mind alone*, thus distinguishing it from the rightness—rectitude, i.e. straightness—that is perceived by corporeal vision in bodily things. There is truth of a thing only where a requirement, an ought, is put upon the thing. The thing's truth then consists in its fulfilling the requirement, satisfying the ought, being or acting as it should. But what fulfills the ought is thus far right. Hence its truth lies in the specific mode of rightness it thereby attains.

For instance, man ought to do good (we assume this with Anselm for the argument's sake). Hence, his actions are under the requirement of doing good. A human action in

the concept of a coin, of such a thing as a coin. The concept here is not an idea of what we *require* the thing to be, under the rubric of an ought-to-be; it is just an idea of what the thing might be, an idea simply held as an idea to which the thing may or may not conform, not as a standard to which it ought to conform. On this interpretation of truth of things, to say "A conforms to the concept of a coin," "A is a true coin," "A is a coin," "The statement 'A is a coin' is a true statement," are all equivalent (except for fine points of semantic doctrine). That is, the truth of the coin and the truth of the statement that the thing is a coin come to the same thing here. Hence this interpretation of the formula of adequation of thing to concept does not really introduce a new concept of truth. It only introduces a different way of talking about the same thing that truth of statement talks about. Only when the concept is taken as a standard which the thing is required to satisfy is there a new sense of truth. Thus when we think of someone as being a true friend, we do not only think of him as truly exemplifying the concept of friendship. We think of him as putting forth the claim to be a friend, of assuming thereby the obligation to be a friend, and of fulfilling that obligation. In other words, we think of the concept of friendship here as a standard which he is under obligation to fulfill. In so far as "He is a true friend" means only "He in fact does fulfill the concept of friendship" without our taking this concept as an ought, nothing new, as far as the idea of truth is concerned, has been added to truth of statement.

[2] Translated by R. P. McKeon in his *Selections from Medieval Philosophers* (New York, Charles Scribner's Sons, 1929), I, 142–184, from Migne, *Patrologia Latina*, Vol. 158, col. 467–486.

which the man actually does good is, to that extent, as it ought to be. It is right as an action, hence true as an action. It possesses the kind of truth that belongs to actions as entities.

In the eighth chapter of his dialogue Anselm makes theological use of this idea in his attempt to demonstrate that everything that is, is as it should be, so that truth and rightness are in the essence of things. But such a doctrinal use of the idea of truth of things is not essential to the idea itself, and it may be set aside in our present considerations.

More germane is Anselm's application of the idea to statements. For, after all, a statement is also a thing or entity, and therefore it, too, falls under this second concept of truth. For the purpose of affirmation is to signify that that which is is (the first, theoretical, sense of truth); it *should* do that. Hence it has an ought (i.e. to be true in the first sense). When it does what it ought to do, namely, signify that that which is is, it signifies as it should, and therefore signifies rightly, so that being right, it is true (now, in the second sense).

We should notice that the thing-truth the statement is here shown to have is not the same as the truth of statement discussed above, but is a new truth that is only based on its being true in the earlier sense. For the thing-truth of the statement is, strictly, the statement's *conformity with its ought*. It so happens that in the case of statement the ought's content is itself another species of truth, namely, statement-truth. That is not so in the case of other things, e.g. the thing-truth of human action. A statement, thus, has thing-truth *qua* statement if it signifies as it ought to signify, i.e. if it signifies in such a way that it has statement-truth.

This is not mere quibbling. The distinction is of basic significance. In truth of statement, the statement yields to

existence. In thing-truth as it applies to statement, the statement yields to *the self's purpose with it,* which may or may not be the realization of truth of statement (theoretical, cognitive truth). The two ideals of truth look in exactly opposite directions. The statement (our posture toward the existent in the manner of exhibiting), as subject to both standards, exists always in a state of tension between their pulls on it.

The distinction appears also in the controversy between the correspondence and the pragmatic theories of truth. According to correspondence theory, a statement is true if it agrees with or conforms to the fact, the thing, the existent. The concept of truth of statement as outlined above is essentially the correspondence concept, where the conformity is understood in its ideal sense as identity of intended and existent. Now pragmatism, being a practicalistic vision of the meaning of existence, and hence basically concerned with the governance of existence by the self (mind, intelligence), could not be satisfied with such a theoretical concept of truth. It sought for effects, works, control. It demanded of ideas that they would do practical jobs, for which they were much needed—e.g. establishing health, increasing longevity, reordering social existence in accordance with principles of justice, and in general solving the practical problems of existence from the most trivial to the greatest in scope. The merely theoretical ideal of the conformity of mind to reality, which was defective in addition because it contained in itself no hint as to how the mind was to reach reality, to verify itself in contact with reality, to take hold of reality, and to guide it toward ideal ends—that merely theoretical ideal was, for pragmatism, too weak, too passive, and too empty to be suitable.

Accordingly, pragmatism demanded of ideas not that

they "correspond to" reality in the transcendent sense of being in a miraculous identity with it, but that they serve a practical function. Pragmatism replaced the theoretical ideal by the practical concept of truth (although the latter had to include, in one way or another, something of the theoretical form within it as its foundation, as we have seen above, if statements were to fulfill their practical functions). It defined the truth of an idea as its fulfilling the function of an idea, and it assigned to ideas the function of being guides to operations upon things leading to their transformation. Toward ideas about physical nature it adopted the standpoint, one might say, not of the theoretical physicist but of the engineer.

A popular, but on that account all the more revealing, presentation of this life attitude toward ideas is expressed in these words of Dewey's:

If ideas, meanings, conceptions, notions, theories, systems are instrumental to an active reorganization of the given environment, to a removal of some specific trouble and perplexity, then the test of their validity and value lies in accomplishing this work. If they succeed in their office, they are reliable, sound, valid, good, true. If they fail to clear up confusion, uncertainty and evil when they are acted upon, then they are false. Confirmation, corroboration, verification lie in works, consequences. Handsome is that handsome does. By their fruits shall ye *know* them. That which guides us truly is true—demonstrated capacity for such guidance is precisely what is meant by truth.[3]

[3] *Reconstruction in Philosophy*, p. 156. Dewey did not submit fully to the crass notion that the truth of an idea consists solely in its *practical* consequences. See the author's article, "Concerning a Certain Deweyan Conception of Metaphysics," in Sidney Hook, *John Dewey: Philosopher of Science and Freedom* (New York, Dial Press, 1950), for an argument to show that the transformation brought about in inquiry, according to Dewey's logic, is strictly a transformation in *significances of things*, so that the essential power of ideas that Dewey had in mind was not primarily the power to effect practical results outside knowledge (though it was this eventually), but to

Here Dewey views ideas as plans of action aimed at clearing up specific situations. When the plan is acted on, it guides us successfully or unsuccessfully, leading us to or away from our end. In the former case it is true, in the latter false, and as Dewey says:

Its active, dynamic function is the all-important thing about it, and in the quality of activity induced by it lies all its truth and falsity.[4]

These words were contained in lectures given at the Imperial University of Japan in Tokyo during February and March of 1919. Its audience could have seen here the practicalistic concept of truth at work organizing the life of ideas, and by implication the whole of life, in accordance with its vision of validity. To see this, to see its difference from the theoretical concept, to realize the sphere in which it operates by right, and (as will later appear) to see where the concept of spiritual validity departs from it—these are not trivial but significant points, insight into which depends on the distinctions of concepts of truth and validity being drawn.

The field of vision that is opened up by the concept of truth of things is so extensive that it is impossible to describe in the compass of a few words. It is no less than the whole world of practical life. Within that field there lies whatever the human will may wish to apply its own concept to, requiring of it that it subordinate itself to that concept. Everything, in so far as it comes under the volition of the self, thereby falls under some concept, explicit or im-

effect interpretation and reinterpretation, the building of significances, within knowledge.
 [4] Dewey, *Reconstruction in Philosophy*, p. 156.

plicit, which the will brings to bear in its effort after the governance of existence. Thus in the sphere of thing-truth there lies everything essential to the two spheres of action determined by will, spheres which get their designations ultimately in ethics, which itself stands at the border between thing-truth and truth of spirit. These two spheres are the teleological or axiological and the deontological.

The teleological or axiological sphere is that of means and ends, goods, values; the deontological is that of rules, laws, and obligations. The two overlap, since there are rules concerning means-ends and goods, and there are values belonging to rules. Nevertheless the concepts are distinct and they distinguish different aspects of things. In the teleological sphere the concept of the end or good to be accomplished determines the ought. A technical maker, for example, adopts as his end some good to be made—a clock, a shoe, a locomotive. Everything in the process of making, including the product, is testable according to whether it serves the purpose of realizing that end. The goal of happiness or of self-fulfillment similarly determines the whole of a life as being subject to test as falling under that ultimate end. Here there is set up an ought, determined by the end to be realized: the ought is what ought to be, which is constituted as an ought-to-be only in so far as it is adopted by the will.

Similarly in the deontological sphere. Here the rule, law, duty expresses or constitutes the ought. The national government duly passes a piece of legislation controlling the manufacture of sedative drugs. It is valid as legislation, i.e. as duly passed in accordance with standard constitutional requirements. It itself has thing-truth as a legal entity. But it also determines an ought in regard to practices in drug manufacture. It sets up requirements that they must satisfy,

and this defines a circle of thing-truth for such practices. The practices are now things that can be right or wrong, as they should or should not be.

Ultimately here, too, in the case of the ought-to-be-done, as in the foregoing case of the ought-to-be of the end, the will is the constituting agent of the ought. Only where and in so far as the law's ought is willed as ought does it determine a sphere of thing-truth in reality. The law of the national government, the positive law, must be acknowledged as valid by a will capable of willing it (even of willing it in obeying it) for it to exercise the reality of an ought. Otherwise it remains a mere theoretical possibility of ought. The legal prescription must be adopted as actual prescription if it is to be deontological in reality. In the sphere of morals, again, the question as to what makes duty duty, in the sense of what makes a theoretically recognizable ought an actual ought, having and exercising moral weight as such, is a question concerning how the will finds itself actually obligated as moral will to acknowledge the law as law, e.g. how my will finds itself actually obligated as a moral will to acknowledge that I *ought* to keep my promises.

Teleology and deontology between themselves encompass all things from matter to God. Everything can be subjected to the thinking and willing that takes shape in accordance with the concepts of means-ends, values useful and final, and laws (positive, prudential, moral) of right and wrong. Such categories lay claim to a universal jurisdiction, just as the understanding that operates in the aim at truth of statement presumes to be universal, in subjecting everything to inquiry as object of the scientific impulse.

It is curious to observe how even God gets subjected to thing-truth. When, for example, Enlightenment turns its

attention to God, it requires Him to suit its own concept of what He ought to be. Thus speaks Kant: "Even the Holy One of the Gospels must first be compared with our ideal of moral perfection before we can recognize Him as such." [5] Is God the true God? Before He can be admitted to be such, says Enlightenment, He must conform Himself to *our* concept.

This enables us to observe what takes place in the sphere of thing-truth. In this sphere the will sets itself up to be the source of the possibility of truth. Whereas in statement-truth the statement is required to direct itself toward identity of what it intends with the thing itself, now in thing-truth the thing itself is required to direct itself (or be directed) toward identity with what the willed idea intends. In both forms of truth there is identity of intended content and actual thing. In statement-truth, man, as understanding, seeks to conform himself *via* this identity to existence. In thing-truth, man, as will, *via* this identity, requires existence to conform to himself.

Thing-truth is therefore the mode of being in which the human being, as characterized by will, seeks to make himself the governor of existence. We must recognize that thing-truth could not exist without the existence of will, for a concept can be a standard only by virtue of the energy of will by which the concept is adopted and acknowledged *as* standard. But this act of adopting or acknowledging a concept as a standard is an act whereby the human being sets himself up as the judge of things. That he cannot make all things obey his will raises serious questions for him, showing him one face of his finitude; but that he sets himself up, through will, as the judge, and thus far as the governor, of

[5] *Fundamental Principles of the Metaphysic of Morals,* fifth paragraph of *Second Section.*

existence, is clear, and it is further clear that, as a being of will, he attempts to execute his judgment as far as existence gives him scope.

Across the street from where I live there is a park. In the park there are benches. The benches are made of wood and concrete. To get the wood, trees were sawed down, ripped into planks, and the planks cut into slats. The slats were shaped and finished to size and then bolted to concrete supports, and now they are fixed there as benches. People see them as things to sit on, and unconcernedly apply their backsides to them. Children climb on them, nursemaids gossip on them, drunks sleep on them, lovers embrace on them, dogs urinate on them, vandals tear them apart. The Park Department carpenters repair them and repaint them. Eventually, after men, dogs, and the weather have had their will with them, and they are too rotted and dilapidated to be rehabilitated, they are carted away to the dump and there consigned to nothingness.

Such in brief is an average example of the rise of a thing to truth and its fall into falsehood and oblivion. It is essentially at the same time an example of the meaning of human existence as far as this existence is defined by its concern with thing-truth, i.e. by will in its separateness as the determiner of the ought against that which exists. For the meaning of human existence here becomes a new form of being. In it the self, looking toward what exists, requires it to submit itself to the self. The self holds its being against the being of the existent thing and commands the latter to transfigure itself. The self sets itself at the center of being. It sets itself up as the reason of being, determining the why of things by the form of the ought that it imposes on them. Thus the *is* of the human being becomes the source of the *ought* of the world and of what is in the world. The

self elects itself to be the governor of being in the sense of being the despot, however enlightened, of being. In this posture toward things there is possible a great satisfaction. It is the satisfaction of the determiner of being, ultimately of the creator. In so far as the determiner of the existent is a determiner, and thus retains his commitment to the ought that he sets up as an ought, the perception of its realization is a perception of the ought-to-be, i.e. the good, on the one hand and, on the other, of the fulfilled being of the self. The maker looks upon his creation and calls it good, and in this declaration he affirms the fulfillment of his own volition in existence, hence the realization of his being along this radius. The satisfaction brought about in fulfillment of volition, which is a form of realization of the aim to be, is thus the counterpart, equal in weight, to the satisfaction of the understanding in knowledge, and indeed this latter receives an added dimension in the knowledge of the goodness of existence that has thereby been brought about.

Before turning to the limitation of thing-truth and the passage to truth of spirit, it is necessary to take note of the truth of language that relates to this domain. Here there are in particular three kinds of language whose validity comes into view.

(1) Many forms of language belong to the sphere of thing-truth because they are themselves entities that owe their being as such to a function assigned to them, i.e. to a concept that the human will adopts as standard for the determination of their ought.

For instance, a religious official, having gone through the proper form of the marriage ceremony, concludes, "I pronounce you man and wife." In this pronouncement he is not merely reporting the fact of his pronouncing. There is,

of course, a statemental element in it; he is indeed reporting what he is doing, but this is only part of his meaning. His pronouncement is not just an autobiographical datum. He is executing a religious-legal act of permission, sanctification, and binding obligation upon the couple. In his pronouncement he announces a change in their religious, legal, and social status, subjecting them to a complex of rights and duties, being empowered to do so by his office and doing so in the context of the correct procedure of the ceremony as determined by the religious-legal code. The function of the pronouncement, then, is just to announce this change of status. *Qua* pronouncement it is the institutive announcement of the condition of marriage between the two persons united. This instituting or establishing in announcing is its function and mode of being. The meaning it has—which would be described by a detailed description of the subject, verb, object, etc., in their connections—is determined and articulated exactly in order to fulfill this assigned function of institutive announcement of the marriage condition.

By law the form is determined in which such an institutive announcement can be made validly. An exact ritual is prescribed which must be followed; and only if the pronouncement occurs in its proper place in the ritual is it valid. (It is not even statementally true as an autobiographical report if it is not rightly ordered in the ritual.) Thus the thing-truth of this pronouncement is defined in terms of the ought provided by the law.

In analogous fashion, the thing-truth and meaning of many other forms of language can be specified by observing them in their actual context and noting what is intended in and with them there—for instance, a judicial decision, an executive order, a legislative decree, a magic incantation, a declaration of war.

(2) The imperative mood includes a phase that strikingly illustrates the sphere of practical truth. In this, the phase of command, language articulates most directly the form of human existence as bare will. Command occurs in simplest form in the pure fiat, "Let it be the case that p," where p is a proposition, as in "Let it be the case that the door is closed." This is the form used in Genesis, I:

And God said, "Let there be light: and there was light,"

and so, too, with the firmament, the dry land, the fruits of the earth, the heavenly lights, the living creatures of sea and earth, and eventually man in the divine image.

A command is not true in the way in which a statement is true. It does not aim at uncovering an entity that *is*, as it is. Its analogous semantical relation to the entity it intends, e.g. the door that is to be closed or the light that is to be, is rather expressed by the term "satisfaction"—a fiat is satisfied if and only if what it commands is the case. A command aims at being satisfied. That God's fiat was satisfied is indicated in Genesis by the second part of the verse, "and there was light," i.e., p. My fiat, "Let the door be closed," is satisfied when and only when the door is closed, i.e., p.[6]

A command is satisfied, or what it commands is the case, if and only if the entity it intends is as the command commands it to be, i.e. if and only if the entity intended is true in the sense of thing-truth. Thus thing-truth is the foundation of the satisfaction of imperatives.

But contrasted with the satisfaction of a command is its

[6] For the beginnings of formalization of imperative theory in these terms see "On the Logic of Imperatives," by the author and J. C. C. McKinsey, *Philosophy of Science*, VI (1939), 446ff. Consult also Hare, *The Language of Morals*, Part I, "The Imperative Mood," for a general discussion of questions relating to imperatives in the context of ethics.

justification or rightfulness. Ought it to command what it does command? Is what it commands something that ought to be the case? Here the command itself, or equally, what it commands, becomes subject to a new form of thing-truth. This is symbolized by the term "ought," which is most characteristically employed in the usual form of the imperative, not "Do so-and-so," but "You ought to do so-and-so" or "So-and-so ought to be or ought to be done." The question of justification is further considered in the next section.

(3) There is the specific language of the assertion or denial of thing-truth and associated properties. Thus when we say, "This is a good action," i.e. this action is in some degree as it ought to be, we are in fact asserting the thing-truth of it. Similarly, we affirm thing-falsehood or invalidity of an action in calling it bad, i.e. declaring it to be in some degree as it ought not to be.

This kind of language—the language of the so-called value-judgment—is of special interest at the present juncture. As the language of criticism in general, it articulates the mode of human being that constitutes itself in the sphere of thing-truth. Namely, that special posture toward the existent which was described above, in which the self, locating itself at the center of being, launches forth its oughts upon the world, requiring the things that exist to conform themselves to its intentions regarding them—this attitude receives its articulation in the language of criticism, where criticism is understood in the broadest sense as the act of considering the relation of something to its ought.

The language of criticism puts on the form of statement, and thus appears to be a reporting of fact, like the statement discussed above under the head of truth of statement. But if, following the lead of Husserl and even of the empiristic verification theory, we look to the process of confirmation

to discover what is intended by the truth of this kind of language, we find ourselves conducted in a somewhat different direction than heretofore.

If I say, for example, "This park bench is still good," how is the truth of this critical statement to be understood? Am I merely attempting to report on the character of an entity as it is in itself, or is there something else involved? In part, I am reporting on the character of the entity itself. Suppose that our standard for park benches requires that at least four of the five slats be whole. Then, in saying that the park bench is still good, I am implying that it fulfills this requirement, i.e. that four of its five slats are whole. This latter is a statement that genuinely belongs to the sphere of understanding; it makes sense to raise the question of confirming it by looking to see whether the entity in question—like the picture hanging askew on the wall—is the selfsame with the entity as intended in the statement.

But there is a new element. This consists in the fact that we adopt the above standard *as* a standard, i.e. that we exercise our will in committing ourselves to the concept of four-out-of-five-wholeness as part of the requirement put on park benches. Without this commitment of will, the concept is merely theoretical and useful only for descriptive purposes; it is not yet a standard that can articulate an ought and thus function to state goodness or thing-truth. This act of adoption of a concept as a standard is something that we will and do. It is articulated in the critical sentence, even though it is not stated there explicitly as such. In saying that the park bench is still good, we do not explicitly state that we adopt a concept as standard, nor do we explicitly say what our standard is in particular, but both are presupposed as foundation for the sentence and both must be understood if we are to grasp the full meaning of the sentence.

Thus a critical sentence like "This park bench is still good" reports on the thing in the context of articulating our attitude toward it in the mode of the will to govern existence. To understand this sentence, we must grasp this attitude as such, of which the report on the thing is only a part; and indeed we must grasp the attitude in its subjectivity, not merely as object.

How, then, do we determine the truth of such a sentence; what is its mode of confirmation? Since it is only in part a report on the thing, the mode of confirmation only in part rests on the factual mode of confirmation characteristic for truth of statement as such. We cannot appeal only to the perception of the thing to determine its goodness (of this kind). We must also appeal to our own will. Do we accept, adopt, eventually acknowledge the given concept as a standard? This is not a question addressed to our understanding, asking for information about ourselves (that would be treating our attitude as mere object); it is addressed to will, asking it to decide. Hence our freedom, in the sense of our capacity to decide, adopt, acknowledge, has to come into play in the confirmation of a critical sentence. If man seeks to be governor of existence, he cannot avoid the responsibility of deciding its ought.

Critical language, in the broad sense intended here, is the language of practice and of the truth of practice (thing-truth). It is the analogue to statements in the sphere of understanding that report on the truth or falsehood of statements there.

We must turn at last to the limitation of thing-truth. Since thing-truth determines and is determined by the attitude of practical existence, we are at the same time concerned with the limitation of practical existence and, in

particular, of the thought that is native to that existence, namely, practical thought, which receives its articulation in the form of the language of command and, eventually, of criticism.

In practical life, as everywhere in life, man seeks to be. As in the sphere of understanding man *is* the aim at truth-of-statement (of understanding) or the intending of things in the mode of uncovering them, so in the sphere of the practical will or thing-truth he *is* the aim at the governance of things.

Here, too, as in the cognitive life, there is a *split* introduced, not just between the ought and the is of thing-truth in general, but between an ought and an is in the very being of man that constitutes him as practical in his relation to existence. For in practice, i.e. in so far as he exists as the aim at governance, man finds his own *actual* being subjected to an *ought*, namely, the ought-to-govern. And just as, in understanding, the aim at uncovering is generated from within, not imposed on man from without, so here in practical life the aim at governing issues spontaneously from man's own being. To be man, he must attempt to govern things in the world. But in this attempt to set himself up as governor, he already subjects his own self to an ought, the ought-to-govern, that belongs to him as human. The will to govern is intrinsic to man as a second radius of his being. It lives in every act he performs in the spirit of practice, and is an inescapable destiny.

The thinking that accompanies this mode of being, namely, practical or critical thinking, also lies within the field of tension between the ought-to-govern and the actual fact of capacity to will and to control. We must in particular consider here the question of the capacity to will. For, in the endeavor to be as he ought to be along this line, man

must be able to will the ought for all the things he is to deter-
mine as governor. The obligation to decide, to will, to be
for and against, is laid upon him in the intrinsic structure of
being governor. If his self takes it upon itself to set itself, as
will, at the center of being, it must be prepared to fulfill
the obligations of the office. How is it qualified to accom-
plish this task?

To ask this question is to raise the question of thing-truth
about the will itself, or in other words about man himself as
practical being. If man, in his own being, exists as the aim at
governance, if his own being finds itself in subjection to an
ought, the ought-to-govern, he nevertheless further finds
this very ought-to-govern subjected, in his own being, to an
ought. We see this latter ought entering at the very point
at which man exercises his practical being, for here the
question arises: Is man's ought, as practical being, what it
ought to be?

Let us see what this question comes to in concrete form.
It is a question which can be asked about any standard
whatsoever that we choose in making a practical critical
judgment or in imposing by our will an ought upon a
thing. Thus, for instance, suppose that, in deciding how I
ought to spend the afternoon, I make my enjoyment of it
the primary consideration. The afternoon then becomes for
me something that ought to contribute to my enjoyment.
Contribution to my enjoyment here becomes the standard
according to which I judge whether or not the afternoon is
good or is as it ought to be. So far as I can take it upon myself
to be the governor of what is, I have by my will imposed
this ought upon the afternoon. But the question can be
raised here: Ought I to have imposed this particular ought?
Was I right in making this decision? Put in that way, the
question concerns myself in my act as practical being. It can

also be put about the decision itself: Was that decision a right one? Was it as it ought to have been as a decision? Once man acts as practical being he lays himself open to this question: Am I right? Is my decision right? Moreover, if he tries to answer this question with a new decision, that decision is again subject to the question. For instance, suppose I say that the decision to spend the afternoon on enjoyment is right because, having worked hard for these last three weeks, I now require some recreation for the purpose of health, and the use of the afternoon for enjoyment just fits that need. Here I have made contribution to my health into the decisive point. My maxim becomes: Act so as to satisfy the requirements for health. The ought that is placed upon the afternoon is now that of being contributory, by way of enjoyment, to my health. But this decision to make my health the standard is itself subject to the practical question of the ought. Ought its contribution to my health be the standard that determines the ought for the afternoon? And if this new ought-question is answered by a new decision, as for instance that my welfare demands consideration of my health, then the new standard, of welfare, is again subject to the question of its ought.

In his search for a grounding of his practical action and life, man looks in the two directions already mentioned: the axiological or teleological and the deontological. That is, he looks either to goods and ends to be accomplished or to obligations, duties, and laws to be obeyed—or to some combination of the two. And in both directions he finds himself confronted by the limitation of practical existence as such.

For (1) about any ends or goods the practical question can always be raised again. Thus if I decide that my ultimate aim will be to endeavor always to realize by my action

the maximum good for the largest number (ideal utilitarianism), the question can be raised: Ought the maximum good for the largest number be the aim of my action? Ought I to try to bring about the maximum realization of what ought to be (the good) for the greatest number? This is a question which I address not merely to my understanding in its separateness, such as is concerned with truth of statement by itself, but to myself as a being involved in practical existence. For it is my will—i.e. myself as a practical being charged with the task of governance—that must receive determination. I am asking for a reason of the person, not merely a reason of the understanding.

(2) Similarly, if I come to the point at which a decision rests on some concept of duty, as e.g. the duty to fulfill my promises, the question can always be asked: But is this my duty? And if this is pushed back to another duty, more ultimate, such as the duty to realize my moral self or the duty to treat others as ends and not as mere means, the question reappears: But is this my duty? Ought I to try to realize myself or to treat others as ends?

This recurrence of the practical question can be avoided only by finding something that is able to break the chain of oughts. That which breaks the chain, furthermore, must do so not by violence—which can always be questioned anew—but by the power of persuasion. Thus, to say that the end of self-realization is ultimate, that I am necessitated by my nature to pursue it, and that therefore no further question can be raised about it, is to attempt to break the chain by violence. It may stop a person's head from questioning for a while, but it can never stop him as a person from needing a reply. For about my own self-realization I can always be confronted with the question: Ought I to make my own realization the standard for existence? Here I must decide

between self-realization and self-sacrifice, a decision which is not aided by hearing that self-realization is an ultimate end; and in the limit, I can question the whole realm of ends altogether.

Similarly, no appeal to the law, to moral obligation, to what others require of me, if it is merely an appeal to a final obligation, can break the chain of practical questioning. For about the alleged law, obligation, or requirement, the question, "Is it obligatory? Should I obey it?" can again be raised. This question is asked, not by understanding in its isolation, but by the person himself who has set himself up, as practical being, to govern existence.

The need for personal reasons indicates the presence of a limit of practical life. A reply that can be adequate to a question of ought about the practical life itself cannot be answered within the terms of practical life. Practical life cannot be its own foundation. The question of what justifies the will in its final decisions is not answerable by another decision of the will. We cannot claim, for example, that our decisions need never be wholesale and ultimate because our problems are always particular, in this context or that, and that the reasons for decision are always particular reasons drawn from the particular context. For any such particular reasons, however ultimate relatively to the particular context, are only further cases of decisions that can be challenged by a new ought. And, in the end, we can always question whether we ought to have allowed ourselves to be confronted by this or that problem at all.

Realization of the limitation of the practical dimension of existence is to be found, at least by implication, in the doctrine of moral intuitionism and is a reason why that doctrine has had a strong attraction for many thinkers. Intuitionism

has offered, as a means of breaking the chain of practical oughts, a special form of knowledge or understanding, a knowledge that is not of the merely ordinary sort of which the understanding in isolation is capable, but one that can give a reason to the person.

An example of this intuitionist point of view may be found in the classical article by H. A. Prichard, "Does Moral Philosophy Rest on a Mistake?" [7] The core of this article lies in its claim that man has a mode of knowledge that has the character of an *appreciation* of moral obligations. An appreciation of an obligation is able to answer the question of ought in such a way that it does not recur, just as the observation of a phenomenon can answer a question of fact so that it need not recur. Is the picture hanging askew on the wall? I look to see. If I see it hanging askew, I can answer the question. I do not need to ask it again. [8] So in matters of morals. There is, according to intuitionism, a kind of observation or perception which is competent to answer questions about the ought. When this is brought into play, the chain of ought-questioning is broken. It is broken by the incursion of a new form of knowing or understanding into the sphere of volition.

According to Prichard the appreciation of the rightness of an action is an activity of *moral* thinking, not of what he called *general* thinking. He believed that this moral thinking was a form of immediate apprehension, like mathematical

[7] *Mind*, Vol. 21, 1912. Reprinted in Wilfrid Sellars and John Hospers, *Readings in Ethical Theory* (New York, Appleton-Century-Crofts, Inc., 1952), pp. 149–62. Other intuitionists in recent thought, e.g. G. E. Moore, W. D. Ross, A. C. Ewing, adopted a similar viewpoint.

[8] Questions regarding the possibility of error or of improbability might arise, but they are in principle soluble by similar appeal to observation of factual states of affairs. Hence no fundamental question of principle arises.

apprehension, that it was an intuition of a moral obligation. Just as we realize that a three-sided figure *must* have three angles, so we realize that, X having done us an act of kindness, we *ought* to give him a present, or, the telling of a certain story being liable to hurt the feelings of someone present, we *ought not* to tell it. Moral thinking, or appreciating, is a realizing of this kind of moral fact.

It is worthwhile to separate two points made here by Prichard, the one maintaining the existence of a special kind of knowledge, namely moral appreciation, and the other comparing it to insight into mathematical necessity. Other intuitionists make different comparisons. Thus G. E. Moore maintained that our intuitive knowledge of good was like our perception of a quality such as color: as we see that an object is yellow, so we see that an occurrence or an act is good. Such assimilations of moral appreciation to knowledge of the more ordinary kinds, however, tend to be more misleading than helpful. The real question is whether something of the nature of moral appreciation—that is, a knowledge which could answer a question of ought—exists, and if so, what its character is as such. And the answer to the latter question is arrived at not by comparison but by observation.

The important point that must be recognized here is that practical life, as such, confesses its own limitation. Its limitation is that its central principle, the practical will (man as aim to govern existence), is not self-limited. That is, the limitation of practical life consists precisely in its inherent lack of limitation. The practical will is infinite in the literal sense of that term. It does not have the capacity to set its own boundary or end. It is intrinsically indeterminate. Something else must give it a limit and provide it with measure. Or we may put this in other terms. Practical free-

dom, the freedom to decide upon the standards that constitute thing-truth, is not intrinsically limited, i.e. limited *in itself*. It is the freedom to say yes or no, to decide for or against, and left to itself it is the freedom of arbitrary choice, ultimately of mere caprice. What could remove arbitrariness from freedom would be a knowledge that is competent to tell it what its bounds should be, thus providing it with a truth that is appropriate to it as freedom, as will. Only when such knowledge intervenes can the will set limits *for itself*. It is the assertion of the existence of such truth that, apart from any comparison of our insight into it with intuitions of qualitative fact or of relational necessity, gives to moral intuitionism its appeal as a philosophical position.

The question facing us is, therefore: Is there a truth of this sort? Is there a form of truth and knowledge that would make the person competent to break the infinitude of the merely practical will and give measure to it? Is there a form of truth that is competent to guide man out of the anchorless depth of practical freedom into a sphere in which his existence could become rounded into completeness? Is there a form of insight that can tell man what his ought, as a practical being, should be?

With this question we reach finally a new level of human existence. For here we are asking about the possibility of truth that encompasses the nature of the two previous forms of truth within itself. But this means that we are asking about the possibility of a mode of human existence that encompasses the two previous forms of existence within itself. Man exists as the aim to uncover the existent; he exists as the aim to govern the existent. Now we ask whether and how it is possible for man to exist in such a way as to comprehend both uncovering and governing.

both understanding and will, in the unity of a new truth. If such a possibility could be realized, then it would resolve a problem that is constitutive of man's existence itself. As the aim to uncover the existent, man himself exists as an ought, the ought of knowing. Here already he has his own possibility of thing-truth as knower. He subjects himself to his own governance in this way, for he imposes an ought upon himself: he ought to know. But the obligation to know, in the mode of truth of statement, is itself subject to the inclusive aim at governance that man is as practical being. It is subsumed under the practical aim. As practical being, or as aim at governance of the existent, however, man exists as a problem. For, as we have just seen, he exists always subject to the question of the ought. In so far as he is *merely* a practical being, engaged *merely* in the sphere of thing-truth, he exists as an unanswered question, and is capable of existing only by arbitrary acts of will, by caprice, hence blindly. Caught up in this sphere, as will in its intrinsic infinitude, he exists in the form of stabs of will in this, that, and the other direction. But these stabs always end in a question mark, the mark that follows the question, "But ought this be so?"

A genuine answer to this being-in-question of man, coming from a form of knowledge that would make man competent to give finitude and measure to his practical will, would enable man to rise to a new level of existence. This new level we call the level of spirit, and the knowledge and truth that belong to it the knowledge and truth of spirit.

[7] *Truth of Spirit*

The question that has led us to the present level of inquiry is whether there is a kind of truth that enables us to break the chain of our own unlimited positing of the ought, i.e. a kind of truth by virtue of which the person can give measure to his intrinsically unlimited will. Such a truth would have to fulfill certain conditions. We can see already that it would be a truth in the sense of the third interpretation of the traditional formula for truth. According to that interpretation, truth is the mutual adequation of intellect and thing. That is, not only does the intellect conform itself to the thing, but also the thing conforms itself to the intellect; and conversely, not only does the thing conform itself to the intellect, but also the intellect conforms itself to the thing. How can this be? And what can such truth be in particular?

In speaking of the mutual adequation of intellect and thing, the formula of truth requires a two-way conformity. There must be in this truth (1) something of the nature of an uncovering or truth of understanding, like the truth of statement, and (2) something of the nature of a governance, i.e. something like a thing-truth, practical truth, or truth of will. And (3) these cannot be unrelated to each other. If intellect and thing are mutually adequated, then the intellect, in uncovering the thing, must at the same time

be governing the thing; and again, in governing the thing the intellect must at the same time be uncovering the thing. But this language, borrowed from the two previous concepts of truth, is only provisional; for it would be just as true to say that it is the thing that uncovers the intellect and the thing that governs the intellect. The concept that is identical in intention with the thing, in the act of uncovering the thing, must at the same time, in the act of governing, be the concept that the thing identically realizes in being as it ought to be.

This can only happen if either (1) the concept belongs to the thing itself and I (the intellect) identify my concept with the thing's concept, or (2) the concept belongs to me (the intellect) and the thing identifies its concept with mine, or (3) both.

Such are the conditions that have to be satisfied for truth in the third sense to be possible. Accordingly, in order to see whether it is possible and, if so, what it is like, it is necessary to see whether and how these conditions can be satisfied. In the present study, the consideration of this problem is restricted to the aesthetic dimension of human existence. The possibility and manner of fulfilling the conditions of this third kind of truth beyond the limits of the aesthetic form no part of its limited aim. At the same time, however, it will be necessary to take note of these very limits of the aesthetic dimension and therefore of the need to extend and solve the problem beyond those limits.

One further abstract deduction is in order before proceeding to a more concrete presentation of the nature and possibility of the third kind of truth. Suppose that the first of the above conditions is fulfilled, so that the thing's concept, which is for it the ought that is to be realized, is

identified by me (intellect) as the ought willed by me. This means that, so to speak, I will what the thing wills; I yield my will to the thing's will; I say to the thing, "Not my will, but thine." What happens then to the phenomena of governance and uncovering?

Instead of imposing my will on the thing, I behave toward it in such a way that the thing also governs me. It does not govern me, however, by a violent imposition of its will upon me, as though I were a mere thing or an instrument like the park bench. Rather, it extorts from me the yielding—the identifying of my ought with its ought. It is cogent in regard to me; it persuades me by a power that it has to persuade one who has understanding and will; and on my part, as persuaded, I acknowledge it in its position of cogent governance. This acknowledgment is not that of the mere understanding taken in its isolation. It is not mere agreement with a truth of statement regarding the factual character of a mere thing, and again, it is not the acknowledgment of the mere will when confronted with a stronger will. It is personal. I, who am more than a mere thing, and who have an understanding and a will—I acknowledge the cogency of the thing; and cogency is more than power—it is a rightful power. Understanding what I am doing, I yield my will to the thing in an acquiescence that is given to it as due to it.

On the other hand, I could not yield my will to the thing, identifying my concept with its concept (my ought with its ought), unless at the same time its concept were at root identical with my own. Its concept must be such as can persuade me to take it as my own. It is, after all, I, this self, and not another, who must be persuaded, and I can be persuaded only if the persuasion aims at me, this I.

Governance by violence thus becomes transformed into governance by consent. Between me and the thing there is no longer exercised the violence that is alone open to will in its isolation or lower existence. It is not that power has been lost; where power is lost, spirit is lost too. On the contrary, the cogency with which I am persuaded is indeed a power; but it is a power that exists now on a different level than hitherto. It is no longer mere power of will backed up by force. It is the power of spirit—of will and understanding in their mutuality of truth—which can be exercised only on a person by the path of persuasion.

To bring this point out more distinctly for ourselves, it is necessary to fix in mind the ideas of person and spirit.

A person is, first, an ego, self, or subjectivity. But subjectivity alone is not enough to determine personality. Subjectivity already occurs in the first and second forms of truth. The person exists as such only in a context in which he recognizes another also as a person. Under such a condition he becomes able to say "I" in distinguishing himself from a "thou," and to speak to the other and be spoken to by the other as a "thou," recognizing that each has his own selfhood, character, rights, duties, weal, woe, falsehood, and truth.

Below this level he exists only as understanding and will, uncovering and governing, recognizing and imposing truth —i.e. acknowledging only thing-facts and treating things only as mere things and as means; he exists in a state whose ultimate ground of relationship is that of mutual violence with regard to everything, including himself. Even in looking at truth of statement we quite properly speak of the *brute* facts. Such a relationship is that between an I and an it; and in conformity with the truncation of the other into an

it, the I itself is truncated into the mere I of isolated under-
standing and will, or as we may say, the unspiritual self, the
merely natural self.

In recognizing and acknowledging another also as a
person, a transformation occurs in my understanding and
will. I perceive the other as also a will and understanding
and I become able to acknowledge the will of the other as
worthy of consideration as such. I am able to move thereby
from the state grounded on violence to the state grounded on
persuasion. In other words I am able to shift into a mode of
being in which my comportment toward the other becomes
a being with the other in a mutuality of the nature of the
third kind of truth.

At this new level I am a subjectivity whose existence as
an aim or project is a disposition toward validity or truth of
the third kind. Man is an arrow pointed upward. Because in
this third kind of truth the subjectivity brings its under-
standing and will (hence the first two kinds of truth)
together into a living unity, and thereby becomes a personal
being, i.e. a spiritual being, we are permitted to call the
third kind of truth spiritual truth, and consequently con-
ceive of a *person* as an entity whose being is *subjectivity in
quest of spiritual truth or validity*.

Equally, we may think of spirit as that level of being at
which the third kind of truth, spiritual truth, becomes
possible and accessible, so that to be a spiritual being is to be
one that inhabits that realm and exists as a will to the third
kind of truth. That is, we may think of *spirit* also as *subjec-
tivity in quest of the third kind of truth*. To be a person is
thus to exist as a spiritual subjectivity: *a person is a self that
exists in the sphere determined by the third kind of truth
(and falsehood), namely, spiritual truth*.

Personality, spirit, and spiritual truth are defined in rela-

tion to one another. This is not a logical fallacy; it illustrates only a familiar kind of conceptual interconnection which occurs wherever there is an attempt to describe a unitary relational whole. The more insight into the whole grows, the more distinctly and determinately do the constituent terms and relations become articulated.

We may now return to the concept of the third kind of truth, spiritual truth. In this preparatory abstract deduction of certain of its characteristics we have already seen what happens to governance, i.e. will. In the sphere of personal existence, governance by violence gives way to governance by consent, so that the relation of I to it is transformed into that of I to thou. In the same process of transformation, however, understanding, too, changes its character. What it uncovers is no longer a merely factual thing toward which it can be in the simple mode of ordinary statement truth, or a mere means toward which it can be in the mode of practical truth. It uncovers the other as being or pertaining to a person, a thou that it acknowledges as such and to whose cogency as such it opens—uncovers—itself. It thus uncovers personality in its cogency as personality. What it uncovers matters to it, no longer as a mere thing to be governed, but as a being in relation to which its own spiritual truth becomes possible. With the uncovering of the other as personal being, through personal understanding, the realm of spiritual truth is for the first time opened up and made accessible to the subjectivity in quest of this truth, so that this subjectivity is itself uncovered as person in the process.

The understanding that functions in spirit is an understanding that attempts to uncover the spiritual being of the other and therewith the sphere of spiritual truth. It thus works with the transformed will. On the other hand, that

will, as it functions in spirit, does so only in virtue of the vision of the other as it is uncovered as person or spiritual being, dwelling within the world of spiritual truth (and falsehood). Thus, by reason of the nature of spirit and personality, the understanding and the will of a self (an ego or subjectivity) are able to cooperate with each other and so be united into the spiritual character of a person; and the self is thereby enabled to enter into the sphere of the third kind of truth (and falsehood).

It will be evident from these abstractly deduced characteristics of truth of spirit that the realm in which this truth is genuinely realized is a realm in which persons come into relationship with each other as persons. This is a sphere of falsehood as well as truth. In it for the first time there is opened up the possibility of spiritual evil and sin as well as goodness and holiness. In making the truth of spirit accessible it also of necessity must open up the path toward error. But both truth and falsehood occur here in their most characteristic modes as a comportment toward persons, which is a being with them. Consequently the field in which spiritual truth is most authentically at home is that of personal interrelationships, namely the ethical and, eventually and ultimately, the religious.

The theory of truth therefore finds its last chapters devoted to the philosophy of ethics and religion. But before it arrives at this point, it must go through the theory of beauty, sublimity, and art. In these there occurs the first form in which spiritual truth exhibits itself, namely the form of its immediacy or the form of imaginative presentation.

The most elaborate version of the nature of truth in the third sense, truth of spirit, is to be found in the philosophy

of Hegel. Indeed it would not be too extreme to say that this concept of truth was the seminal idea of Hegel's systematic thinking, by which he attempted to make all the phenomena he dealt with intelligible in themselves.

The present study is far from being a repetition of the Hegelian view. It could not be that, just because of those aspects of Hegelian thought that it finds unacceptable. These include: (1) the logicizing of truth; (2) the eternalizing of its process and content; and (3) the transformation of it into a gigantic (not to say monstrous) monistic metaphysical process of the evolution of a single, total divine self.

But behind Hegel's construal of truth in a rationalized, eternalized, monistic form as the essence and process of a single totality of being, there lies his recognition of the third kind of truth as such. While it came out of the Kantian tradition, and was already developed in its essential character by Schelling, although not under the name of truth, we owe its clarification as a concept primarily to Hegel. It is the general concept of truth, as such, regardless of the uses to which Hegel put it, that is of special interest to us in this place, and all the more so in that one of Hegel's clearest accounts of truth occurs in his explanation of the concept of beauty in general.[1] This is not accidental, for, on his view, beauty, and especially the beauty of art, is the first or immediate form of absolute spirit or realization of the Idea, which latter is the actuality of truth itself.

Central to all three concepts of truth is the identity between what is intended in the concept and what *is* in the thing. In statement-truth our concept directs itself toward intentional unity with the thing as it is in itself. In thing-

[1] *Sämtliche Werke*, 12, 153–66 (X₁, 137–50). In Osmaston's translation, *The Philosophy of Fine Art*, 1, 147–59.

truth, the thing is intended by our concept to be as that concept requires it to be. Now, in the third sense of truth, there is a new identity. In both the other forms stress was laid on the fact that the concept was *our* concept. In the third form it must equally—and indeed first of all—be the *thing's* concept. (Hence the thing itself must be intentionalistic.) For in this form of truth the thing is to be uncovered as being what it ought to be in and of itself, which can be the case only if the concept is the thing's own; and it is through this intrinsic character of the thing's own truth that *our* concept is led to identify itself with the thing's, or that we are brought to experience the truth of the thing as evidence of our thought and realization of our will.

The third kind of truth, therefore, is in the first place an *objective* occurrence of truth, on which the *subjective* realization of thought and will depend secondarily. This is pointed out by Hegel in his estimation of the relation of truth to existence or reality.

A thing that appears is not true by the fact that it has an inner or an outer existence, and is in general a reality, but only by the fact that this reality corresponds to the concept. Only then does the existent thing have actuality and truth. And, indeed, truth not in the *subjective* sense, that an existent shows itself to be in conformity with *my* representations, but in the *objective* sense, that the ego or an external object, action, event, state, realizes in its actuality the concept itself. If this identity does not come about, then the existent thing is merely an appearance.[2]

[2] *Sämtliche Werke*, 12, 159–60. In connection with this distinction between actuality (truth) and appearance, it should be pointed out that Hegel's concept of truth and actuality is sometimes perversely interpreted in order to criticize him exactly where he does not deserve it. The usual point of attack is the statement in the preface to the *Philosophy of Law* that "What is reasonable is actual; and, what is actual is reasonable." This is misleadingly translated as "What is reasonable is real; and, what is real is reasonable." Opponents immediately seize on this to argue that Hegel thereby wanted to justify

We can hardly overemphasize the significance of this point. Unless a thing itself, as the thing that it *is*, is true, nothing like the third kind of truth, truth of spirit, is possible. For in this truth we are to find in the thing itself that which can break the chain of the merely subjective repetition of the ought in the second kind of truth; and what can do this can only be, in the thing itself, its own truth, which compels our assent by its power of persuasion, its spiritual cogency.

The definition of truth requires that there must be an identity between the thing's intention and its realized existence. This identity, moreover, must run in both directions: intention must conform to realized existence and realized

everything, all evil, all brute force, all stupidity, and the domination of existence by the Prussian mentality. But Hegel never meant by "actuality" (*Wirklichkeit*) the flat, bare existence (= appearance) that his opponents took him to mean. Actuality is existence that has been mediated; it is existence in its truth, existence that attains the status of self-realization and, eventually, of full freedom. Hence Hegel's definition of it as the unity, become immediate, of essence with existence, or of inward with outward. Only a vulgar conception of actuality would mistake it for bare existence, bare appearance, what is palpable and directly obvious to the senses. See *The Logic of Hegel*, pp. 257, 259. And hence, too, Hegel's explanation: ". . . existence is in part mere appearance, and only in part actuality. In common life, any freak of fancy, any error, evil and everything of the nature of evil, as well as every degenerate and transitory existence whatever, gets in a casual way the name of actuality." But, as he says, even experience has sense enough to distinguish "the mere appearance, which is transient and meaningless, from what in itself really deserves the name of actuality," namely, "that core of truth which, originally produced and producing itself within the precincts of the mental life, has become the *world*, the inward and outward world, of consciousness." *The Logic of Hegel*, pp. 9–10. Understanding "actuality" in this way, the propositions in the *Philosophy of Law* are so far from being false that they are, indeed, logically necessary. And the problem that has genuine significance then becomes: Where, if anywhere in existence, can actuality be found? That is the sort of question with which our present study deals. Its thesis is that it can be found at one of the highest levels of its possibility in art, which is one ultimate form of the actuality—or truth—of spiritual life.

existence to intention. Therefore, in order that a thing should be objectively true, it must possess for itself the intention or concept which is in conformity with the thing's realized existence and it must realize this intention in its existence. The thing must be one whose being, as a thing, is a realization of its *own* intention and whose *own* intention uncovers itself eventually as what it is. A true thing must be a self-attaining nisus toward a truth that is the truth of its own being. In other words, it must be a thing whose concept, or ought, is the concept of truth itself in the particular form it takes in that particular entity.

This is the sense of the definition of truth that Hegel repeats in every context and with regard to every aspect of existence: truth is the concrete unity of concept and objectivity. The concept shows its power of being in truth. The very concept of the concept, as we may say, is to preserve unity with itself in its other. In this way, it is really and truly a totality, to which Hegel gives the name of "Idea." The Idea is at once the ideal unity and subjectivity of the concept and the real objectification of that unity, in which the concept rediscovers itself. It is thus whole on both sides, subjective and objective, and is the whole of the two. Hence he can write:

In philosophy, truth is the correspondence of the concept with reality. For example, a body is the reality, the soul is the concept, but soul and body ought to be adequate to each other. A dead man is therefore still an existence, but no longer a true one; it is a conceptless existence, and it is for this reason that the dead body decays. The truthful will is such that what it wills, its content, is identical with it, so that freedom wills freedom.[3]

[3] *Grundlinien der Philosophie des Rechts*, Vol. 7 of the *Sämtliche Werke*, 1952, 21. There are translations under the title *Hegel's Philosophy of Right* by Knox, and by S. W. Dyde (London, Bell, 1896).

And again, in the explanatory notes that Hegel's students derived from his lectures on logic, he clarifies the concept:

Truth in the deeper sense consists in the identity between objectivity and the concept. It is in this deeper sense that we speak of a true state, or of a true work of art. These objects are true, if they are as they ought to be, *i.e.* if their reality corresponds with their concept. When thus viewed, to be untrue means much the same as to be bad. A bad man is an untrue man, a man who does not behave as his concept or his vocation requires.[4]

In its objective phase, therefore, truth must be understood as constituted by an essential and immanently evolved purposiveness. The ought, though it includes the moral ought, is not merely a moral ought. The bad man is not bad in a moral sense alone (although he is that, too)—he is the unliving, inactual man, the man whose spirit is defective in some way, so that it is neither fully adequate as spirit nor does it adequately realize itself in the actuality of his life. Thus, if a man fails to reach aesthetic actuality, this already stamps him as to that extent defective, though it is an aesthetic rather than a specifically moral failing.

In its objective phase, again, truth is eventually the actuality of freedom, or being that is fully itself: the formation of the self's existence in conformity with the self's own intention, which goes hand in hand with the very attainment of a self-intention to be thus realized. The true thing is in actuality the realizing of the possibility of its own being; it is the projecting as well as the carrying out of the project that consists precisely in itself. It is the projecting-realizing of a self, which is the same as to say it is actual freedom. To be true, objectively, is to be an entity whose being consists in

[4] *The Logic of Hegel*, Wallace's translation, p. 354. I have taken the liberty of substituting "concept" for Wallace's "notion" as translating *Begriff*.

projecting its self-realization and in realizing this self-projection. The carrying out of this projecting-realizing *is* the process of arriving at an adequation of concept and objectivity, or truth. This is why we can speak of the third kind of truth not only as truth of spirit but also, in its objective phase, as truth of being, and can understand how truth of being is fully arrived at only when being reaches the level of spirit.

In this process there is always a unique, individual element, a unique coloration of the projecting-realizing, namely, what we intend to name by "its" and "self." Every "itself" is ineffably inimitable and indispensable. It is a particular understanding will that is realized in its own being and a willing understanding that knows its realization in its own being. In this sense it is spiritual and its concept is its own essential being as nisus toward the truth of spirit. How this is possible must be illustrated in the aesthetic domain.

In the *subjective* sense of truth, i.e. in relation to *me* as understanding and will, the objectively true thing must appear both in the form of evidence (uncovering) and as fulfillment (governance). In its appearance to us it must show itself as being what we ourselves intend as understanding of truth, and it must show itself as being what we ourselves intend as willing of truth.

How this is possible must also be illustrated in the aesthetic domain.

Our illustration will be drawn first from the aesthetics of nature rather than of art. In art the truth of spirit is more fully realized than in nature; but just because of this fuller realization, it is more involved. Nature has the advantage of lesser complexity here.

And in the aesthetics of nature we must turn first and

above all to the phenomenon of beauty. In modern art the representation of beauty is almost entirely out of order. This artistic irrelevance of natural beauty is connected with the specific directions in which contemporary artists must conduct their quest for truth. But if natural beauty were on that account to be neglected by aesthetics, it would result in irreparable damage to our understanding of man. For beauty in nature is the most direct form in which the aesthetic fact, namely, truth of spirit in the form of immediacy, comes to our attention. Man never has lost, and never will lose, his sense of natural beauty, no matter what his artistic evaluation of it may happen to be. The phenomenon of natural beauty is coessential with man's nature, a permanent possibility of human experience. It points to the classical center of his being, from which there is the possibility of departure on all sides, and to which he must ever look as to a pole of existence.

Although the beauties of nature are infinitely manifold—from the inorganic beauty of the snowflake, the sunset, the forest lake, through the varied beauties of plants and animals, to that of human beings, their institutions, thoughts, and deeds—there is nevertheless an analogical, if not a specific, unity that brings them all under the same heading. Wherever we experience beauty, we experience a union of power and measure, a dynamic or living harmony. Both elements are needed. Power, force, or vitality without measure is exciting but not beautiful. Measure without power is correct, but dead and unbeautiful. Only the two together—where, in particular, the power is the substantial factor, the ground of the phenomenon as its drive or impulse, and the measure is the formal factor, the state or condition into which the substantial ground enters—are sufficient to constitute the phenomenon of beauty itself.

If we think of the most obvious examples of natural beauty, we shall see that in every case their beauty is the union in them—as they appear to us—of power and measure, measured power. We take three instances: the snow crystal, the color of gold, the horse.

(1) The form of the snowflake stands on a thin peak of beauty. Its very regularity tends to be stiff, so that the impression of forces that are persuaded to submit themselves to the measure of an architectonic idea tends to be weakened. When this impression is altogether absent, the crystal appears simply like a geometrical construction, a neutral and anaesthetic diagram, satisfactory to the isolated understanding in its quest for law and order, but repugnant to taste. Slight irregularities or variations are necessary in order to suggest that there are forces at work which, if not brought under control, would go off aimlessly on their own account. Control and its regularity can be too great, however, even when the impression of force is retained; and then there results the effect of a strict constraint upon the force, and instead of measure we get a violence practiced on the immanent life, which is again repugnant to taste. On the other side, irregularity can also be excessive, with the result that the forces fly out of control and measure breaks down into incoherence. These are only some of the possible departures that surround the beauty of the snowflake's form on all sides; but at their center there is a peak, a region of forms where the contrasts of the one and many, simple and complex, regular and irregular, great and small, straight and curved, etc., are so determined that the single total impression of dynamic measure is produced; and we then experience the snowflake's form as beautiful.

(2) The shining sun has always been felt to be beautiful; and in general, golden light, the gleaming splendor of the

precious metal, has always been a type of the beautiful. Every color has its own charm, but warm gold, as a color, stands at the aesthetic center—the color of beauty itself, as one might say. Now it is a simple error, based on a failure of observation, to think of gold, or any other color, as a simple quality. As a quality it is a unity with a multitude of dimensions—hue, value, saturation, location, consistency, purity, tone, dryness, transparency, physiognomy, etc. —and in taking on its determinacy (form) among these dimensions, it does so as a pulsing energy and not as a dead state.

Color lives in its light. Not only does it give to its object the effect of being something; it itself appears as an energy of emergence into being, and especially in its character as light. Light breaks through the oppressive weight and smothering density of darkness, penetrates, and fills it, uncovering its mysteries; on the other hand, it pitilessly and cruelly exposes secrets that should remain hidden; it excites and it stuns, it arouses and it transfixes.

Everything depends on the particular selection or ratio of the specific dimensions of the color. A low saturation grays it, weakens its dynamic character, makes it die away; a low value reduces it to a whisper; greens on the one side and purples on the other move away, toward the darker shades of being, from the brightness and splendor of yellow. All in all, gold is the color that realizes best of all, simply *as* color, the union of energy and measure that impresses us as beauty. Warm, brilliant, beneficent, but not shrill, harsh, or destructive, it shines upon us and around us, like Apollo and his sun, enlightening the world, giving fruitfulness, hope, and joy, the very promise and image of fulfillment. A too great value or intensity makes it terrifyingly blinding, a too small value weak and insipid; too little yellow pales it,

too much makes it tawdry. There is a measure to gold, and within the range of this measure, gold reaches a zenith of beauty.

(3) Among animals one of the most beautiful is the horse, in particular the Arabian, the thoroughbred, the palomino, and the American saddle horse. When we think of these horses we think above all of life-energy manifested in form and movement. At the foundation of the horse's beauty is this impression of abundant energy, of the power of life compacted within its sculptured, flashing body of tensed and quivering flesh. It is an impression, first of all, of energy, vitality, and vigor of muscle, especially of muscle in its tension, tonicity, elasticity, and spring: the horse is muscle in tension and expansion; a tensed, springing muscle.

But this muscle, and with it the abundant vitality that dwells in it, has taken on a form or architectonic frame that brings it to measure. Measure does here what it does everywhere. It brings out the vitality, not allowing it to dissipate and not throttling it into weakness; it brings it under control, giving it meaningful order and direction, not allowing it to undo itself in the aimless explosive violence of brute power. Raised up and thrust forward, supported on its noble neck in whose mane life gracefully waves as in a semicadential phrase, the horse's head terminates the body by its inclination, tapering half toward the ground, half ahead, with its eyes straightforwardly intent on the course to be run. Its flaring nostrils quiver with the breath and the movement of life. Its ears, small, upright, intelligent, direct their auditory sense forward again, toward the goal. Extending behind is the rhythmic trunk, with its climaxes in the shoulders and haunches, from which there descend the finely contoured legs, narrowing gradually, though with

rhythmically varied changes, to their termination, brought to a close at the turn of the fetlock joint into the hoof, the very incarnation of life dancing on its tiptoes. And then, finally, the ending at the back, in the long, flowing tail that repeats the meaning of rest and motion, extended horizontally in movement and falling softly at rest.

If we wish to see what defective form is in the animal, we need only look at animals that depart from the horse—the giraffe, for instance, in whom the neck and limbs are too extended and the body and tail too small, so that the idea of movement becomes ludicrous in it, or the elephant on the other side, in whom the idea of movement becomes ludicrous on account of the too great bulk and the lack of articulation of its members. We can see and understand how the forms of giraffe and elephant are adapted to the particular needs and habits of their life-world. But adaptation to a given purpose, although it impresses us as beneficial and reasonable, is not beauty. The measure that belongs to beauty is not drawn from the standard of utility (which falls under the second kind of truth). It is drawn from the standard of being and of the truth that belongs to being.

Vitality, energy, power is the ground of being; measured form is the condition or the determinate state in which the dynamic ground of being becomes a being; the entity formed is the being that results as an actuality. The horse strikes us as a being that is actualized, that has come to its own truth. In it—as in the color of gold or in the snowflake —we perceive the actuality of being: energy, dynamism, life emerging into the open sphere of actual existence. It is able to emerge *as* being, exactly by the measure of the form. The measure gives it opportunity to take shape, i.e. emerge, without obstructing it by a too unrelenting stricture or dis-

sipating it by one too weak, without smothering it by a too great burden of corporeity or thinning it out by one too slight.

Life disports itself in the horse, living itself out there in all the naïve glory of animal being. That, at any rate, is our impression of the horse. And that is one reason why, in addition to the long friendship between us and despite the intervention of a thousand technological marvels of speed and transportation, we love the horse, finding it beautiful.

What is important in the phenomenon of beauty is the impression we have, not the facts underlying the impression. Beauty is an aesthetic phenomenon, having to do with perception and the appearances of things, not with their factual reality. We know, of course, that the giraffe and the elephant are just as alive as the horse, that indeed they are better fitted for life than the kind of horse man has bred to live with him in use, sport, and companionship. But their beauty or ugliness, like our own physical beauty and ugliness, is not a question of what they are; it is a question of what they look like. In beauty, therefore, we seem to be getting away from truth.

The truth in beauty lies, however, in the appearance. Beauty is the appearance of truth—not of any truth at random, but of truth of *being*. It is because beauty is the appearance of this essential kind of truth that beauty always has been, is now, and always will be, the central aesthetic phenomenon—even when, as in the present era, we find it in such unlikely places that it appears to be absent.

Truth of being in the objective sense comes about when a being projects and realizes its own being. When we think of power or energy as related to truth of being, we think of it as directing itself. That is, we think of it as endowed with

the characteristics of life, and especially as life in the form of will, life-will, the foundation or ground of freedom. It is, of course, anthropomorphism to attribute life and its will to power or energy. To see the snowflake as a manifestation of an indwelling energy that presses, yes even yearns, toward definite existence—i.e. toward existence in the form of a somewhat, a thing or entity—is indeed to have one's perception filled with an anthropomorphic content. Nevertheless when we see the snowflake as beautiful this is what we experience. To go further and actually identify energy with life-will would be to affirm a voluntaristic metaphysics, like Schelling, Schopenhauer, and Nietzsche. There is nothing but a deep desire to rediscover ourselves in the world that could make such postulation plausible. For the understanding of beauty and, eventually, of truth of being, it is useless.

For the projection and self-realization of living being, we may imagine the following model. It is a model not of or for the technical scientific intellect but of and for the common human imagination. The ground is power or energy of the nature of life-will. This is energy that is impulse, drive, instinct. It presses. It is will-to-be. It does not yet have aim, however, even though it presses; it blindly aspires. At the same time it shrinks; it is tender, subject to pain, thwarting, anxiety. It is desire without an object, the will-to-be without knowing what and how to be. Desire needs an object and guidance, just in order to become actual as desire, as being. In order to be, it must project its own being as end, thereby giving itself a purpose or reason of being, hence an aim or object of aspiration. It thus projects the concept of its own being, itself. In this way it limits itself, bringing itself from the indefinite or in-finite state of pure indeterminate pressure and shrinking to a finite, limited state in which it can undertake the enterprise of being something. It

has thus become the will-to-be-this-being. So in the animal world we may imagine the life-will limiting itself to being a horse, a giraffe, an elephant.

That there may be no such thing as this life-will is beside the point at present, since we are describing a model for common imagination, not an explanatory scheme for science or metaphysics. If it looks like a myth, that is all to the good, for the experience of beauty in nature is native to the mythological form of the human consciousness rather than to the scientific or overtly philosophical.

In addition to the concept of its own being, the will-to-be needs also a medium for its realization. A medium is an element which, both resistant and plastic, provides the matter and the conditions under which a purpose is realizable. It must be resistant, hence hard to manage, in order that it should be capable of retaining form; it must be plastic, hence reasonably manageable, in order that it should be capable of receiving form. The capacity to receive and retain form is made possible by the existence of a structure of causality, i.e. conditions necessary and sufficient, on the basis of which the purpose can define itself concretely in terms of the form to be realized. Thus in the case of animals, the medium is body, together with the psychical powers necessary to animal life, such as sensitivity, perception, memory, habit, anticipation, thinking, and the like. Physical, psychophysical, and psychological causality here provide the groundwork of conditions that make it possible for a dynamic equilibrium such as the determinate form of being of horse, giraffe, elephant to be arrived at and maintained.

Given such a medium, with its causal structure of conditions, we have all that is needed to define regions of realization of being and regions of falling off from realization. This holds for the realization of any purpose at all, and *a*

fortiori for the realization of the will-to-be a particular being. For instance, if I want to reduce for health's sake, there is a certain range of weight most to be desired. But my weight depends on intake, storage, and output of food-energy. If I eat too much or exercise too little, I store up too much energy; if I eat too little or exercise too much, I store up too little energy; in between there is the mean, the measure of the conditions of eating and exercising, which makes possible the optimal value of weight. This mean is relative to me and the problem of my weight. There is a range of combinations of diet and exercise which would be suitable to the weight aimed at, i.e. just *right* for the desired weight, for me; it would be different for someone else.

So it is with horse, giraffe, and elephant. We may imagine life-will as projecting in each of them a different mode of being as its concept, its Platonic or Hegelian Idea—to be a horse, giraffe, or elephant—and of being confronted by the problem of defining and carrying out the realization of this concept in the medium and under the conditions of material-psychological existence.[5] Each of these particular animal ideals calls for a different combination of the conditions of anatomy and physiology that would be just right for its realization. Within each of the species we are thus able to imagine a type that would be ideal, such that departures from it could range from slight defect to monstrosity. (That your image and my image of the ideal type might differ is not at present to the point. In any case you and I are both imagining some such ideal type.)

So far, however, we have not reached beauty. For while in a relative sense an ideal elephant or giraffe might be

[5] Fichte imagined the life-will, i.e. the ego, as giving rise to the medium itself, i.e. the world, as part of the total project of the self-attaining of being.

called beautiful, and while an ideal elephant is as ideal and perfect an elephant as an ideal horse is a horse, the horse is beautiful in a manner superior to that of the elephant or giraffe, and indeed, it is beautiful in a more categorical, less relative, sense. This is a matter of the phenomenal character of beauty, and instead of trying out of sympathy to defend elephants and giraffes we should try to understand why the horse is beautiful in a way in which the others can never be.

It is because the horse *appears* to be closer to the realization of life-will itself, *as* life-will, than the others. For, as we have seen above, the horse's visual appearance makes it *look* like life-will—energy, vitality, mobility—come to perfect realization, whereas the elephant and the giraffe, though equally and perhaps more vital in themselves, look less perfectly alive. The horse is like gold, the elephant like iron, the giraffe like tin. Thus in the horse there appears a certain rightness or measure of form—just the right size, shape, distribution, proportion, color, physiognomy. This rightness is relative not merely to some particular form of life, but to life itself. The particular form of the horse is one of a small number of species among the many animal species in which the meaning of life-will, which we imagine as the fundamental nature of the entire genus of animals, most fully comes to view.

As long as being is imagined by us as life-will that projects and realizes itself in beings, so long *must* the horse be beautiful. The rightness or measure of form that belongs to it in its appearance is the rightness or measure that belongs to life-will, and hence to being itself. In the horse, not in the elephant or giraffe, we experience the phenomenon of life-will projecting and realizing itself fully. The phenomenon is one of the mutual adequacy to each other of concept and

realizing form, concept and objectivity. It is as if, in the beautiful animal, being, *qua* animality, aims at its own truth, i.e. its own full and complete self-attainment, and succeeds in reaching it. Thus the beautiful animal is beautiful as the image of truth of being. It shows in its appearance the third kind of truth in objective form. It is a picture of truth, and it is so precisely in its ideality, its departure from the common reality, i.e. its beauty. For here the common reality has become more than merely real; it has become actual or, at least, its appearance is the appearance of actuality.

We have thus far seen how a beautiful thing of nature—a snowflake, gold, the horse—attains to the appearance of the third kind of truth in its objective sense, or truth of being. But this is only one side of the truth of spirit, and in describing it we have been presupposing the co-working of the subjective side of this truth. For all the way through we have taken for granted the effective presence of the being (our self) for whom the natural thing is beautiful. Even setting aside all questions about the role of the ego in constituting the phenomenon of beauty, there is the question of its recognition by the self. "Recognition" is taken here in two senses, namely, recognition by understanding (evidence or the uncovering of truth in the first sense) and recognition by will (acknowledgment by will of truth in the second sense). The unity in which these two forms of truth occur together is the subjective side of truth of spirit as it is manifested at the level of the experience of natural beauty.

In order to be able to speak of it as such, let us call this subjective side of truth of spirit by the name of truth of recognition. (In the foregoing, we have called the objective side "truth of being.") How does truth of recognition

occur here, in the experience of natural beauty like that of the snowflake, gold, or horse?

(1) First, then, it occurs as evidence, or the uncovering of truth of being by the understanding in perception.

We can imagine ourselves perceiving the snowflake, gold, or horse in an aesthetically neutral way, in which the thing would appear merely as an object, something simply present as such, showing itself only in a static way as a datum, a phenomenon of factual observation, deprived of the appearance of life. Such perception would note in the object those characteristics of it that are relevant for purely natural-scientific understanding. In this neutral natural-scientific observation, everything apparently living in the phenomenon is suppressed, or—since it is virtually impossible for a human being to perform the actual suppression—is neglected. Such observation is abstract and highly selective; without it nothing like natural science could have been developed, and man's consciousness of nature would have remained physiognomic and mythical. It is the kind of observation that is eminently fitting for truth of statement in its isolation, i.e. the utmost subjection of thought to existence without regard to the demands of mind upon the latter. By this observation we uncover in existence exactly that which *is* regardless of the demands of mind upon it.

But in the case of the aesthetic phenomenon of beauty, understanding cannot work in isolation. The person must come into play here. For at the heart of the phenomenon is the appearance of objective truth of being, and this can never be a datum of natural-scientific observation. It is a phenomenon which we can have only in so far as we behold the thing in the manner of a person—in the manner of love, as we shall see, for beauty, and of admiration and awe for the sublime—not in the manner of a natural-scientific observer.

Why and how is it that the perception of truth of being requires the person? Because truth of being is the self-attainment of being (i.e. being attaining its own form of existence), and being is self-attained only by way of a process in which a self rises to its own actuality as self. Only a person can understand this fact of self-attainment. The reason is that only a person can grasp the very concept of the self in its relation to the attainment of being.

The person who is color-blind can never understand what yellow or blue is as such; the person who is tone-deaf cannot understand what musical harmony is. It is true that, helped by those who can distinguish colors, the color-blind person can calibrate optical instruments to tell him when the physical conditions for their perception are present, and thus it may be possible for him to develop a physics and physiology of color. But in all this, the phenomenal colors themselves would be missing, and without the possibility of experiencing them, he would still lack the possibility of that direct understanding of them that is at the basis of the arts of color.

Just in the same way, a being lacking direct acquaintance with subjectivity, selfhood, and personality, no matter how intelligent otherwise (it could be an elaborate computer with its own apparatus for programming), could never understand the struggle for actuality, or truth of being, as such. It would not have the perceptual basis for that understanding. It would not even see the striving or its successful attainment in any phenomenon given to it. Indeed, the capacity to perceive this kind of phenomenon is a necessary condition for being a person, and those of us who starve it find our own persons being starved.

Now the impression of life-will or will-to-be, more or less realized by its own efforts in struggling with the medium of its being—this impression, which we have in the experience

of natural things as beautiful or ugly (failure), is already
the impression of a self involved in the struggle for being.
The degree of selfhood may be low, but selfhood is defi-
nitely there as phenomenon, understanding by selfhood sub-
jectivity in its effort at distinguishing and relating itself to
its opposite, its world. Consequently only personal observa-
tion can uncover the phenomena of truth and falsehood of
being. Only in the beholding performed by a person can
there occur the perception of truth or falsehood of being.
Other beings are blind to these possibilities of truth in the
first sense, uncovering.

A serious question, however, remains. For the possibility
of error and illusion (e.g. the painted illusion of a real pic-
ture on the wall) is always present along with phenomenal
uncovering. The question is not only whether the entity as
given is identical with the intention of the understanding
or statement, but whether also the entity as it really exists is
identical with the entity as phenomenally given, for the
latter is also the result of interpretation. Thus the question
arises: Is the snowflake really a life-will, albeit of a very low
order, struggling to climb out of its obscurity up to the
light of actuality and succeeding? That is: Is the snowflake
in real existence what it appears to be as beautiful?

An answer to this question could only be given in the
form of a metaphysical assertion about the constitution of
the snowflake as a real entity. Physical science can help us
toward the answer, but cannot itself give the final answer.
In terms of it we understand that the snowflake is the prod-
uct of the behavior of physical energy in connection
with matter; in it the molecules arrange themselves, as heat-
motion is dissipated, into positions of relative equilibrium,
so that when forces on them are balanced a (usually hex-
agonal) symmetrical pattern occurs. As to what the ulti-

mate nature is of physical energy, matter, and force, however, science neither tells nor wishes to tell, for it has no way of answering that kind of question. It does not even know what the question means, in the sense that it knows no way of finding evidence relevant to the issue.

On the other hand, while we may imagine physical energy as a relatively undeveloped form of life, this is as yet no more than imagination. We have no perceptual access to an inner mode of existence of physical entities like snowflakes. Hence metaphysical system dogmatizes against metaphysical system. The idealistic and voluntaristic metaphysical systems of modern times, from Bruno and Leibnitz to Whitehead, together with their materialistic and positivistic counterparts, interesting as efforts of the speculative imagination, are unconvincing as accounts of existence. They all presuppose what they want to prove.

What is said of the snowflake can also be said of gold and horse. It can be said of any instance of natural beauty, for in every such case the same question about the identity of the phenomenal with the existent entity can be raised. And behind this problem of identity of phenomenal and real entities there looms the question of the existence of real entities altogether, i.e. the question as to the existence of entities independently of, and differently from, the way in which they may be given in phenomenal appearance. The issue between subjectivism (epistemological idealism) and realism, as far as natural beings are concerned, far from being the scandal that Heidegger supposes it to be (because he himself presupposes a realist answer to it [6]), is one that can

[6] See *Being and Time*, Sec. 43. Heidegger repudiates the title of realism for his own view, but is able to do this only because he gives it a peculiar sense. He eliminates the problem for himself by assuming that the entities that are phenomenally given *are* the entities that are.

be raised by understanding but settled only with the aid of a decision of will—or of faith.

Nevertheless there is one observation that must be made in common by all parties to the metaphysical dispute, namely, the relatively steady growth in complexity and the general heightening of the appearance of purposive realization of being, from the inorganic, through the organic, to the human level. If the snowflake appears to us in aesthetic experience as the realization of a will-to-be, that will appears to be of a very primitive kind, wholly unconscious, acting itself out as though thoroughly hypnotized, intelligent yet blind, and satisfied with an existence that does not go further than a decorative hexagonality. The concept of what it ought to be, which we attribute to it in imagining it as will, is of a rudimentary form, a low rung on the ladder of being.

So also with gold.

The horse, on the contrary, is already many steps higher on this ladder. The idea that appears to be the essential determinant of his will-to-be contains determinations not only of body but also of soul. He is a being with sensitivity, knowledge, desire, affections, so that we can enter into relationships with him that are analogous to personal relationships among human beings. He can love and hate, appreciate and resent, repay kindness with kindness—not in a self-conscious way, and without reflection, yet in a genuine way. We notice that in English it is natural to say, as we have just said, "he" about the horse, which we do not say about the snowflake.

When we arrive at man, the model of truth of being appears most definitely applicable. But here we encounter a situation that is unique, since human being stands in a spe-

cial relation to this model. The discussion of this topic must therefore be postponed to the next chapter.

(2) We now turn to the second sense of truth of recognition (the subjective side of truth of spirit), namely, acknowledgment of the objectively true being by our will. This is a crucial component of truth of recognition. It is at this point that the chain of oughts in truth of the second kind, practical truth of things, is broken. This is the point at which truth of being initiates, as a principle, a practical truth that does not flounder in the sea of mere will. Our discussion, however, is to be limited to objective truth as manifested in the experience of natural beauty.

Here we encounter a phenomenon of signal importance. On the side of the object we may speak of its *cogency*, on the side of the self, of *seizure*. In this phenomenon the beautiful thing exhibits a real and effective power, the power it has of persuading the self of the thing's own truth.

> Beauty itself doth of itself persuade
> The eyes of men without an orator.
> (Shakespeare, *The Rape of Lucrece*)

It is a phenomenon that is analogous to evidence in the first kind of truth, but, occurring as it does in the structure of truth of spirit that unites understanding and will, it is at the same time the point of origination of truth of the second kind.

In evidence the self finds its own intention, in statement or thought, fulfilled in the identification of the intended and the given entities. The perception is therefore able to convince the self of the truth of the self's intention. Now in the third kind of truth, the intention of the self that perceives the thing in its appearance of objective truth has to do with

the ought, the aim of the will-to-be, of that thing. It is an intention of the will, not merely of the understanding, that is in question here. Our will has to be convinced of the ought of the thing, whereas in the former case our understanding had merely to be convinced of the *is* of the thing. And where we actually experience beauty our will is in fact convinced. In being convinced, we find ourselves in an experience in which we identify our practical intention with that of the object, not through an arbitrary decision on our part but because of the persuasive power of cogency of the object itself—because, that is, the object seizes us by the power its validity gives it over our spirit.

Primal aesthetic experience is one of gripping and being gripped. Aesthetic experience is living in the grip of the valid object. Its validity is experienced not as the theme of a cool reflective act of judgment, but as the power of a vital presence. Critical judgments of appraisal or personal judgments of preference—"That is almost perfect," "I like it very much"—come later, and can themselves in the end be justified only by return to the primal experience, whose report is "That is beautiful."

The term "seizure" is borrowed from the painter Delacroix, who used it in regard to the experience of art, and from Dewey who recognized its significance.[7] Delacroix had remarked that "before knowing what the picture represents you are seized by its magical accord"; and Dewey noted that such seizure occurs in other aesthetic experience, as when we are seized "by the sudden glory of the landscape, or by the effect upon us of entrance into a cathedral when

[7] But Dewey emphasized too much its early phase in aesthetic experience and too little its continuity throughout, despite the fact that his own theory of the unitary pervasive quality in an experience should have suggested the contrary to him. See *Art as Experience*, pp. 145, 191, and especially 194.

dim light, incense, stained glass, and majestic proportions fuse in one indistinguishable whole."

The landscape, the cathedral, or the painting seizes us, but also only because we grasp it in its sudden glory or magical accord. In correlation with my grasping it in its apparent truth of being, the naturally beautiful thing seizes me as a person and bends my will to itself, not by violence but by the force of that very validity that I grasp.

One connotation of the word "valid" is cogency. The valid, as valid, is cogent; and the cogent is what has authoritative weight, the force of soundness, effective binding power.

In knowledge, what is well grounded in evidence has authoritative weight and effective binding power upon our rational understanding. It commands our cognitive acknowledgment, and we acknowledge that it does so rightfully. Knowledge as experience is not a system of propositions inscribed in a book; it is an experience of the realization of insightful conviction in a sound manner. Truth in the first sense, as an experience, is not the logician's correspondence of a proposition with a fact, but the living person's realization of the binding force of perceived or understood evidence upon his belief. Thus even truth of understanding partakes in its own way of truth of being; for the truth of being that occurs in it is the truth of the being of evidence and of belief. Everything that happens in man's existence somewhere bears the imprint of truth of spirit.

In morals, the valid is what is just and sound, what can be justified on moral grounds and therefore can rightfully command our respectful acknowledgment and call to us with the ringing voice of the good or of duty and conscience. In law, the valid is what is legally sound, effective, being sanctioned by legal principle, precedent, and purpose,

and therefore it has legal force and is sustainable in law; it is consequently acknowledged as binding upon us. In religion, the valid is what is holy, sacred, divine, and therefore has authoritative might attracting and compelling our religious acknowledgment, our love and awe, our willing submission, and our worship; it has binding power over the whole of our life, superior to all other binding power.

So also in the aesthetic domain. Here the thing that appears has cogency simply by virtue of its appearance, as semblance. Because of its beauty in particular, or its show of truth of being, it has authoritative weight, force, binding power over our spirit in its immediate existence, or feeling. It compels our consent in a direct and immediate way, in the working of our personality as a feeling entity. Its grip upon us is not that of a brute force, but of a power that claims and compels our willing yielding, so that we feel obliged and delighted to yield, cleave, and cling to it as we do to the true in cognition, the good and right in morals, the lawful in law, and the sacred in religion.

Phenomenological study of this cogency of the beautiful thing is crucial to understanding the aesthetic experience of nature and of art. In this place one relevant phenomenon may be particularly mentioned, because of its association with the previously noted phenomenon of the ladder of being. Although beauty everywhere exercises the cogency under consideration, that cogency becomes on the whole more subtly related in a personal way to the beholder as the object rises on the ladder of being. The beautiful object comes closer to us as it becomes more akin to us, until in the case of human beauty we are susceptible to a highly passionate and tender mode of binding; and this increases as the rise continues up the spiritual ladder.

The Gothic romanticism with which he invests the expe-

rience may seem distant from our present existence, and the historical fact itself may be much exaggerated and distorted, but there can be no questioning of the deep human possibility of the description Dante gives in the *Vita Nuova* of his first sight of Beatrice.

Nine times already since my birth had the heaven of light returned to the selfsame point almost, as concerns its own revolution, when first the glorious Lady of my mind was made manifest to mine eyes; even she who was called Beatrice by many who knew not wherefore. She had already been in this life for so long as that, within her time, the starry heaven had moved towards the Eastern quarter one of the twelve parts of a degree: so that she appeared to me at the beginning of her ninth year almost, and I saw her almost at the end of my ninth year. Her dress, on that day, was of a most noble color, a subdued and goodly crimson, girdled and adorned in such sort as best suited with her very tender age. At that moment, I say most truly that the spirit of life, which hath its dwelling in the secretest chamber of the heart, began to tremble so violently that the least pulses of my body shook therewith; and in trembling it said these words: "Here is a deity stronger than I; who, coming, shall rule over me." At that moment, the animate spirit, which dwelleth in the lofty chamber whither all the senses carry their perceptions, was filled with wonder, and speaking more especially unto the spirits of the eyes, said these words: "Your beatitude hath now been made manifest unto you." [8]

The beatitude that is beauty is made manifest to the spirits of the eyes—it is an intuited apparition—but also, the spirit of life, dwelling in the secretest chamber of the heart, trembles and says, "Here is the deity that shall rule over me." Beauty is not an inference. It is a presence that reaches in to shake the spirit of life, fill the animate spirit with

[8] From the translation by D. G. Rossetti in *Dante's Vita Nuova together with the Version of Dante Gabriel Rossetti,* edited by H. Oelsner (London, 1908), pp. 3-5.

wonder, and govern the soul in the name of love. It is thus felt in the fullness of the apparition's cogency. Beatrice, the stronger deity, shall rule. Beauty has the power to rule over the heart. But it is more than a power; it is a deity, and a deity has the right to exercise its rule, extorting from the heart not only subservience but acknowledgment. In being acknowledged it becomes the focus and source of the heart's thrill, for in acknowledging it as a rightful power we at the same time become willing captives and cleave with all the power of our desire and love to this master.[9]

Dante, again, may tell us something of seizure by the cogent binding power of the beauty that mystical vision discerns above man.

> And so I was the bolder, as I mind me, so long to
> sustain it as to unite my glance with the Worth
> infinite.
> Oh grace abounding, wherein I presumed to fix my
> look on the eternal light so long that I consumed
> my sight thereon!
>
>
>
> A single moment maketh a deeper lethargy for me than
> twenty and five centuries have wrought on the emprise
> that erst threw Neptune in amaze at Argo's shadow.
> Thus all suspended did my mind gaze fixed, immovable,
> intent, ever enkindled by its gazing,
> Such at that light doth man become that to turn thence
> to any other sight could not by possibility be ever
> yielded.
> For the good, which is the object of the will, is therein
> wholly gathered, and outside it that same thing is
> defective which therein is perfect.[10]

[9] Plato's *Phaedrus*, 251–52 should be read in this connection.
[10] *Divine Comedy, Paradiso,* Canto XXXIII, lines 79–105, from the translation in the Temple Classics edition (London, J. M. Dent & Sons, 1932).

Seizure by virtue of the cogency of the beautiful thing, then, is a genuine phenomenon of human existence. It gives us a glimpse of how, in direct confrontation with an object, we may find in the object something that convinces us as persons of its right to claim our adherence to its own ought. This ought is not, as such, a moral ought; it is an ontic ought, the ought of a will-to-be that the thing appears to us to have and to realize in its own self. It is thus the realized ideal *as* which we see the thing in perceiving it as beautiful. This realized ideal, or identity of ought and is, it is that persuadingly compels our personal will.

This seizure is the seizure of love. We would not be able to be seized by the beautiful thing unless we were susceptible to love. And the relationship is not one of sequence. It is not that first we see the beautiful object and afterward we love it. The perception of beauty is an act of love. In order to see the object as beautiful we have to see it in terms of its own will and its own truth, and we have to be convinced in our personal will of this truth by means of the seizure. But that is already to be in an attitude toward the thing not for the purpose of using it but just in giving ourself to it. This is the so-called aesthetic attitude in the experience of natural beauty. If further acts of love or acts inspired by love follow, that is because love breeds love.

Thus the acknowledgment of truth of being by our will in the case of beauty, as indeed it is everywhere, is the acknowledgment of love and the act of the person.

Early in the development of aesthetics as a separate philosophical discipline in the eighteenth century, after Boileau's translation in 1674 of Longinus had been assimilated, the sublime was accorded a place as an aesthetic category

alongside beauty. Addison set the stage in Number 412 of the *Spectator*, for June 23, 1712, by citing (after Longinus) three sources of all the pleasures of the imagination that arise from the vision of outward objects: the great, the uncommon, and the beautiful, or, greatness, novelty, and beauty. Novelty, or deviation from the ordinary, is connected with beauty on the one hand and with ugliness and the comic on the other; it will not be further noticed here. But the sublime, or in Addison's term, greatness, stands as the second chief aesthetic category. It has had a continuous history down to the present, since any aesthetic theory that wishes to be taken seriously must account for it.

Essential to sublimity is power, and, in particular, great power. Although size, together with other forms of magnitude, has sometimes been thought to give rise to a form of sublimity, reflection on experience shows that the size or other magnitude functions only as a way in which power is exhibited; and the power itself is ultimately of the nature of will, i.e. experienced as such. Thus, although Kant distinguished mathematical from dynamical sublimity, his instances of mathematical sublimity, when realized in experience, turn out to be dynamical at the core.

Apart from the pyramids and the interior of St. Peter's, which are not cases of natural sublimity, he mentions such things as shapeless mountain masses towering one above the other in wild disorder with their pyramids of ice, the dark tempestuous ocean, and the spatial cosmos. But suppose the pyramids were made of cardboard and one saw them as such. And the soaring, majestically thrusting-reposing dynamism of the dome of the cathedral cannot be seen as mere size apart from the gigantic ordered power it embodies. The same is true of wild and towering mountain masses and the ocean in a tempest. But even the sublimity of space itself, of

mere and pure extension or, in plain English, spread-outness, involves a sense of the spreading-out of the space, i.e. of the existence of space as a primordial form of realization of that urge or thrust of being that comes to be felt as will-to-be in more familiar forms. Our perception of space, like all our perception, is physiognomic. The perceptual meaning of space is grasped only as the dynamism of being in a most elementary way. The vastness of space then becomes sublime because of the sheer, inexhaustible, indestructible, outgoing force of the urge to be that we can feel working itself out in the vast reaches—a not-accidental word here—of the infinite cosmos. Space indeed is being reaching out to exist, to be something definite, if only mere outness itself.

And with this we see why there should be a category of the sublime as a fundamental aesthetic concept. Our primary human experience of being, which we know from within ourselves and in whose image we perceive the outer world, is the experience of urge, drive, desire, thrust, or will-to-be, i.e. of power or force seeking to establish and maintain its hold in existence. As our vision rises up the ladder of being, it sees this will, this essential vitality and livingness of being, developing for itself a part or function that it uses to guide itself: will develops understanding, insight, and reason, that makes it aware of the world, itself, and its ideal possibilities, teaching it the laws it must obey and the goals it may and ought to aim at. First this happens in inorganic matter, and the world shows the order of physical rhythm and regularity. Then, on that basis, life arises, as plant, and organizes itself still more subtly and intricately, evolving the actual image of purposiveness. Plant life is surmounted by animal life, which brings with it a higher development of the guiding, regulating, limiting principle in the lower forms of soul. Then appears man, in whom the forces of

existence show their true character as unlimited will and limiting reason. And above man? The imagination, having gone thus far, does not hesitate to go further, envisioning divine beings in whom both the force of being and the principle of intelligence reach heights far above the human.

In beauty we experience the truth that being reaches by way of its ordering into its own rightful existence. In the sublime we experience the greatness of the thrust that lies at the root of all existence, the power of being. Whatever is, is in some degree. It is a great or a small being. Whatever mode of being an entity may have, it may be great or small in that mode of being. There are great substances, great qualities, great quantities, great relations, great actions, great passions, great characters. A great oak is a great tree, and it is noble and sublime because of its greatness as a tree. If, gnarled and bent in its struggle against wind and weather, it stands out against the world, stubborn, determined, bearing the burden of being with a thrust that reaches up and out into the sky, it is all the more sublime for the very image it is of the will-to-be. We do not ask it to be beautiful as well—there are other things that are both beautiful and sublime, like the sun and the god Apollo. Existence is too hard for most things to be able to be beautiful. It is enough that the oak should succeed in existing; and when we see a being existing, establishing, and maintaining itself despite all obstacles, overcoming them, imposing its being, or when we see it failing and going down to defeat only in the face of great and insuperable opposition, it shares the phenomenon of existence with the great heroes of mankind. It is the same phenomenon at root, from the sublimity of infinite empty space to the sublimity of the tragic hero.

A theory of sublimity would need to be articulated in many directions, as would a theory of beauty. Neither is being offered here, where the sole purpose is to open up to reflection the concept of truth of spirit. In beauty, the rightness of the actuality of existence is emphasized. The beautiful being is a being that, by some grace or magic or luck, is able to find an order in an articulate form in which the ought of its will-to-be and the is of its factual existence come together into a unity. It is as though in the beautiful thing the will developed a rational insight into its own possibilities of being, projected that insight as a vision, and guided the being sensitively toward its realization. Beauty is the appearance of *truth* of being.

In sublimity, the root of existence, the being that is the thrust toward existence or the will-to-be, shows itself in its greatness of being. The stress in sublimity is on the greatness of the being, not on the rightness to which it is able to attain. Hence the sublime often appears in the very destruction of rightness of order, as in the terrible tempest, the tiger, the criminal, Satan. Hence also, the sublime is a phenomenon that is closer to the primal character of what-is than beauty. Beauty is on the side of its final character. Sublimity is the appearance of *power* of being, its initial character.

In line with this difference in the contents of beauty and sublimity, we understand also the difference in their cogency and our acknowledgment of it in seizure. In the beautiful we are seized in an act of love by the appearance of rightness or truth of being. In the sublime there is a seizure too, but it is by virtue of the cogency that belongs to the majestic, noble, heroic on the one side, which is met with admiration on our part, or the terrible, awful, horrible on

the other side, to which we correspond with awe, fear, or terror; or there is a form between these poles. The cogency of the sublime object is not owing to its objective validity as a being, in reality or in appearance. It is owing to the presence in sublimity, however, of a certain phase of truth, namely, the objective truth of power itself, i.e. of the being that is, for human imagination, at the root of all existence. Power shows itself as power—it even vents itself as power, as it may in rage and destructive fury—in the sublime object, where it seizes us in our admiration, awe, and terror.

The possibility of the model of being, and eventually of human being, as a will-to-be, a nisus toward being and ultimately toward truth of being, seems to be built into our constitution as human beings. The child uses it from the beginning of its experience. We do not wait to develop a science of psychology in order to be and be with others. We acquire naturally, in immediate relation to culture, a knowledge of self, others, and world, that is suitable to our condition as the finite beings we are. Here, too, the question arises as to the relation between our model of what is happening and the truth, in the first sense, of what is happening. But it arises because the model of truth of being does in fact grow naturally as the common human image of reality. It is an articulation of man's instinctive heritage of understanding. If seen as a myth, it has also to be seen as a vital myth, without which we could not continue to exist as human beings. It is a knowledge that is a necessary condition for the existence of that of which it is the knowledge.

But it is more than that, too. This knowledge, in which what-is is interpreted as will-to-be and thereby as possibility of an ultimate spiritual truth, is the medium in and by which our own being arrives at its meaningfulness. Within this medium the spiritual life of man is played out. In man's

spiritual life that which is occurs in such a way that it can have meaning and be true or false in its own eyes. This is a plain empirical fact about the world. It depends on no metaphysical interpretation of existence but, on the contrary, is an observable fact which metaphysical theories are challenged to explain. Whether meaningfulness and the possibility of truth or falsehood of being occur below man and stretch continuously upward to him in gradually unfolding sequence, or whether they come about only with the emergence of life, or whether they coexist only with consciousness or eventually only with man—these are difficult problems of science and philosophical speculation. But one fact is plain and unspeculative, namely, that man exists in the world and that with the occurrence of the human mind there is given a clear possibility of a self-interpretation of what-is, in which what-is attains to meaningfulness and the possibility of truth or falsehood of its own being. Somewhere, and clearly already in man, being gives birth to a being for whom it has meaning and the possibility of truth.

In metaphysics it was customary to speak of this juncture of existence as being's attainment to its own self-disclosure. That is, the truth of being that was here arrived at, truth of the third kind, was also conceived as a truth of the first kind, as though in beauty, goodness, and sanctity, being finally uncovered itself to itself in its pristine splendor. But the image of uncovering and revelation assumes more than is given. It assumes that what is in the end was in the beginning, that reality is a serpent swallowing its own tail, and that the human imagination is a measure of the depths of existence. The doctrine of the human spirit as the uncovering and revelation of being is a picture of human pride in the face of the mystery of existence; it is human finitude

blowing up the image it needs for its own being so as to make it appear as the very presence of the fullness of being itself.

What we know as a matter of fact, however, is that in the life of the human spirit a tiny fragment of being has open to itself the possibility of meaningfulness and truth of being. This in itself is a sufficient marvel not to induce us to imitate the frog who wished to be thought of as the king of beasts. By virtue of the life of spirit that is open to man, this tiny fragment possesses a dignity that places it above the hills, the mountains, and the galaxies. It does not make man a truer picture of reality in the first sense of truth. It does not give him the right to be an absolute and despotic governor of things in the second sense of truth. It does not even make him better by nature than a grain of dust, since he can be worse by his own doing. It determines, rather, the sphere in which his destiny lies. Matter exists as matter, color as color—man exists as man. His dignity consists in his being the entity whose existence is a task the only solution of which, if it is at all possible, is truth of spiritual being. Man is an arrow pointed upward—but what and where are up and down? That question is the essence of man. He is the posing of it. To be that question and to live the attempt to answer it is man's dignity, which comes to him as a destiny.

The model of the human being as an aim at being is the language in which this question can be asked and any answer can be formulated. It is in this sense a necessary condition for the existence of what is represented in it. We should not ask for the impossible. The candle that is set up in us shines bright enough for all our purposes. If man speaks this language of the spirit, it is because that is the language he has to learn to speak in order to understand in its own terms his possibility and destiny. Its light is the

candlelight by which the servant must attend his business. This is a condition that comes to us with our being, which must be accepted as a condition under which the enterprise of truth of being first becomes possible. However far we develop science (truth of the first kind) or the governance of things (truth of the second kind), these two forms of truth have to be brought into the unity of truth of our own being, which is the being of spirit, on pain of the neglect and consequent destruction of our humanity.

Spirit is subjectivity in search of the truth of its being. Subjectivity is, first, will, impulse, blind thrust toward existence; secondly, it is will limited and controlled by itself through the understanding which it develops for the purpose of controlling itself. But something more is needed, namely, the transition of subjectivity to spirit, which is made by virtue of the aim at truth of being. There is an element in will, the measuring element, which enables it to aim at truth of being. Without this element, will finds its realization only in the second kind of truth. At that level, understanding serves will by enlightening it as to the truth of its ends; for in the first and second kinds of truth, understanding has not yet found any being in regard to which the chain of practical oughts can be broken.

Thus in truth of the second kind will is as yet left free, in the arbitrary sense of a rational indifference of choice, to choose its ends. It can just as well choose to destroy other beings or itself in its rage and fury as it can to serve them in its warmth of attachment. It contains within itself all possibilities, from the full giving of self (to others and itself) to the destructive withholding of itself, from love to angry hate.

Moreover, anger is more natural to it than love, in so far as

it is still in the stage of indifferent freedom. For love, as we have seen, is connected with seizure by the cogency of truth of being, whereas will in the stage of truth of the second kind has not yet reached this third kind of truth. Therefore, while it has the seeds of love in it, the love it is at present actually capable of is still only a facsimile of genuine love. It is desire to possess something or it is satisfaction in something that fulfills desire. Perhaps the pure form of this facsimile of love is that which Spinoza defined as essential love: "Love (*amor*) is pleasure accompanied by the idea of an external cause." [1] In this sense we love what pleases us simply as such. It need not do anything else except please us, i.e. affect us so that we make a transition from a lesser to a greater state of perfection or fulfillment of appetite or desire (*cupiditas*); and the cause of its pleasing us need not be anything other than the mere being of the thing. But because this love is not founded on the truth of being (actual or potential), but depends on our pleasure, it is erratic and can just as well shift to the violence of anger and hatred without any change in its object. It is only the hollow shell of love. It is without a basis in the being of that which is loved.

The element in will by which it can aim at truth of being is the same as that by which subjectivity can become spirit. It is the spiritual element in will. That the spiritual element exists is shown by the fact that will can and does in fact aim at truth and reach it in appearance in art, in reality in morals and religion, in thinking in philosophy—and that the driving aim in all these domains is toward this goal. Through the spiritual element in will, will opens up for itself a direction toward truth of being which, once found, seizes will by its cogency and persuades it to cling to it. Genuine love is this

[1] *Ethics*, Third Part, Definitions of the Emotions, VI.

openness of the spiritualized will to the evidence of and seizure by true being, both in its presence and in its absence from that which, deprived of it, needs it. From the very beginning the spiritual factor makes itself felt, and in every distraction of will it resonates as though it were a remembrance of a perfection and innocence long lost; its most familiar form is the moral conscience.

Because of the spiritual element the self is called on to remain free of any irrevocable commitment to any decision short of the seizure by truth, and it is equally called on to remain free of any intellectual conviction short of the evidence of truth. It is permitted to hover in irony above itself, except when it is confronted by truth of being; this truth announces itself as the self's absolute end, from which it ought not to withhold itself and, indeed, from which it cannot keep itself except by rebellion, which is called evil and sin in morals and religion. It cannot avoid willing in the beginning; it must not avoid willing the truth in the end. The "must" is the voice of the spiritual element in will, calling freedom to bind itself to the truth.

This finality of aim that defines the spiritual element in will is what unites understanding and will in spiritual life. In so far as it is present, man is spiritual and has become a person. Man therefore exists as a person only insofar as he is open to the evidence of and to seizure by the truth of being, i.e. only insofar as he has opened himself to love. This means that he finds the truth of his own being ultimately only in discovering, in love, the truth of being that lies beyond him.

At this stage, and only at this stage, in existing as a person, man has a definite *character* of his own. His being which, as will-to-be, has striven toward a definite existence that

would be its own actuality, finally attains it in the form of a mode of life in which the basic principle of its actuality, the spiritual element of love of true being—which is the only principle that can break the practical chain of oughts—is the ruling factor. At this stage the particular will, limited by its particular understanding, and given measure by its particular spirit, has become *individualized*. It is complete as a will. The nature of will, as the seething urge to be, has been fulfilled by the attainment of limitation and measure. The result is therefore a full being in its unique particularity, a person having a character.

Character is more than temperament. Temperament is standing tendency to feel, to like and dislike, to be sympathetic or antipathetic; it is the steady feeling-aspect of will-to-be. Character is standing disposition to do and be. It is the aspect of the complete will, limited by understanding and brought to measure by spirit, and shows itself in all action by the direction and determination with which the man as person behaves. The person, with his character, is the substantial or essential being, the realized will as such, that henceforth performs its acts as its very own, not by calculation but by character. These acts, as forms assumed by the essential being, are thereby impregnated with the individuality, i.e. ultimately with the unique love that is this and only this person's prerogative. From this manifestation of the reality of person and character in outward forms there flows the phenomenon of *style* in everything that we do that depends on our personal self, from the personal bearing of our body in walking to our patterns of speech, diet, dress, abode, interpersonal relations, and religious practices. As animal being takes on a definite style of its own in horse, elephant, or giraffe, so human being, when and as it is at the

stage of completeness, takes definite form along the lines that belong to it as its very own.[2]

The search for the truth of its being by which subjectivity is spiritualized can be shunted into the special form of symbolical articulation. This special form of the search (i.e. of man's existence as the question of the truth of being and the search for its answer) is the aesthetic dimension of human existence. Insofar as the artist is an aesthetic artist, it represents his particular way of carrying out the spiritual search. The work of art is thus two things at once. It is aesthetic, like the beautiful thing in nature, and it is symbolic, like man's language; it is the *aesthetic symbol.*

As a symbol, it articulates the search for and, eventually, the finding of truth of being and, ultimately, of truth of being of the spiritual person himself, truth of spirit. This means that it does not merely present us with an aesthetic object, e.g. a beautiful or sublime or tragic thing, as nature does, but that it goes beyond this to articulate also for us the human will that directs itself essentially to that object. It does not give us the beautiful horse, for example, but in the statue of the beautiful horse (purposely not a real horse) it gives us the human love of the horse.

So Phidias, the sculptor of the horse of Selene,[3] fixed for all time the high-reasoned admiration with which Greece

[2] In relation to this whole section, Schelling's extraordinary sketch for a philosophical anthropology, the *Anthropologisches Schema* of 1840, should be consulted.

[3] From the east pediment of the Parthenon, among the Elgin Marbles in the British Museum. The sight of these marbles, we may recall, reminded Keats of the weight of mortality: "I must die, Like a sick Eagle looking at the sky." (*On Seeing the Elgin Marbles*) From the time of Keats, Haydon, and Goethe (for whom it was an *Urwesen*) to the present, this horse's head has stirred the profoundest admiration and the most elevated enthusiasm. See, for instance, Ernst Buschor, *Pferde des Pheidias* (Munich, Münchner Verlag, 1948), p. 23.

beheld and comprehended the possibility of truth of being it discerned in that noble animal. This head is as much an utterance of the Greek spirit as it is a representation of the ontical truth of the horse. It is the two in their inescapable unity. Indeed, the ontical truth of the horse uncovered here is one that transcends any merely animal beauty, as can be seen in its departure from naturalism and its stylistic unity with the human figures. It is a truth of the sort that the Greek mind found in the world as a cosmos, and in man and other beings as microcosms, and that simply manifests itself in one proper degree in the peculiar form of the horse as in another in that of man. We understand the sculpture only when we grasp the beauty of the represented horse as a specific mode of beauty, which is the correlate of a specific mode of love that realizes itself in touch with this beauty; so we must grasp the love as the love of that beauty and the beauty as the object of that love. It is, in this case, the Greek rational love of the architectonically beautiful, showing itself in an exquisitely powerful taste.

In the work of art we are confronted with a symbol which, like all language, articulates human existence, but in particular articulates that mode of human existence which has to do with the search for spiritual truth. In its culminating moments it articulates a consummation of the search. The culminating moments are those in which beauty is found whole and present, as it were, in a moment that gives to time an eternal significance. Here above all the nature of the artistic symbol becomes clear. It is what might be called an *ontological symbol.*

By this expression is meant a symbol which *is* essentially what it intends. The work of art *is*, as such, the entity that it intends. In this, it is unlike the symbol that occurs isolatedly in the context of truth of statement alone. A state-

ment is not identical with what it intends. The statement about the picture hanging askew on the wall is not itself the picture hanging on the wall.[4] The entity intended is intended *as* other than and existent beyond the intention articulated in the statement. There is a difference of ontical position instituted between the intending and the intended. This is necessary to the very idea of statemental truth (in its isolation), for its goal is the uncovering of what exists as such, and hence it must allow for what exists independently of the intending of it. Even when a statement has statement-truth, and actually uncovers the intended entity as existent, this uncovering takes place, as it were, from a distance, the symbolic distance of truth of the first kind.

The situation is analogous in language having to do with the practical truth of governance, as brief reflection will indicate. Thus the marriage-prounouncement is not itself the condition of being wedded. Here, too, there is an essential difference between intention and intended, even when the thing intended satisfies the requirements of the intention.

But in the symbolism that articulates truth of the third kind, the gap between intention and intended is bridged. Let us take Selene's horse as example. (We are dealing here with representational art; nonrepresentational art would be even easier to analyze in this fashion.) The meaning of this symbol contains two essential components, the beautiful horse and the human admiration of it. Both are present in

[4] Even in the rare cases of statements that refer to themselves, as e.g. "S is a statement containing seven words," where "S" is the name of that very statement and thus talks about itself, there remains an inescapable difference between S as intending and S as intended. This becomes obvious in the *conventionality* of the definition of the letter "S" as the name of the statement. Only through that conventional connection does S refer to itself. Thus S *is* what it means, not essentially, but only accidentally.

the meaning of the work, i.e. in its mode of being as a symbol.

It might be thought that they are not. For (1) if the sculpture is of a horse, then what it represents is something biological, living, real, beyond the marble representation. So, at least, one might speak; but that would presuppose a false conception of artistic representation. In artistic representation, the primary factor is presentation. That is, something is made present in the so-called representational work. What is present is something that serves the function of an image; hence we can say that it itself is an image. As an image, it is an image *of* something—a horse.[5] But this "of" does not say that the image points out to a horse beyond it. It says, rather, that whatever is of import in a horse outside has been brought into the work. The only thing about horses that is relevant to the work's meaning is the image that has been incorporated into it. Thus representation, as a mode of meaning, does not look from the world of the work out into the "real" world, but just the reverse, it brings the gaze back from the "real" world into the world of the work and requires it to linger there. (2) Again, it might be said that the love or admiration which is the second component of the work's meaning is supposed to be an expression of the artist's (or his culture's) feeling or attitude on the one hand, or the spectator's feeling or attitude

[5] Although in the Parthenon pediment the sculptor represented only the horse's head (in the north corner, where Selene and her team are setting beneath the horizon), we should have in mind a whole of the sort represented by this head. Hence all the way through I speak of the horse rather than the mere head. Some sense of such a whole is to be gathered from a group of three cavalry horses in the west frieze of the Parthenon, also by Phidias, even though they do not quite reach the level of the head. For a striking pair of photographs of a cast of the London head in its original place in the pediment see Frank Brommer, *Die Giebel des Parthenon, eine Einführung* (Mainz, Von Zabern, 1959), plates 33, 34.

on the other. Thus in this respect the work seems to point back out of itself in the direction of a feeling subject. But this observation, like the foregoing, is erroneous, being misled now by the notion of expression as the former was by the notion of representation. Whatever "expression" (the word "articulation" is preferable for the reasons given earlier) the work contains of a subjective nature belongs to the meaning of the work itself. There is an admiring love in the work, as part of its meaning, which may be more or less like the feeling of the historical artist or the present spectator. But the love in the work is not there as something that points back to a subject of either sort outside the work. Like the representational image, it is something that has, rather, been brought into the work—in the peculiar way in which subjectivity can be directly symbolized in a work— to remain there as a constituent of its symbolical being.

The only pointing that there is in the work lies within it. The admiration articulated in it points to or intends the image presented in it, and the image presented in it fulfills that intention. The meaning of the work as a whole is a certain *fulfilled intention* (the core of all truth), a certain love in the presence of its beloved.

If, now, we look at this meaning of the work as a whole and ask what the work as a whole aims to be, the answer can only be: it aims to be just such a symbol containing intrinsically just such a meaning, which is a fulfilled intention. This fulfilled intention is, in the case of the aesthetic work of art, a truth of the third kind, or spiritual truth (since it is a seizure by an ontically true thing); and the meaning of the work is just that spiritual truth.

Now since the image in the work *is* ontically true (being beautiful) and the admiration in it *is* a seizure—and therefore, since the work both *presents* the image and *articulates*

("expresses") the admiration, and does not merely refer to them as entities lying beyond it but contains them within itself in its peculiar way—what the work intends as work is just what it itself is. Its *own* intention (aim) as work, in addition to the admiring love that occurs within it, is fulfilled in its own being. We do not need to look beyond the work to something outside it to understand what it means and is. To be sure, we must understand the spirit that the Greeks were able to attain to if we are to understand this work. But that is not because the work *refers to* the Greek spirit. It is because it *articulates* that spirit. We must study the history in order to get to the essential content of the work. But in doing this, we enter into the essential content itself.

Because of this identity of intention with what is intended in the work, both truth of understanding and truth of things receive a significant development that extends them by an appropriate transformation into the context of of spirit. These two truths represent specifically the truth-possibilities lying in the experience of the beholder and the artist, namely, the truth of the beholder's interpretation of the work and the truth of the work as a realization of the artist's intention.

(1) *Truth in beholding.* We have seen how the experience of natural beauty is one in which the self is seized by the beautiful thing because of its cogency as beautiful, and how this seizure is a seizure of love; similarly we have seen how the sublime object seizes the self by the cogency of its majesty or its awfulness. A complete account of aesthetic experience would describe and explain the possibility of a whole range of experiences related to the cogency of the object, extending from the beautiful to the grotesque. The

reader is asked here to imagine the possibility of extending this account of aesthetic experience from the love of the beautiful throughout the range of *concern*, or interest in the important-trivial, as it occurs in pure imaginative perception, of which the interest in the beautiful (love in its aesthetic dimension), the sublime, the grotesque are special forms.

Aesthetic experience, therefore, takes the form of concern that is limited to imaginative perception. That is the way it occurs in its root manifestation, the aesthetic experience of natural entities. The work of art, however, is a symbol whose meaning is just such aesthetic experience. It therefore gives rise to a second level of aesthetic experience. It is not simply another aesthetic object, like the natural thing, save that it is an artifact. It is, in the strict sense, not an aesthetic *object* at all, but rather an aesthetic *symbol*, part of whose content is an aesthetic object, since it articulates aesthetic experience. Thus Selene's horse is not an object like a horse. It is a symbol which articulates the spiritual grasp of a beauty that is given by the stylized horse-image. The vitality that resides in the work is not only and not merely horse-vitality; it is the vitality of the spiritualized will that finds in the vitality of the horse-image a truth of being that seizes us in a special love belonging to the spiritualized will; and it is this vitality of spirit that gives its own *symbolic form* to the work.

Now the beholder, in approaching a work of art, must try to grasp this meaning of the work. Thus he must try to grasp the aesthetic experience of which the work is the articulation. In order to do this, he must himself project an interpretation of the work. Such an interpretative project is partly like, but not the same as, a statement. It is more concrete than any statement. The interpretative statements of critics can be useful to the beholder in helping him to

form his interpretative project, but they are always too abstract and too fragmentary to fit the concrete being of the work itself. The interpretative project is nothing other than *a projected concern* which, aimed at the work, intends to coincide with the concern articulated in the work.

There are questions of detail that arise here, especially since the work can never be and is never intended to be so unique as to permit one and only one definite project for its interpretation. A work is always more or less of a score, so that the concern articulated in it is indefinite enough to admit a variety of interpretations.

The beholder's interpretative project is to the work like a statement is to the entity it intends. The interpretative project of the aesthetic beholder aims at the art-symbol. The project is a projected meaning of the symbol. It is therefore able to become identical in content with the symbol by experiencing it in that meaning, provided the symbol allows of the experience. Thus, our projected love can be projected into the horse-symbol and fit there just because the horse-symbol articulates a love of this kind. In other words, we can find a mode of concern that identifies itself with one belonging to the work's range (part of our finding, thus, is itself creative) and in this way we can experience the work in the work's own intention.

There is consequently a truth that our interpretative project may approach, which would be the identity between it as an intended form of aesthetic concern with an actual form of concern opened up in the articulation of the work. Our interpretative project can uncover the work—or at least some part of the work—and confirm itself by moving into an identity with it, i.e. by actual participation.

This latter possibility, namely, actual participation in the work, distinguishes the truth of uncovering that belongs to an aesthetic interpretative project from that which belongs

to a statement. For between the statement and its object there is a gap, and the statement-meaning is not essentially identical with the object, whereas in aesthetic participation the beholder can actually participate in the being of the work through his interpretative project just because the work is a symbol of human existence. Namely, just because the work articulates a form of concern, and concern is of the nature of human existence, the observer with his concern can enter into the concern of the work. Here, then, the gap between intention (of the observer's project) and intended (the work's being as symbolical or meaningful) is bridged, and the identity is consummated. Truth of the first kind reaches a limit, and truth of spiritual being, in its aesthetic dimension, comes into the observer's possession. He participates in it.

This is the source of the unique joy of art. The beholder is able not merely to observe truth of being at a distance, standing here in his concern with it over against the being that is true in itself, as happens in the aesthetic experience of nature. He is able to enter into the truth of the *spiritual* being that has been articulated in the work and thus participate in such truth on his own account.[6]

(2) *Truth in creating.* In the case of the beholder of a work of art the work is already there, like a thing, and requires to be known in its own being as a symbol. Hence

[6] It is true, of course, that we can experience nature in the way in which we experience art. We then see the natural object as a symbol of the artistic kind, imagining a creative spirit at work in its formation. The object then really looks different to us; it becomes, as it were, hollowed out and dematerialized; the horse begins to look like a piece of moving sculpture, whose vitality stems not from the substance within but from a spiritual source. But such an experience depends on the essence of art, and it is no longer aesthetic experience of nature *as such* but of nature transformed by the beholder's imagination into art.

the beholder's approach is principally that of understanding and the first kind of truth. But in the case of the artist the work first has to be produced. He has materials available which he can form into a work, but he has to supply the concept or intention that is the guiding principle in the process of creation and that is to be fulfilled by the product in the end. Thus his attitude is principally that of the will and the second mode of truth, truth of things.

The uniqueness of the artist's creation derives from the nature of his goal. For his aim is to form a symbol whose meaning is a form of concern in the aesthetic dimension. So, the aim of the sculptor of Selene's horse was to form an aesthetic symbol of a certain love. Consequently the concept of the work, as in the case of the beholder, is both like and unlike a concept or intention in the domain of isolated practical truth. In that isolated domain, a concept is a concept of ordinary understanding transformed into a standard or project, and capable of being fully stated in universal terms, e.g. the concept of a park bench. But the so-called concept of a work of art is closer to what Kant called an idea, and especially an aesthetic idea, namely, an image whose meaning can never be exhausted by any finite set of concepts.

Indeed, the idea of the work is the junction of the impulse toward a certain concern e.g. a certain love, and a specific imaginative form, e.g. a horse; and the greater part of the idea, like an iceberg, is below consciousness, since it is the living will of the artist, including his understanding and, above all, his spirit, that is thrown into play. I speak, naturally, only of genuinely creative and spontaneous art, no matter how much regulated by learning and skill.

The beginning of wisdom in thinking about the idea of a work is contained in some remarks of Arnold Schönberg

about the idea of a piece of music. He does not himself explicitly trace the idea down into the spiritualized will, but he opens the path thereto:

In its most common meaning, the term idea is used as a synonym for theme, melody, phrase, or motive. I myself consider the totality of a piece as the *idea:* the idea which its creator wanted to present. But because of the lack of better terms I am forced to define the term idea in the following manner: Every tone which is added to a beginning tone makes the meaning of that tone doubtful. If, for instance, G follows after C, the ear may not be sure whether this expresses C major or G major, or even F major or E minor; and the addition of other tones may or may not clarify this problem. In this manner there is produced a state of unrest, of imbalance which grows through most of the piece, and is enforced further by similar functions of the rhythm. The method by which balance is restored seems to me the real *idea* of the composition. Perhaps the frequent repetition of themes, groups, and even larger sections might be considered as attempts toward an early balance of the inherent tension . . . One thinks only for the sake of one's idea. And thus art can only be created for its own sake. An idea is born; it must be molded, formulated, developed, elaborated, carried through and pursued to its very end. Because there is only "l'art pour l'art," art for the sake of art alone.[7]

It is by asking what is the source and meaning of the musical imbalance and tension and what is the nature of the drive toward the restoration of the balance that one is led to the spiritualized will from the idea of the work; and it is in this context that the true meaning of *l'art pour l'art* that Schönberg descried becomes visible—namely, the absolute finality of spiritual truth by reason of which it serves nothing else but instead constitutes the end and meaning of existence.

[7] "New Music, Outmoded Music, Style and Idea," in *Style and Idea.*

Thus there arises the possibility of a practical truth of things here. The thing (no longer a mere thing) that is practically true, by conforming to the concept (no longer a mere concept) imposed on it, is the work of art as created in accordance with the particular aim of the spiritualized will. But here, too, unlike ordinary practical truth of things, the gap between intention and intended is bridged. Already in natural beauty we have seen how the idea of the thing appears to be the thing's own idea, e.g. the idea of the horse, so that it is the thing's own will that is realized in its formation. Now again, in beauty of art, it is the will that belongs to the work that is realized in the work. The work is experienced by us as a symbol, but a symbol of an extraordinary sort, since its meaning is a form of the spiritualized life-will. In the work the spiritualized will articulates itself in a definite form.

That it is the spiritualized will is shown by the essential *rightness*—or truth of its own being, its conformity as objectivity with its own concept—that characterizes a successful work of art.

This rightness is sought in and through the artistic mastery of all the materials and tensions that face the artist in creation. We must grasp the work in its rightness if we are to understand it truly. From the artist's standpoint, this is the ultimate goal of his search. It lures him on as a destiny. It takes the shape of an aesthetic necessity that must be realized, a condition in which the idea has been fully delivered, the work finished, everything in it as it ought to be, nothing any longer changeable.

Needless to say, this is an ideal, and even the greatest works on the whole succeed only in arriving at an approximation to it. It is easier to arrive at in decorative art, where the depth and breadth of the will-to-be is contained in a

small compass and pitched at a shallow level, for which reason it is generally more obvious in such works.

A work of art is a fragmentary articulation of something that can never be fully articulated, but that lies at the ground of our being and demands utterance. It is the primal thrust of the will-to-be toward its own truth. In the very act of striving to order the chaos of visual phenomena into a necessary whole, the forces of the painter's being rise to articulation in vision, in a visual form that reflects to him something that has attained a complete, necessary existence.[8] The culminating point of the creative movement is reached (as similarly pointed out by Schönberg) where the form in which the visual conception is developed stands out clearly, is complete and necessary to the artist. The visual idea has been worked out and brought to the point at which "this way and no other" becomes a necessity to him.[9] The unclarity, fragmentariness, and arbitrariness—the essential *inarticulateness*—of the world of ordinary vision (or hearing, imagination, thought), because of which it is a chaos of unrelated phenomena, has given way to a clear and coherent order, connected by means of a comprehension of the internal relationships of the visual world, complete in itself and pervaded by necessity.

From the beholder's standpoint, the work appears as an entity that has a purpose of its own which it works out in its own being. Thus it is purposive, although it is not like an instrument and can be used for no definite purpose except that of aesthetic experience. Its purpose, otherwise, can only be to be what it is in its pure purposiveness. This is how the beauty that Kant defined, from the point of view of the relation of purposes considered in the judgment of taste, and in special regard to beauty of nature, as "the form

[8] Fiedler, *On Judging Works of Visual Art*, p. 58. [9] *Ibid.*, p. 57.

of the purposiveness of an object, so far as this is perceived in it without any representation of a purpose," is also to be found realized, within the aesthetic purpose of art, as the aesthetic rightness or necessity of the work.[10]

The rightness in art is that of the spirit, which seeks the self-measuring of will, or the attainment of truth of being by life-will itself. Thus it is truly described, with an insight that comes from direct realization of his own purpose as artist, in the famous statement by Matisse, who finds ultimately the right name for the beauty that he seeks: a living harmony that realizes the spirit of the picture.

In speaking of his choice of colors he says:

There is an impelling proportion of tones that can induce me to change the shape of a figure or to transform my composition. Until I have achieved this proportion in all the parts of the composition I strive toward it and keep on working. Then a moment comes when every part has found its definite relationship and from then on it would be impossible for me to add a stroke to my picture without having to paint it all over again.[11]

The form with its "this way and no other" is the conclusion of a process of striving, the realization of will. What is present throughout is the artistic idea, which has an individual shape in the individual process. Here it is the "impelling proportion of tones," the "definite relationship" which, once it is worked out into the whole picture, demonstrates itself to be to such an extent what it must (ought to) be

[10] *Critique of Judgment,* end of Sec. 17. In this connection we should also note the important remark on the relation of beauty of art to beauty of nature. "In a product of beautiful art we must become conscious that it is art and not nature; but yet the purposiveness in its form must seem to be as free from all constraint of arbitrary rules as if it were a product of mere nature. . . . Nature is beautiful because it looks like art; and art can only be called beautiful if we are conscious of it as art while yet it looks like nature." Sec. 45.

[11] Henri Matisse, "Notes of a Painter," in Barr, pp. 119–23.

that nothing can be changed any longer. This artistic idea is the unique measure that spirit aims toward and wishes to give to its will as the truth belonging to it.

The process of painting itself, whose outcome is to be a visual form that is clear, complete, and necessary, is throughout a continual search for this form as the realization of the idea. This is the extension of the ideal of thing-truth into the domain of spiritual truth. At every stage there is a form which, though it has features approximating to what is sought, is deficient in one point or another. The conclusion is reached when the form is found that shows itself to be clear, complete, and necessary in its own terms, so that here the objectivity conforms fully to the concept and so that—since the concept is a concept of *truth*—the objectivity is essentially described as a mode of *rightness*.

It is necessary . . . that the various elements that I use be so balanced that they do not destroy one another. To do this I must organize my ideas: the relation between tones must be so established that they will sustain one another. A new combination of colors will succeed the first one and will give more completely my interpretation. I am forced to transpose until finally my picture may seem completely changed when, after successive modifications, the red has succeeded the green as the dominant color. I cannot copy nature in a servile way. I must interpret nature and submit it to the spirit of the picture—when I have found the relationship of all the tones the result must be a living harmony of tones, a harmony not unlike that of a musical composition.[12]

This striving to balance the elements so that they are not mutually destructive but, instead, sustain each other, this impulse to modify and transpose, to organize and reorganize ideas, to change the composition and color relationships continually until the spirit of the picture has found its

[12] *Ibid.*

proper form—this is the measuring activity of spirit which, in the painter, takes the shape of a drive toward a living harmony or necessity of visual reality. Notice how Matisse characterizes the form sought after: a living harmony of tones, not unlike that of a musical composition. This living harmony is the form that, for Matisse, the conception or idea, to which the work is to be true as a thing, assumes. Thus the concept that is the standard of thing-truth in art is itself a living will's demand for the truth of its own being, found when that being has come to existence in the form of an aesthetic rightness or necessity.

If we ask, "What is the artist's intention in his work?" the answer must be this. The artist is for the most part unknowing of his intention until he realizes it. He may know in advance that he is aiming at truth—as Matisse knew in advance that he was aiming at a living harmony that realizes the spirit of the picture or as Schönberg knew in advance that he was aiming at the complete development of the idea of a composition to the final restoration of balance—but what the concrete living harmony or idea is that thrusts toward fulfillment he does not know until it has become knowable to him in the work. He cannot know it in advance, because it is his own will itself, together with his understanding and spirit, that drives toward concrete, definite existential form in the particular mode of symbol, hence toward symbolical articulation. The "idea" or "concept" that is the standard here is the very being of the self as an aim at its own ultimate form of truthful existence.[13]

[13] It was Kant's understanding of this point that led him to a solution of the problem of the relation of genius to rules. Genius corresponds to the self in its capacity to drive toward its truth in the language of the symbol; the rules correspond to a concept to be imposed, in the second form of truth, on the work as a thing. Kant's solution is that nature, i.e. the innate nature of the genius, takes the place of the ordinary concept or standard. "*Genius* is the talent (or

There is always some local, accidental element in the idea, around which the powers of the artist gather and which, like the grain of sand in the oyster, is the irritant that induces a pearl—something seen, heard, some incident or sudden image or rhythm flashing across the mind. Around it, first, the substantial element of will, largely unconscious, seethes, throwing the imagination and memory into play, bringing up image after image. Second, the formal principle of understanding, the know-how of skill and forms—cool, critical, capable, largely conscious—cuts into this turbulent mass, separating out, transforming, bringing into shape. But, overriding all and inspiring will and understanding so that both substance and form can subserve their proper end, there is the spiritual element, ultimately the love itself that looks longingly forward to true being that is connatural with it. The idea of the work is the unity of all four: the particular material occasion, the substantive will, the formal understanding, and the spiritual concern. It is the unity of the first three under the persuasion of the fourth.

The spiritual concern, ultimately the love that seeks true being as its object, is what gives its specifically aesthetic character to the emotion in artistic creation. We have looked at it in the case of representational art, as in Selene's

natural gift) which gives the rule to art. Since talent, as the innate productive faculty of the artist, belongs itself to nature, we may express the matter thus: Genius is the innate mental disposition (*ingenium*) *through which* nature gives the rule to art." Art presupposes rules, based on a concept of what the thing ought to be; yet beauty cannot be judged by mere rules or concepts; hence, the rule must come from something which is not an ordinary concept, namely, genius—"beautiful art is only possible as a product of genius." And because the source of the rule is not a usual concept, the author of a beautiful product does not himself know how he has come by his ideas; they are nature speaking through him; he cannot devise them at will or by plan or communicate to others effective precepts for producing beautiful art. *Critique of Judgment,* Sec. 46 and elsewhere.

horse. It is even more obvious in nonrepresentational art. The central aesthetic question here was formulated by Clive Bell in a manner aimed especially at the thesis that abstract art is the most genuine form of art: to explain why certain combinations of forms are perceived to be right and necessary, and why our perception of their rightness and necessity is moving.[14]

Bell's answer was that the rightness of the work is connected with a particular emotion, which he called the specific artistic emotion or the aesthetic emotion, and which is an emotion that is felt for objects seen as pure forms that are ends in themselves. He suggested that the reason why a form could be an end in itself was that it was "the thing in itself" or "ultimate reality." Hence his so-called metaphysical hypothesis that the artistic-aesthetic emotion was an emotion felt for ultimate reality. But such a solution would be at a loss to account for the historical differences of taste, the divergent realizations of rightness and artistic styles (only some of which are wholly abstract), that confront us so obviously in fact. It would therefore have been more fruitful if Bell had looked back to a more direct relation between the pure form and the aesthetic emotion.

"Ultimate reality" can also mean reality that reaches an ultimate stage, the eventual form that being takes when it reaches truth of being. The emotion would then be the emotion we feel for true being. And is that not the very sense suggested by the phenomenon of the rightness and necessity and emotional power of certain combinations of forms, of lines, and colors? Is that not the sense suggested by the phenomenon of the form that is an end in itself? What is right, necessary, and an end in itself is what has

[14] *Art*, p. 28. See especially Chapter I, "The Aesthetic Hypothesis," and Chapter III, "The Metaphysical Hypothesis."

attained to truth of being, i.e. to a condition of being in which it is as it ought to be in terms of its own ought. That is exactly the experience we have of a combination of pure forms that strikes us with its necessity and rightness—it presents itself as a being that has arrived at its own truth of being. If, then, we are profoundly moved by it, as indeed we are, what can this emotion be but our concern for true being, which is but another name for love?

Mörike's celebrated lyric, *On a Lamp*, captures this impression that a work of art gives us as of the ultimacy of being that a thing may reach in itself as its own fulfillment.

> Still undisturbed, o beauteous lamp, you grace,
> Lightly hanging here by delicate chains,
> The ceiling of this nigh forgotten room of joy.
> On your white marble bowl, its border wreathed
> By goldgreen brazen ivy woven round,
> A band of children intertwines in happy dance.
> How all entrances! laughing, yet a tone
> Of graveness poured about the form entire—
> A work of art of truest sort. Who heeds it now?
> But what is fair, blissful it seems within itself.

The final verse is possibly ambiguous in the original: *Was aber schön ist, selig scheint es in ihm selbst. Scheinen* means showing or shining as well as appearing or seeming. *Selig* would be the predicate adjective "blissful" if we take (as in the above version) the verb in the sense of seeming; but it would be the adverb "blissfully" if the verb were taken in the sense of shining: "But what is fair, blissfully [or blessedly] shines in itself." The poem is discussed in a correspondence between Emil Staiger and Martin Heidegger, published in the former's *Die Kunst der Interpretation*.[15] Heidegger distinguishes Staiger's reading as equivalent to

[15] Atlantis Verlag, Zürich, 1955, under the heading "Ein Briefwechsel mit Martin Heidegger."

"*felix in se ipso (esse) videtur*" from his own as equivalent to "*feliciter lucet in eo ipso.*" Says Heidegger:

I read: feliciter lucet in eo ipso; the "in ihm selbst" belongs to "scheint," not to "selig;" the "selig" is rather an essential consequence of the "in ihm selbst Scheinens." The articulation and "rhythm" of the final verse place the stress upon the "ist." "Was aber schön *ist*, selig *scheint* es in ihm selbst." "Being beautiful" is pure "shining".

Despite Staiger's graceful accession, I do not find Heidegger's explication (or his rhythm) convincing. It seems to me to be too much of an encroachment upon the poem of his own view of beauty. Heidegger's concept of beauty is here given in terms of the notion of pure shining; in his essay *The Origin of the Work of Art*,[16] it is given in terms of the notion of the establishment of truth in the work. But since, on Heidegger's view, truth is ultimately the uncovering lighting of being or the presence of the present, the notion of pure shining is but another version of pure lighting and pure presence.

Now this notion of beauty as pure shining or pure luminescence of being does not do justice to the fundamental experience of artist and beholder, which we have seen to lie in the living (ultimately spiritually living) rightness of things in nature and works of art. In his analysis of truth Heidegger, indeed, bypasses rightness, neglecting to give it the full consideration it demands. This neglect forces him into a contemporary phenomenological version of the old light metaphysics, but without the central phenomenon of rightness and necessity that is present in the Platonic concept of measure and the Anselmian concept of truth. We have, on the other hand, in the discussion of the color of

[16] In *Philosophies of Art and Beauty*.

gold, seen how the very beauty of shining itself must be interpreted finally in terms of a living rightness. This ultimacy of rightness, of life come to its fulfillment, is precisely what is put forth in Mörike's vision of the lamp as blissful, i.e. happy in the most final sense, in itself: the truth of living being. And, it may be added, we do not love light merely because it shines; we love it above all because it seems fulfilled in itself, and what is truly fulfilled in itself radiates beneficence.

The love of true being as it turns to semblance is, therefore, the specifically aesthetic emotion that lies at the heart of all aesthetic-artistic construction. This spiritual concern, belonging to the human being as a person, is the final determining factor in aesthetic art, in the sense that it is what demands to be fulfilled in the creative process. The artist— for the most part unconscious of what is happening with him at the ultimate level, however conscious he may be of his technical and rhetorical problems—follows the guidance of this concern when he is successful in creating an aesthetic work. The emotion is the ultimate ordering principle of the work, the principle that induces measure (rightness and necessity) in it.[17]

We may therefore say that the idea or concept of the work is the total complex volition that, deriving its occasion from the particularities of the situation, its substance from will, and its limitation from artistic understanding, is ordered and measured by spirit into a love for true being that

[17] For the operation of emotion in ordering the work of art, see the important passage in Dewey's *Art as Experience*, pp. 67–70, where its essential connection with the attainment of measure, rightness, necessity is made clear, but where, unfortunately, this function is assigned to any ordinary emotion that gets expressed rather than to the love of true being, or, in Dewey's language, the impulsion toward the consummation of *an* experience, which is, after all, his concept of the specific motivation of art as experience.

will be satisfied only when it finds the rightness and necessity of true being in its object.

On the other hand, the "thing" that is subjected to this "concept" and required by will to be true to it is the work of art. The work of art is true to the truth of the spiritualized will's being. This is the form that practical truth, or truth of the second kind, takes on in the domain of truth of spirit. And here, too, there is ultimate identity in being, not merely in intention, between the concept and the thing. In so far as it is aesthetic, the work of art *is* the spiritualized will as true, in the particular form of meaning in a symbol that is what it symbolizes; it is itself an instance of love in the form of an ontological symbol.

The purpose of artistic creation is such that the work of art does two things simultaneously. It presents an object that is characterized by rightness and necessity, and at the same time it articulates the aesthetic emotion toward that object. Thus in Selene's horse, as we remember, there is at one and the same time the horse-image, right and necessary in the ultimateness of its appearance, and the love of architectonically measured vitality that breathes in every contour, fold, and plane of that sculpture. The work articulates simultaneously the two polar aspects of human existence: (1) that of the world, limited to this objective image; and (2) that of the being who is in and with the world, and whose disposition toward this limited objective image is brought out.

Moreover, not only does the objective image (in the case of the representation of something objectively beautiful) exhibit a measured will-to-be that constitutes its own objective truth of being. The work itself, in its full density, as including the articulation of the self's concern for this

objective truth, is also a fulfillment. For just as in the natural horse, beauty is the articulation in it of the measuring of its life-will, so in the created work, artistic beauty is the articulation of its own living measure as a work.

In the work that we see before us, we see not just a beautiful horse but a beautiful sculpture. A sculpture is a work of human hands. When we see it *as* a sculpture we see it *as* such a work. It is not merely the work of the hands of a mechanic or craftsman, who operates in the sphere of the first and second kinds of truth, guided by a plan rather than an ontical idea. It is the work of an artist who, in becoming aesthetic, enters into the sphere of the third kind of truth.[18] In order to enter this sphere, he must enter into the domain of spirit, which means that he must energize in love. His love flows through his hands and articulates itself in the medium. This love is not the spiritual element alone, but the seething will, limited by understanding, that is ordered and measured by spirit. It is a specifically human life-will that is articulated by the artist in a human art work, as contrasted with the merely animal life-will that is articulated for vision in the form of the living animal.

The human life-will includes mentality; it is a seeing, a hearing, a touching, an imagining and thinking will that is articulated, not a merely direct push of will. For this reason the work of art includes the two essential phases of the image and the concern that relates to the image. The purpose of the work is to articulate such a concrete concern, full of mentality.

When that concern reaches its proper articulation, the work has its own rightness and necessity, which is the right-

[18] As a beginning, one should read in this connection the lovely essay, "In Praise of Hands," by Henri Focillon, in *The Life of Forms in Art*, 2nd English edition, George Wittenborn, Inc., New York, 1948, pp. 65ff.

ness of the aesthetic work of art. That is why a beautiful work is not necessarily the representation of a beautiful object. It is the articulation of the fundamental concern for truth of being. What makes Rembrandt a supreme artist is not the beauty of the people and objects he represents, but the noble spiritual truth of his concern for them. In their plainness, even their ugliness, he finds the testimony of the possibility of spiritual truth, and this, his finding, is the movement of his concern, his profoundly universal love for the truth of spirit itself. That love is what we experience in any work of his, whether a landscape inevitably etched in a few lines, an unpityingly realistic portrait of himself, an ungainly nude, or the cruel pathos of the crucifixion. The light in which these are bathed is the light of an all-encompassing, all-penetrating concern for spiritual truth.

It is the same with Shakespeare, in whose work all subject matter is embraced within a universally concernful comprehension of the spiritual truth of being, which, at its height, gives to each image and each line its unforgettable rhythm. It is the same with every artist, great or small, to the extent to which the truth of the human spirit has awakened within him and come to articulation through his hands or his tongue.

Because the aesthetic motive of a work of art is ultimately the articulation of fundamental human concern, art exhibits the phenomenon of style. Style is already evidenced in natural phenomena. There are different styles of trees, landscapes, clouds. The horse manifests itself in different forms of aesthetic rightness, so that the more ponderous beauty of the Percheron and the plainer beauty of the hunter contrast with the vivid grace of the Arabian or the romantic grace of the palomino.

Style is the form that aesthetic rightness, or truth of be-

ing in the show of the thing, takes in accordance with the particular life-will that reaches articulation in the show. Focillon defined *a* style as "a development, a coherent grouping of forms united by a reciprocal fitness, whose essential harmony is nevertheless in many ways testing itself, building itself, and annihilating itself." [19] It is because artistic style is the articulation, in the form of a symbol, of the "reciprocal fitness," i.e. the rightness and necessity, that the spiritualized will seeks, that it is at the same time always in process. The living will has always to find itself and form itself anew.

Focillon distinguished style as an absolute, eternal value from *a* style as a variable historical phenomenon. As an absolute, style is "a special and superior quality in a work of art; the quality, the peculiarly eternal value, that allows it to escape the bondage of time." What is this eternal quality? Focillon went only so far as to note that in style as an absolute "we give expression to a very fundamental need: that of beholding ourselves in our widest possible intelligibility, in our most stable, our most universal aspect, beyond the fluctuations of history, beyond local and specific limitations." [20] Thus, for Focillon, while every historical style represents a form of aesthetic rightness, and therefore articulates a style of life itself, style as an absolute does something more—it expresses the eternal, stable, universal intelligibility of man.

But we may ask, What is this intelligibility that belongs to man? Focillon does not answer. Yet, as we see, it must be an intelligibility whose symbolical articulation shows it to be a spiritual truth of being. Every historical style, thus, articulates a form in which man has striven to reach the truth of his own being. Historical styles are the forms of

[19] Focillon, p. 7. [20] *Ibid.*, p. 7.

fruits on the vine of human existence: geometric, archaic, classical, mannerist, baroque, romantic, expressionist. . . . In each of them a human being whose life-will has diverted itself into the symbolical path of art has struggled to arrive at the articulation, in the artistic symbol, of the truth of its own being. The intelligibility of any given historical style is the meaningfulness of a symbol that articulates a real, particular form of truth of spiritual being.

These forms differ because of the historical differences that distinguish groups and ultimately individuals. The generic problem of being, of existing and striving to reach in existence the truth of one's own being, i.e. striving to be true, is the same for all. The conditions of its solution differ, because of innate differences on the one hand and differences of historical, cultural location on the other. In the father's house there are many mansions, and the vine has many branches which, if the sap of the truth of being flows through them, bring forth fruit each in its own kind. The generic problem is that already mentioned: to bring the will from its primal condition of the irrational seething passion to be, with the aid of the self-limiting action of understanding, and under the guidance of the measuring spirit of the love of truth, to the point of a truth of its own being, in which it has limited itself to an end by seeking and finding that objective truth of being to which it can devote itself in loving concern. This problem is posed to the will itself, i.e. to the human being himself, not to another. From the depths of his own self he has to come to the understanding and the spirit that will limit and measure his being.

On the other hand, it is only through finding a truth (actual or possible) that is not merely his but that belongs to being beyond him, that he can find the measure by which the unrest of the unmeasured will of practical truth can be

brought to a poise. Spirit looks out beyond the self to its ultimate object of concern. Thus only in the meeting of the striving self with objective truth can the self's own truth be reached. On both sides, in the self and in the outer world, history places its stamp on truth. There are many truths of being and of spirit.

Focillon thought, nevertheless, that one such historically conditioned style attained a superhistorical dignity—the classical. Classicism is not only a historical style. It is at the same time the embodiment of style as absolute quality. Classicism, wrote Focillon,

consists of the greatest propriety of the parts one to another. It is stability, security, following upon experimental unrest. It confers, so to speak, a solidity on the unstable aspects of experimentation. . . . Thus it is that the endless life of styles coincides with style as a universal value.[21]

And again,

Classicism: a brief, perfectly balanced instant of complete possession of forms; not a slow and monotonous application of "rules," but a pure, quick delight, like the *akme* of the Greeks, so delicate that the pointer of the scale scarcely trembles. I look at this scale not to see whether the pointer will presently dip down again, or even come to a moment of absolute rest. I look at it instead to see, within the miracle of that hesitant immobility, the slight, inappreciable tremor that indicates life.[22]

This classical ideal is realized again and again in history—in Greece, in Rome, in the Visitation on the north portal of Chartres, in the Virgin but not the St. John of the Belle Croix of Sens, and on down the centuries.

In contrast with classical art, every other style falls on one side or other of the *akme*, by defect or by excess. So, according to Focillon, baroque art is excessive. Baroque

[21] *Ibid.*, pp. 11–12. [22] *Ibid.*, p. 12.

forms live with a passionately intense life, proliferating like a vegetable monstrosity:

> They break apart even as they grow; they tend to invade space in every direction, to perforate it, to become as one with all its possibilities. This mastery of space is pure delight to them. They are obsessed with the object of representation; they are urged toward it by a kind of maniacal "similism." But the experiments into which they are swept by some hidden force constantly overshoot the mark.[23]

We must surely recognize the point made by Focillon. Classical style is indeed at the center of art, in the typical historical sequence of styles, of which it is the acme, as well as in the ontology of style. For classical style represents the point at which a given will-to-be, impregnated with historical particularity—African, Asian, Western, Greek, Roman, Christian, Renaissance Italian, French, German, English— reaches for a brief moment a balance, tremblingly perfect yet strong as steel, a life consisting in a love whose object is perfect truth of being itself present here and now. Perhaps the purest case in Western art is that of Mozart, in whose music the passionate will, secretly cognizant of its inherent wildness and its great powers for evil, is so charmed by the spirit that, a Caliban wholly metamorphosed into an Ariel, all its power issues in an uncloyingly sweet melody of eternal truth. One understands how Goethe could have spoken of the classical as health and the romantic—and by implication every departure from the classical—as disease.

Nevertheless, the classical is only truth of spiritual being in its most overt form. We should not confuse overtness with being and its truth. Every style has its own inherent mode of rightness and necessity. Every style has, therefore,

[23] *Ibid.*, p. 13.

its own native *akme*. Consequently every style encompasses the possibility of the eternal significance that Focillon attributed to the classical alone. We have only to compare cases in which such rightness is reached to see their relative equivalence. Who can truly say that, with all its perfection, the beauty of Mozart's music rises above that of Bach's baroque music or Beethoven's romanticized classicism?

To descend to lower heights, compare the rightness of the classicistic Gray with that of the manneristic Donne.

> The curfew tolls the knell of parting day,
> The lowing herd winds slowly o'er the lea,
> The plowman homeward plods his weary way,
> And leaves the world to darkness and to me.

In these lines from the *Elegy* there is almost pure congruence between the natural rhythm of the words, i.e. their semantical rhythm, and the artificial rhythm of the metrical base, that of the regular iambic pentameter. This is poetry of almost pure regularity, which uses the regularity to build its own rightness, but which contains enough of the hesitant immobility, the slight inappreciable tremor, of Focillon's *akme* to avoid rigidity. In its graceful smoothness, balance, measured quality, regularity, clarity, proportionality, poise, and restraint, with enough deviation and return to give it the elasticity of life, it is a typical model of the classical ideal—studied, muted, and late, no doubt, yet typical.[24]

[24] I do not overlook the fact that Gray is ordinarily, and indeed correctly, seen as a transitional poet between the neoclassic and romantic periods, and the *Elegy* as an expression of preromantic sentiment characteristic of the graveyard school. Nevertheless, Gray's poetry and this poem in particular reach a certain apex of classical harmony, perfection, and rightness that justifies Cazamian's reference to an "ideal classicism." See Emile Legouis and Louis Cazamian, pp. 836–40.

O desperate coward, wilt thou seeme bold, and
To thy foes and his (who made thee to stand
Sentinell in his worlds garrison) thus yeeld,
And for the forbidden warres, leave th'appointed field?
Know thy foes: the foul Devill (whom thou
Strivest to please) for hate, not love, would allow
Thee faine, his whole Realme to be quit.

In these verses from Donne's *Satyre III*, the semantical rhythm breaks continually athwart the metrical base, in ever-renewed counterpoint. The overt harmony of Gray is gone, a harmony that depended on congruence of the two rhythms together with smoothness of sounds, harmonious alliteration and rhyme, and quiet harmony of subject and imagery. Instead we have war, trumpet calls, strife, evil, harsh sounds, jerky movement, metrical license, impossible scansion.

Gray is obviously, overtly, openly beautiful. Donne, with his discords and tensions, his jagged, rough, hard rhythms, his rhetorical noise—what is he? Yet there is a rightness and necessity, a truth of spirit here too. The will has not destroyed measure. It has abandoned obvious, easy measure, because it is itself a strong, acrid will that needs a measure suitable to its own nature. In Gray the rightness and necessity are so obvious that you almost think you hear them on the surface, in the form of harmony, because the sounds themselves are harmonious. In Donne, because the surface sounds, images, and rhythms are inharmonious, the rightness and necessity are less patent, but they are there.

There is an accord between the rhythmic form and the meaning it serves to formulate, the rhetorical scorn poured upon man in his worldliness. Such a meaning, in order to formulate itself, must distort the regular rhythmical base

pattern. The distortions are right and necessary in the total effect, as they are in all expressionist art. Were this not the case, we would count the verses as merely ugly, as aesthetic failure. But because it is the case, the distortions occur for the sake of the whole. The overflows, pauses, trochees, and trisyllables exist for the rhetorical scorn and, conversely, the scorn exists for the irregularity of the rhythm. The two exist so that the poetic pendulum can swing between them. Taking the two in their unity, the whole is alive; it beats with the pulse of genuine poetry. And it is right as poetry. The rightness and necessity lie in the whole, not overtly as harmony in every part taken in isolation. Its rightness is of a kind that triumphs over apparent, isolated wrongnesses, obtaining its intensity precisely by being a harmony in and of the inharmonious. Heard melodies are sweet, but those unheard are sweeter. It is a phenomenon analogous to that we encounter in Schönberg's music. Because in recent times art again felt the need to search for the harmony of tension, Donne once more came into favor. In his poetry, as a concrete form consisting of rhythm and rhetoric in their unity, the whole form is in itself right and necessary, and as such it articulates a certain truth of being of the spiritualized will inhabiting it, a way of being in the shape we tend to identify as anticlassical or mannerist.

If, now, we return to Gray's lines, we recognize that there, too, the beauty of the parts—say, of this or that part or the whole of the verse-rhythm—is only subordinate to a poetic beauty that lies, like that of Donne, in the density of the poetry, namely in the unity of the verse-rhythm with its semantical content. The elegiac setting and reflective tone work together with the rhythm to build up a poetic whole— the swing of the pendulum—that is itself livingly right. A poetic spirit lives in that concrete form. Thus in both styles

of poetry, the classical verse of overt beauty and the anti-classical, mannerist verse of overt ugliness, there is a less obvious beauty, not heard or perceived as merely sensuous but grasped by the mind that lives through the poetry *as* poetry and hears it in hearing the sounds. This less obvious beauty, which is the authentic poetic beauty in both cases, is the element of absolute, eternal significance in the shifting historical styles, classical or anticlassical.

In every style there is the region of felicity, in which the spirit native to the style arrives at its *akme*. Every style has its own classical phase, or its own living perfection. Here the human will, limited and measured, has reached an existential form that is suited to its own particular character. The characteristic and the classical come to a point of juncture here. At this point in the flux of history, being reaches upward to an *akme* whose significance is no longer historical, but is the rightness and necessity of spiritual life, the life of love concerned with true being. In this way a moment is reached that encloses within itself an eternal significance.

The experience of natural beauty includes the lower ranges of moments of love of true being. Art contains its higher ranges, because the true being that becomes an object of love for us in art is finally the true being of the human spirit itself. Art therefore is a form of human existence, by participation in which the problem of existing—the problem that the human being himself *is* as a striving being—is solved. To the question, "Where and what is the truth of human being? Where is up?" the work of art stands in and of itself as an answer. It answers the question not by giving a statement—as we do here in philosophy—but by *being* the solution itself.

> For all the history of grief
> An empty doorway and a maple leaf.[25]

When human striving attains to the equipoise of art, the equipoise is the one that belongs to the striving and gives it a temporary station. The arrow has found a target for itself.

Nevertheless, the truth of art is a limited truth. The condition of its possibility consists in the fact that art, in order to be what it is, must restrict itself to the being of the symbol and hence to the limitation of existence in a symbolical medium. The truth it attempts to articulate in an intuitable form is built, not into the medium of life in its full actuality (the total self-world structure), but only into a purposely isolated section of the world, selected and set apart in order to be the locus of a self-contained realization. The spiritual truth is built into a finite real which, however, is not taken as real but is drawn out of the real into a state of ideality by the abstraction essential to aesthetic perception. This is the particular dimension of being into which art falls: finite reality made ideally infinite.

In arriving at the truth that is articulated in Selene's horse, the artist had to work in marble. The object of the concern he articulates is an imaged horse. This imaged horse bears a great burden of truth, which is why it is so precious to us. But it is, after all, an imaged horse.

For the truth of his own being, man needs not only the image of a horse, but also, and above all, the living reality of another who really exists. He needs to find, wherever he can in real existence, the actuality, and if not the actuality then at any rate the possibility, of the objective truth of being that can terminate the infinity of his practical will by giving to him the object for which he exists. If he finds this in actuality, his concern takes the shape of loving par-

[25] Archibald MacLeish, *Ars Poetica*.

ticipation in the blessing of truth. If he finds it in potentiality alone, his concern takes the shapes open to an actually unfulfilled, but not therefore stilled, love—the deep dissonance of tragic suffering, the pathos of the absence of good, the sweet hope of its promise. If he finds even the potentiality absent, he has left to him only the shapes of a love impossible to fulfill—the ironic insouciance of tragicomic unconcern or, at the end, the rage, despair, and madness of the lost being in a grotesque world.

The value of art is that of being a symbol in which all these forms of concern—all of them the shapes of love of true being—can be articulated, so that we can know them for what they are. To one who understands this, the history of the arts becomes a marvelous, unendingly interesting revelation of the possibilities of human existence. In every age the greatest artists have worked to uncover in a symbol the inner meaning of the real truth of human existence, by articulating its character as a fundamental concern for truth of being—in love of beauty, admiration of greatness, grief and gladness at the tragic, pathetic, and happy, carefree unconcern regarding the trivial, or piercing despair over absolute nothingness. The image of the nothing and the image of true being are two sides of the same coin. They are the images of the two extreme poles with which human concern, which is essentially the love of true being, concerns itself. The opposite side of love of true being is hatred of falsehood of being and, at the ground of both, hopeless, gnawing anxiety at the vision of the very impossibility of truth and falsehood of being at all.

Art can show us all these possibilities over and over again, as human life poses itself over and over again as a question seeking its answer. But to find the answer in reality itself, outside the restricted medium of an art, is still the problem.

Man exists outside the shell of the artistic medium. There-fore he must look into the world—he himself is the "must look" here—for those points at which the possibility of truth of being occurs.

In this search he moves into the sphere of ethics and religion. Here the problem of human existence gets posed in a different way. In art, man is able to delimit the problem by restricting his universe to the universe of the symbol. His power is like that of a demiurge over the medium he can work with. He has the whole of a world in his hands because he can limit the whole to the given symbol: it is a canvas, a wall, a building, a stretch of fifteen minutes of sound and silence, a scope of six stanzas that he becomes responsible for.

But in life man is responsible for what he does with the whole of what *is*. His concern must extend to everything, in a certain perspectival depth. He must exist in a world, from the angle of his own subjectivity. The conditions of his existence there are not chosen by him; they are allotted to him. Other persons with other wills contest his habitat with him. Conflict, misunderstanding, blindness, tension, ill-will, evil crowd the sphere of real existence, as well as their opposites. Here is a medium of which man is himself a fragment. What is so clear in art, what is so innocent even in the most sophisticated art, is muddied and polluted in the stream of real existence, where we have to begin over again the search for the measure that brings human being into the eternally valid equipoise of the moment of truth.

Bibliography

This bibliography lists works that have been cited for a specific purpose in the course of the discussion (to which have been added two of the author's articles especially relevant to the topic of this book). It is presented for the reader's convenience, not as a full bibliography of the subject.

Anselm. Dialogus de Veritate, in Selections from Medieval Philosophers. Edited and translated by R. P. McKeon. New York, Scribner, 1929. Vol. I, pp. 142–84. From Migne, Patrologia Latina, Vol. 158, col. 467–86.

Barr, Alfred, Jr. Matisse: His Art and His Public. New York, Museum of Modern Art, 1951.

Bell, Clive. Art. New York, Stokes, 1913 (date of Preface). (Reprint, Capricorn Books, 1958.)

Carnap, Rudolf. Introduction to Semantics. Cambridge, Mass., Harvard University Press, 1942.

Cassirer, Ernst. "Das Symbolproblem und seine Stellung im System der Philosophie." Zeitschrift für Ästhetik und allgemeine Kunstwissenschaft, XXI (1927), 295–312.

——An Essay on Man. New Haven, Yale University Press, 1944.

Collingwood, R. G. The Principles of Art. Oxford, Clarendon Press, 1938.

Croce, Benedetto. Aesthetic as Science of Expression and General Linguistic. Translated by Douglas Ainslie. 2d ed. London, Macmillan, 1922.

——The Breviary of Aesthetic. Translated by Douglas Ainslie. The Rice Institute Pamphlet, Vol. II. No. 4. Houston, Rice

Institute, 1915. This monograph has been reprinted by William Marsh Rice University (the name of the Rice Institute having been changed in 1960) as Vol. XLVII, No. 4 of *The Rice Institute Pamphlet* (1961). The page citations in the text are from the 1915 edition. The original Italian version is Breviario di estetica; quattro lezioni, 14th edition, Bari, G. Laterza, 1962.

Dewey, John. Reconstruction in Philosophy. New York, Holt, 1920.

——Art as Experience. New York, Minton, Balch, 1934.

Farber, Marvin. The Foundation of Phenomenology. Cambridge, Mass., Harvard University Press, 1943.

Fiedler, Conrad. On Judging Works of Visual Art. Translated by Henry Schaefer-Simmern and Fulmer Mood. Berkeley and Los Angeles, University of California Press, 1949.

Focillon, Henri. The Life of Forms in Art. 2d English ed. New York, Wittenborn, 1948.

Gibson, James J. The Perception of the Visual World. Cambridge, Mass., Houghton, Mifflin, 1950.

Gilbert, Katherine. "Cassirer's Placement of Art," in The Philosophy of Ernst Cassirer. Edited by P. A. Schilpp. Evanston, Ill., The Library of Living Philosophers, 1949.

Goethe, Johann Wolfgang von. "Einfache Nachahmung der Natur, Manier, Stil." In Gedenkausgabe der Werke, Briefe und Gespräche. Edited by Ernst Beutler. Zürich, Artemis, 1949–60. Vol. 13, pp. 66–71.

Hare, Richard Mervyn. The Language of Morals. Oxford, Clarendon Press, 1952.

Hegel, Georg Wilhelm Friedrich. Sämtliche Werke. Jubiläumsausgabe. Edited by Herman Glockner. Stuttgart, Frommann, 1927– . Vol. 7, Grundlinien der Philosophie des Rechts. Vols. 8–10, System der Philosophie. Vols. 12–14, Vorlesungen über die Ästhetik.

——The Logic of Hegel. Translated from the Encyclopedia of the Philosophical Sciences by William Wallace. London, Oxford University Press, 1931.

——Hegel's Philosophy of Right. Translated by T. M. Knox. Oxford, Clarendon Press, 1942.

———The Philosophy of Fine Art. Translated from Vorlesungen über die Ästhetik by F. P. B. Osmaston. 4 vols. London, Bell, 1920.

Heidegger, Martin. Being and Time. Translated by John Macquarrie and Edward Robinson from the German Sein und Zeit, 7th ed., Niemeyer, Tübingen. New York, Harper, 1962.

———Vom Wesen des Grundes. Frankfurt am Main, Klostermann, 1949, 1955.

———"The Origin of the Work of Art," in Philosophies of Art and Beauty, edited by Albert Hofstadter and Richard Kuhns, New York, Random House, 1964. Translated by Albert Hofstadter from the German essay, Der Ursprung des Kunstwerkes, originally published in Holzwege, Frankfurt am Main, Klostermann, 1950.

———Unterwegs zur Sprache. Pfullingen, Neske, 1959.

Hofstadter, Albert. "On the Logic of Imperatives." Written in collaboration with J. C. C. McKinsey, Philosophy of Science, VI (1939), 446ff.

———"Concerning a Certain Deweyan Conception of Metaphysics," in John Dewey: Philosopher of Science and Freedom. Edited by Sidney Hook. New York, Dial, 1950.

———"Does Intuitive Knowledge Exist?" Philosophical Studies. Edited by Wilfred Sellars and Herbert Feigl. VI (1955), 81–87.

———"Validity versus Value: An Essay in Philosophical Aesthetics." The Journal of Philosophy, LIX (1962), 607–17.

———"Art and Spiritual Validity." The Journal of Aesthetics and Art Criticism, XXII (1963), 9–19.

Husserl, Edmund. Logische Untersuchungen. 3d ed. Halle a.d.S., Niemeyer, 1922.

Kant, Immanuel. The Critique of Judgment. Translated by J. H. Bernard. 2d ed., revised. London, Macmillan, 1931.

———Kant's Critique of Aesthetic Judgment. Translated with seven introductory essays, notes, and analytical index, by James Creed Meredith. Oxford, Clarendon Press, 1911.

———Werke in sechs Bänden. Edited by Wilhelm Weischedel. Wiesbaden, Insel, 1960. Grundlegung zur Metaphysik der Sitten, Vol. IV. Kritik der Urteilskraft, Vol. V.

Köhler, Wolfgang. Gestalt Psychology. New York, Liveright, 1929.

Langer, Susanne K. Philosophy in a New Key. Cambridge, Mass., Harvard University Press, 1942.

——Feeling and Form. New York, Scribner, 1953.

——Problems of Art. New York, Scribner, 1957.

Legouis, Emile and Louis Cazamian. A History of English Literature. Revised edition. London, Dent, 1961.

Maritain, Jacques. Creative Intuition in Art and Poetry. The A. W. Mellon Lectures in the Fine Arts. Bollingen Series XXXV, 1. New York, Pantheon, 1953.

Matisse, Henri. Notes of a Painter. Translated by Margaret Scolari in Alfred Barr, Jr., Matisse: His Art and His Public, pp. 119–123.

Schelling, Friedrich Wilhelm Joseph von. Anthropologisches Schema (1840). In Vol. V of Werke, edited by Manfred Schröter. Munich, Beck & Oldenbourg, 1927–28.

Schönberg, Arnold. "New Music, Outmoded Music, Style and Idea," in Style and Idea. New York, Philosophical Library, 1950.

Staiger, Emil. "Ein Briefwechsel mit Martin Heidegger," in Die Kunst der Interpretation. Zürich, Atlantis, 1955.

Index

Absolute mind, idealism and, 39
Absolute spirit, in Hegel, 3
Abstract art, Bell on, 195
Actual, distinction between the ideal and the, 89
Actuality, term in Hegel, 139n
Addison, Joseph, 166
Adequacy of language, 90
Adequation: of intellect and thing, 91-95, 105, 130-32; as identity, in Husserl, 93-96; idea and, 105n-6n; two-way conformity and, 130-32; see Truth
Aesthetic as Science of Expression and General Linguistic (Croce), 8, 15, 34-35, 40, 41, 43, 48, 213
Aesthetic experience, 160-65, 183-86
Aesthetic rightness, necessity, see Rightness, aesthetic
Aesthetics: in relation to philosophy, 1; in Kant, 2; in Schelling, 2-3; in Hegel, 3; in Schopenhauer, 3-4; in Cassirer, 5-8, 10-15; in Croce, 8-10, 40-44; history and definition of, 21; distinguished from an aesthetic, 21; as linguistics, 37-52; in natural beauty, 142-48, 150, 151-54; concept of sublime, 165-70; symbolism and, 178, 180, 184, 185-86; see also Art; Beauty; Work of art
Aesthetic validity, 162

Aesthetics (Hegel), see Philosophy of Fine Art (Hegel)
Akme, 204, 206, 209
Anselm, 106-7, 197, 213
Anthropologisches Schema (Schelling), 178n, 216
Appearance: Hegel's concept of truth and, 138n, 139n; beauty as, of truth, 148-70; of objectively true thing, 142; of truth of being, 169; of power of being, 169-70
Apology, 84
Arrow, man as, 134, 173, 209-10
Ars Poetica (MacLeish), 210
Art: as expression of subjectivity, 1-22; in Schelling, 3; in Hegel, 3, 24; Schopenhauer on, 3-4; Cassirer on, 5-8, 10-15; symbolism and, 5-11, 15, 18-20, 24-32, 178-82, 184-86, 189, 199, 211-12; originality in, 13-14; expression theory of, 15-17, 20-21; Susanne Langer on, 18-20; as joint revelation of self and world, 23-36; symbolic, in Hegel, 24; double function of, 26; nature of creative, 34-35; as intuition, 40, 41, 47; difference between language of science and language of, 45-46; as primary process of imagination, 49; search for truth in, 50-51; nature and, 51, 186n, 191n; irrelevance of natural beauty in modern, 143; spiritual